# TONES

6 - 60 - 61 - 63 - 6
44 -

AKLAND +6013

7919 - Keith
JD bo

E TOUR

al y Jack Daniels

ger

**THE ROLLING STONES ★ 1972**

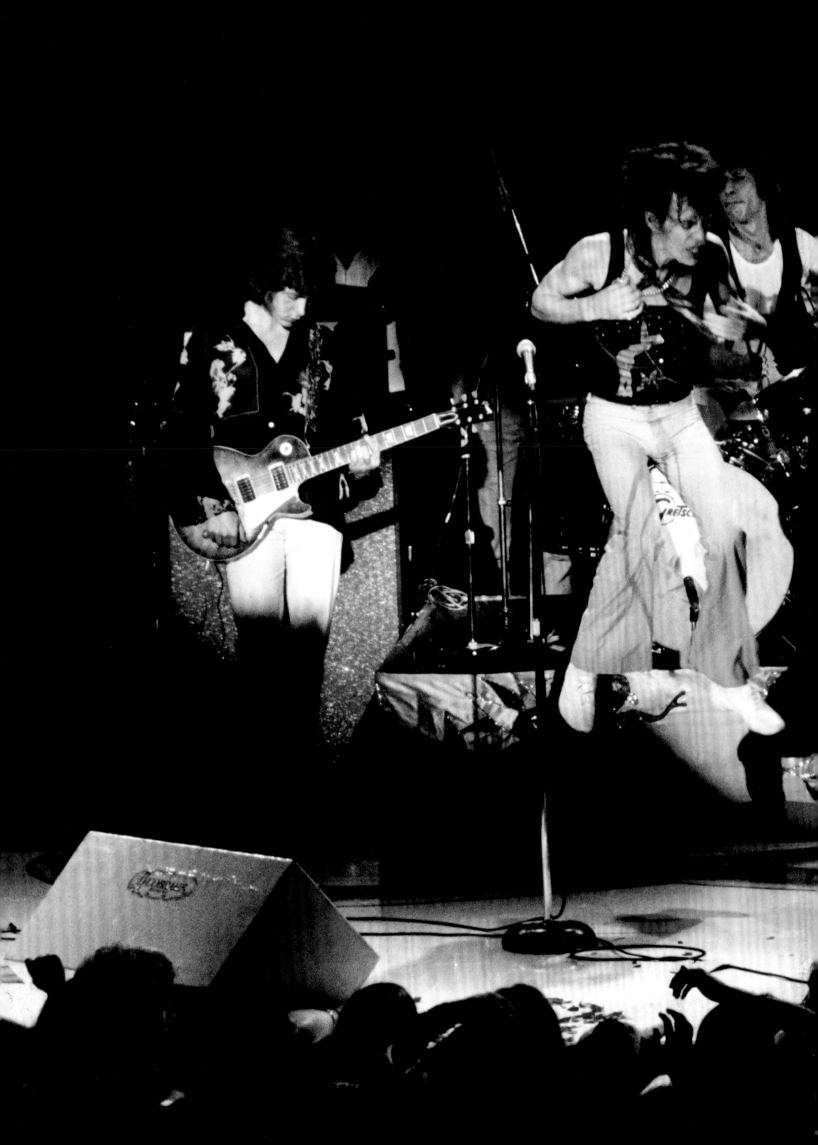

# JIM MARSHALL

# THE ROLLING STONES ★ 1972

## FOREWORD BY
## KEITH RICHARDS

ESSAYS BY
ANTON CORBIJN
AND NIKKI SIXX

INTRODUCTION BY
JOEL SELVIN

EDITED BY
MICHELLE DUNN MARSH
AND AMELIA DAVIS

CHRONICLE BOOKS
SAN FRANCISCO

Library of Congress Cataloging-in-Publication Data:
Names: Marshall, Jim, 1936–2010. photographer. | Richards, Keith,
    writer of foreword. | Selvin, Joel, writer of introduction. | Marsh,
    Michelle Dunn, editor.
Title: The Rolling Stones 1972 / Jim Marshall ; foreword by Keith
    Richards ; introduction by Joel Selvin ; edited by Michelle Dunn Marsh.
Description: 50th anniversary edition. | San Francisco : Chronicle Books,
    2022.
Identifiers: LCCN 2021031517 (print) | LCCN 2021031518 (ebook) |
    ISBN 9781797212609 (hardcover) | ISBN 9781797215419 (ebook)
Subjects: LCSH: Rolling Stones—Pictorial works. | Rock Musicians—
    England—Portraits.
Classification: LCC ML421.R64 M367 2022 (print) | LCC ML421.R64
    (ebook) | DDC 782.42166092/2—dc23
LC record available at https://lccn.loc.gov/2021031517
LC ebook record available at https://lccn.loc.gov/2021031518

Manufactured in China.

Front cover: Mick Jagger backstage at the Forum, Los Angeles,
California (detail).

Back cover: Keith Richards backstage at the Forum, Los Angeles,
California (detail).

Endpapers: Detail of Jim Marshall's 3 x 5 index card for the Rolling
Stones, with proof sheet numbers and notes of iconic images.

p. 2–3: Mick Taylor, Mick Jagger, Charlie Watts, and Keith Richards
in performance at the Winterland, San Francisco, California.

10 9 8 7 6 5 4 3 2 1

Chronicle Books LLC
680 Second Street
San Francisco, CA 94107
www.chroniclebooks.com

# CONTENTS

## FOREWORD KEITH RICHARDS

JIM MARSHALL SAID IT ALL: IT'S A MATTER OF ACCESS. ONCE JIM WAS IN, HE WAS ANOTHER STONE. HE CAUGHT US WITH OUR TROUSERS DOWN AND GOT THE UPS AND DOWNS. I LOVE HIS WORK, WHICH MUST HAVE BEEN FRUSTRATING TO DO AT TIMES, BUT THAT IS WHAT HAPPENS ON GIGS LIKE THIS. WONDERFUL WORK, AND A GREAT GUY. HE HAD A WAY WITH THE SHUTTER AND AN AMAZING WAY WITH THE EYE!

—DECEMBER, 2011

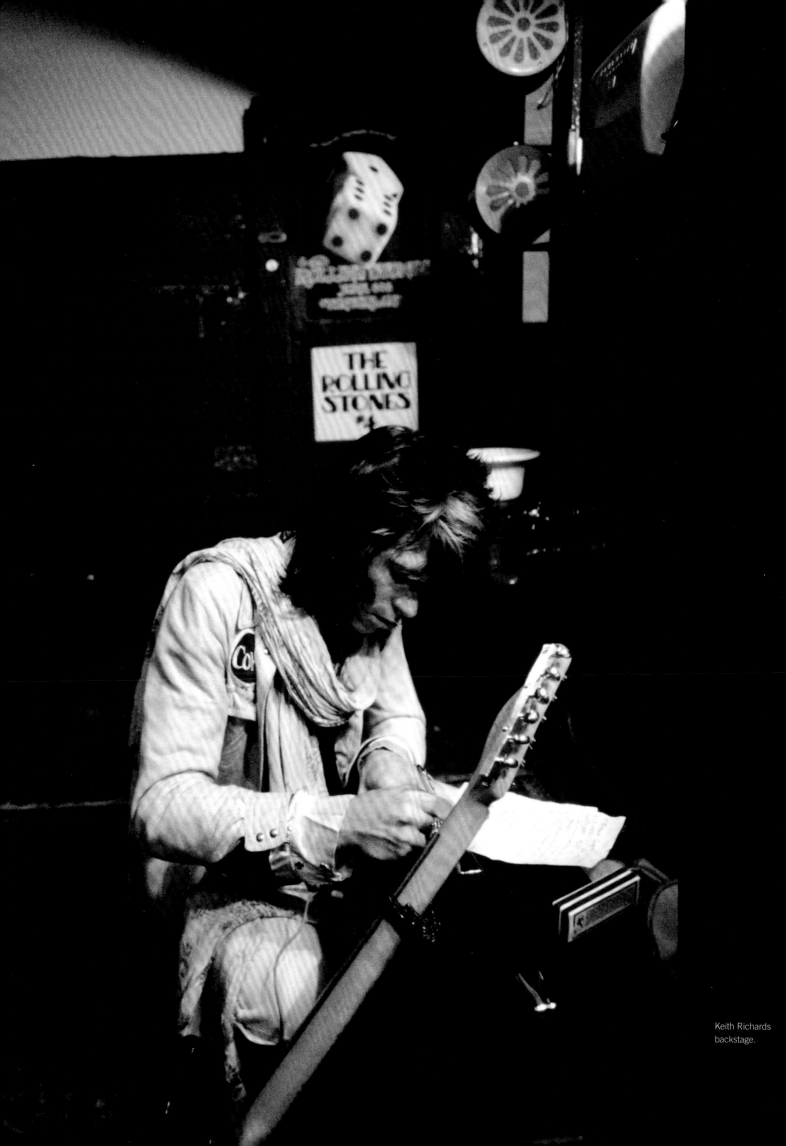

THE
ROLLING
STONES
#4

Keith Richards
backstage..

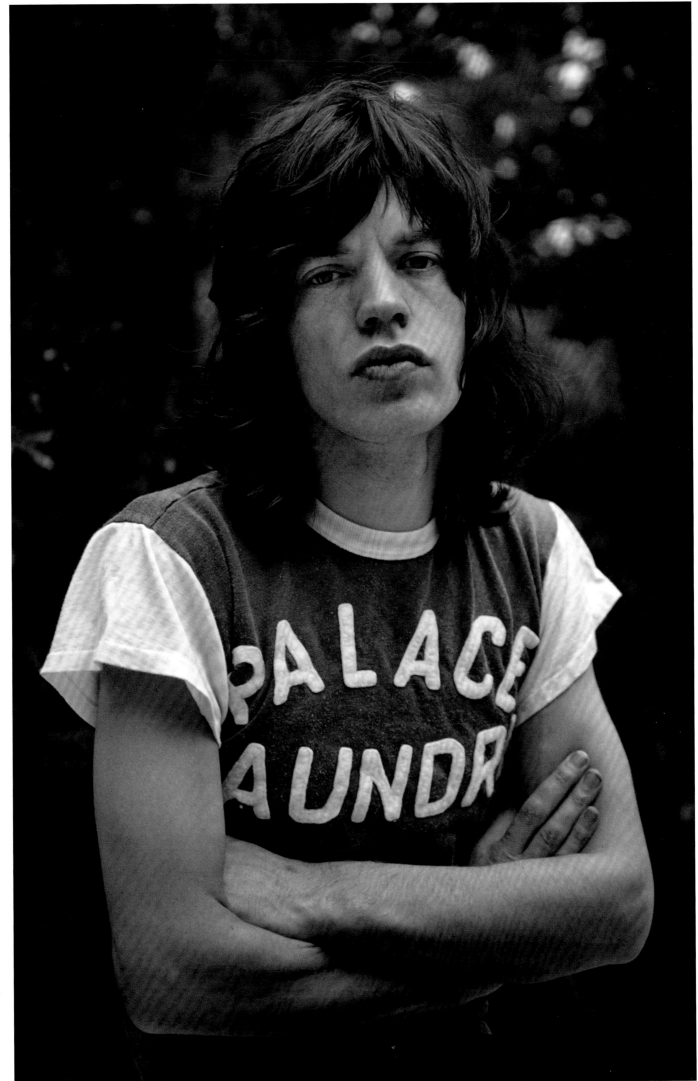

Mick Jagger
at a publicity
photo shoot,
spring 1972,
Los Angeles,
California.

# INTRODUCTION JOEL SELVIN

Summer, 1972—with the Beatles disintegrated and Bob Dylan semi-retired, the Rolling Stones stood, unchallenged, at the peak of the rock music world. Upstarts such as Led Zeppelin may have seized the day momentarily—"Stairway to Heaven" was ubiquitous that spring as the recently released *Led Zeppelin IV* settled into a five-year run on the charts—but the Stones still reigned supreme, exalted above all other rock stars. They had just released a two-record set in May, *Exile on Main Street*, that followed in the wake of three of the greatest rock albums ever—*Beggar's Banquet* (1968), *Let It Bleed* (1969), and *Sticky Fingers* (1971).

The Rolling Stones' cocaine- and tequila sunset–fueled 1972 tour would be rock's most glittering moment, with its four-million-dollar box office bigger than any before, and hangers-on the likes of best-selling author Truman Capote and Princess Lee Radziwill. The band's touring party on the private jet included its own doctor, trained in emergency medicine and always ready to write prescriptions, as well as photographer Robert Frank, who captured the mayhem on his Super 8 home movie cameras, edited into a never-released (but widely seen) feature film, *Cocksucker Blues*. There was Mick Jagger, ready for his close-up, and wasted Keith Richards, wearing a jacket with a Coke emblem and slouching under a sign reading "Patience Please . . . A Drug Free America Comes First!" for photographer Ethan Russell. Annie Leibovitz, writer Robert Greenfield, and others, including Jim Marshall, joined the tour at various stages. They dubbed themselves "STP"—Stones Touring Party—and adopted the stickers from the automotive oil additive with the same acronym, with its double meaning as slang for a popular hallucinogenic drug in the psychedelic underground. They were like a pirate crew where everyone had drunk more than their share of grog. This was rock and roll at its greatest.

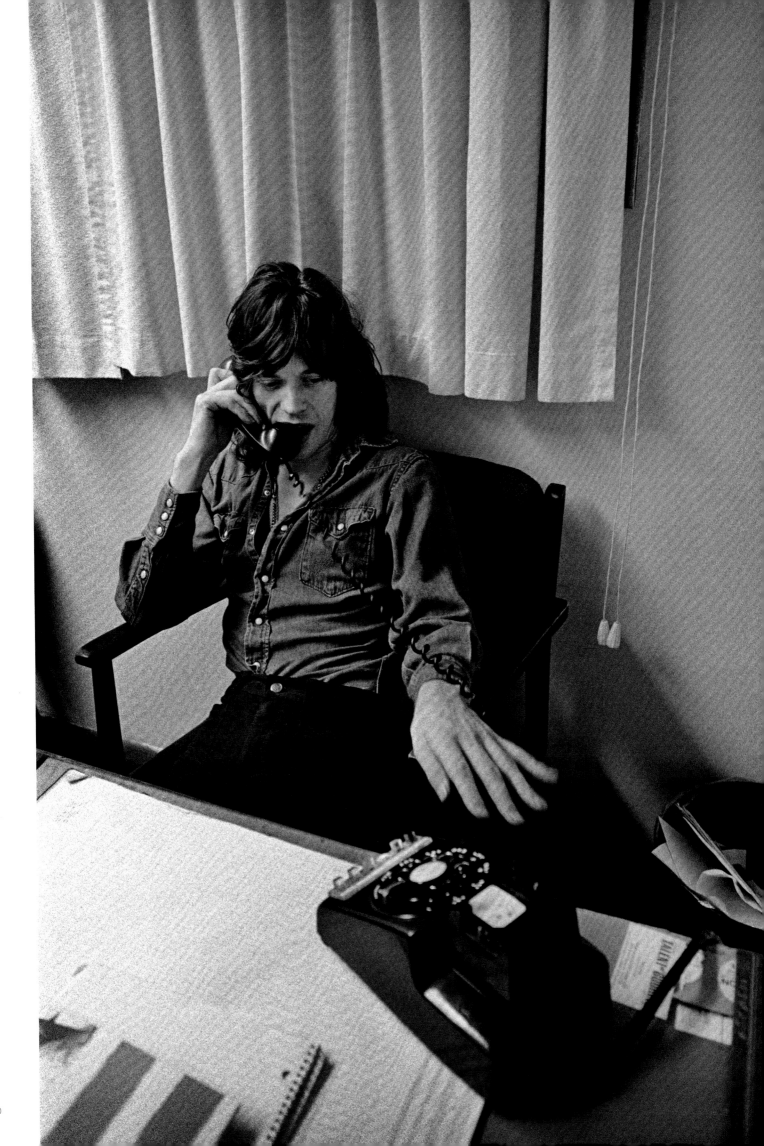

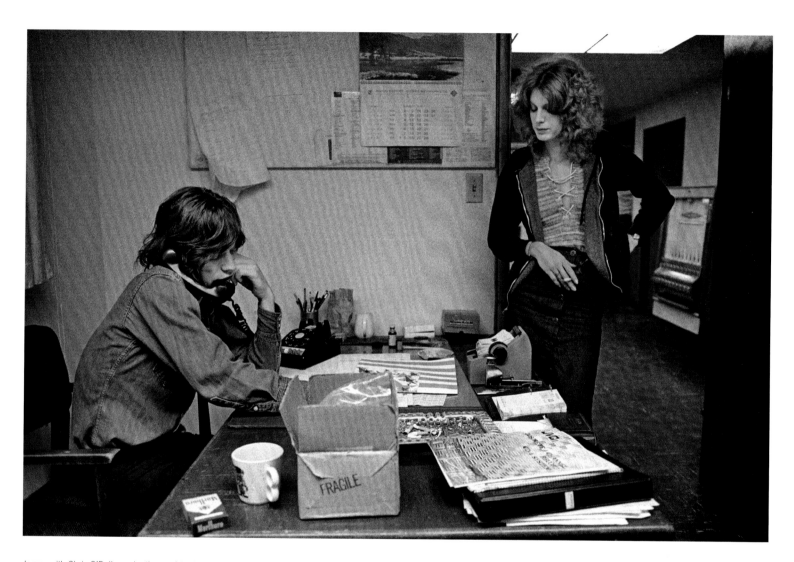

Jagger with Chris O'Dell, production assistant for the 1972 tour. O'Dell started her career at Apple Records with the Beatles, and after the 1972 tour went on to work with Dylan; Crosby, Stills, Nash & Young; and Linda Ronstadt as one of the first female tour managers.

< Mick Jagger at Sunset Sound, spring 1972, Los Angeles, California.

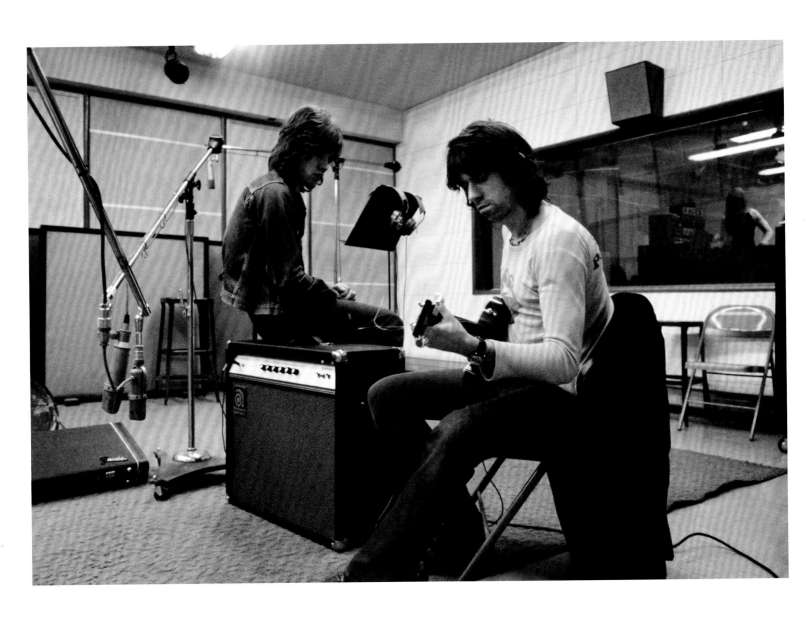

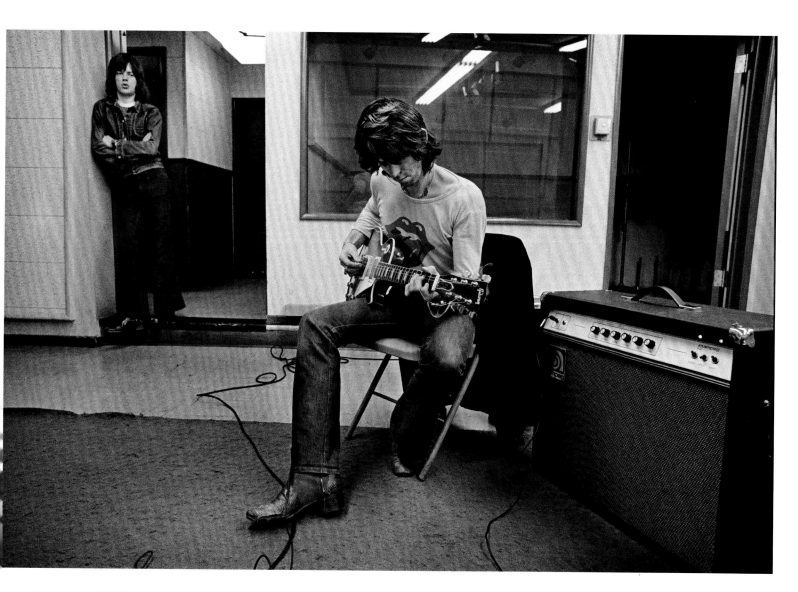

Mick Jagger and Keith Richards at Sunset Sound
doing post-production work on *Exile on Main
Street*, spring 1972, Los Angeles, California.

The band recorded most of *Exile on Main Street* in the basement of Keith Richards's rented chateau in Nellcôte, France, working with producer Jimmy Miller, but retreated to Los Angeles to finish the album at Sunset Sound. That old studio in the middle of Hollywood, where Annette Funicello made all her records, was started in the fifties by Walt Disney's music maestro, Tutti Camarata. Elektra Records practically turned it into a house studio—the Doors made several albums there— but the Stones had also worked the room before, on sessions for *Beggar's Banquet*.

With the record due to be released in May and the eight-week, thirty-city tour set to start in June 1972, engineer Andy Johns spent many sleepless nights through the first three months of that year trying to bring the project across the finish line. Last-minute panic set in. The record went through a number of marathon remix sessions, overdubbing vocal parts and doing whatever might be needed to get the album out the door. On assignment for *Life* magazine, Jim Marshall traveled to Los Angeles and captured Mick and Keith lolling around the studio, also shooting a separate portrait session with Mick. These are precursors to the intimate backstage images Marshall captured from the tour itself.

This Stones tour pierced a veil for rock music. *Life* was mainstream press. The Rolling Stones had become famous beyond the subterranean cultural reaches of the rock-and-roll demimonde. Rock music itself was grandly ascendant, just beginning to flex its popular strength in those early post-Woodstock years, and the Rolling Stones were rock's biggest stars. This tour would be a victory lap under the brightest spotlight and upon the largest stage the Stones had ever known. Rock music would grow bigger, but it would never be greater than the Rolling Stones tour of America in 1972.

The tour began in Vancouver, Canada, where two thousand kids without tickets battled cops outside. The next night in Seattle, the band cut a few songs from the set and tightened up the show. Stevie Wonder was their opening act: a half-hour explosion of talent and soul from his opening drum solo to hopping off stage at the back of a conga line of tall, beautiful Black female vocalists. The Stones cut their set down to under ninety minutes. After two successful shows in Seattle, the band was ready for San Francisco.

The taint of Altamont still lingered over the Stones, especially in the Bay Area. At the end of the 1969 tour, the band left town in a hurry after a planned free concert before an audience of near a half-million turned into a disaster. Members of the Hells

Angels motorcycle club, hired for $400 worth of beer to act as security guards, beat the crowd with pool cues and even knocked out Jefferson Airplane vocalist Marty Balin during his performance earlier in the day. The Stones waited until sunset to take the stage, only to have the performance interrupted by fights and outbreaks in the crowd during "Sympathy for the Devil." People died; one, Meredith Hunter, was killed directly in front of the stage. The band and their touring party took off after the concert in their overloaded helicopter like refugees fleeing Saigon.

In the aftermath, San Francisco rock impresario Bill Graham had some harsh words for Mick Jagger, but nonetheless had managed to coax the band into playing the Winterland for the 1972 tour. The 5,400-seat former ice rink where he held weekly rock concerts generally featured far-less-famous bands. In San Francisco the Stones first encountered the West Coast rock establishment, through musicians such as Jerry Garcia and Neil Young. John Lee Hooker came backstage to visit between shows. And, of course, there were the masses—the computer ticket agency reported more than 100,000 orders for the approximately 20,000 tickets available for the four shows. There also waited media—not just *Rolling Stone* hipsters, although they alone were enough. Jim Marshall was among them.

Marshall was a big-time photojournalist before the term was invented. When he lived in New York, he worked for the top glossy photo magazines—*Life, Look, Saturday Evening Post*—and his shots graced the covers of literally hundreds of album covers, from Miles Davis to Johnny Cash. His landmark photographs of Jimi Hendrix burning his guitar, Bob Dylan kicking a tire, and Janis Joplin snuggling up to her Southern Comfort bottle were cornerstone pieces of the emerging field of rock photography. At age thirty-six, Marshall was already that industry's grand old man.

Marshall first photographed the Stones at their 1965 performance at the San Francisco Civic Auditorium, a turning point in the nascent San Francisco rock scene; six months later, many people in the crowd that night had started bands of their own with funny names like Jefferson Airplane, Grateful Dead, and Big Brother and the Holding Company. Marshall covered the Stones' Oakland Coliseum Arena performances in 1969. He shot Altamont. He knew Winterland like it was his own living room.

San Francisco threw its doors open to the Stones. Bill Graham hosted a party at the Trident, a fashionable Sausalito restaurant owned by Kingston Trio manager

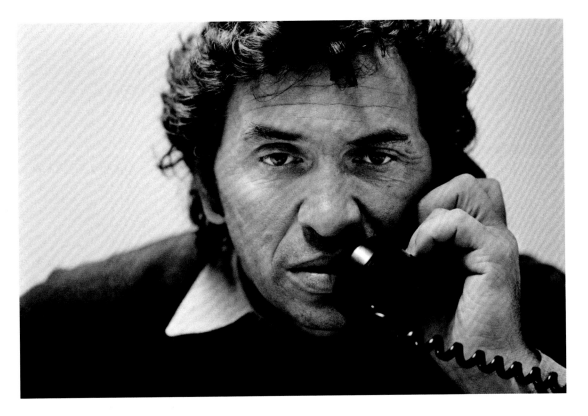

San Francisco rock impresario Bill Graham presented four shows over two nights at the Winterland and was also responsible for promoting shows in the Los Angeles area.

> Graham bought four hundred pounds of peanuts to give away to the crowds waiting outside the Winterland for hours before the show, San Francisco, California.

Frank Werber, who made it happen even though the place was usually closed on Mondays. In between nights at Winterland, the boys sought out the Isley Brothers at a soul joint in a tin Quonset hut across the Bay Bridge.

On the 1969 tour, the band had something to prove. Since their first U.S. tour in 1964, a thousand bands had sprung up. The Stones in '69 proved their primacy, even if the jubilant triumph finished with the massive free concert at Altamont that made a crater of the Woodstock myth, a nasty piece of punctuation to the entire decade. The 1972 model Rolling Stones was different. This time, the Stones rested certain of their status. Before he gave way to grand gestures calculated to play to the grandstands in the massive baseball parks the band soon inhabited, Mick Jagger was the most powerful archetypal rock vocalist in the world. Countless hundreds have borrowed from his book. He remains the single most dominant rock performer in the business, through generation after generation of other would-be rock stars. But at performances throughout the 1972 tour, Jagger was at his absolute peak, giving not just career-defining performances, but genre-defining, the apex of an entire art form.

From San Francisco the tour moved down the coast to L.A. The band had a long history with the city; Los Angeles always treated them like stars. The Stones, who recorded "Satisfaction" at RCA Studios, landed Friday at the Hollywood Palladium,

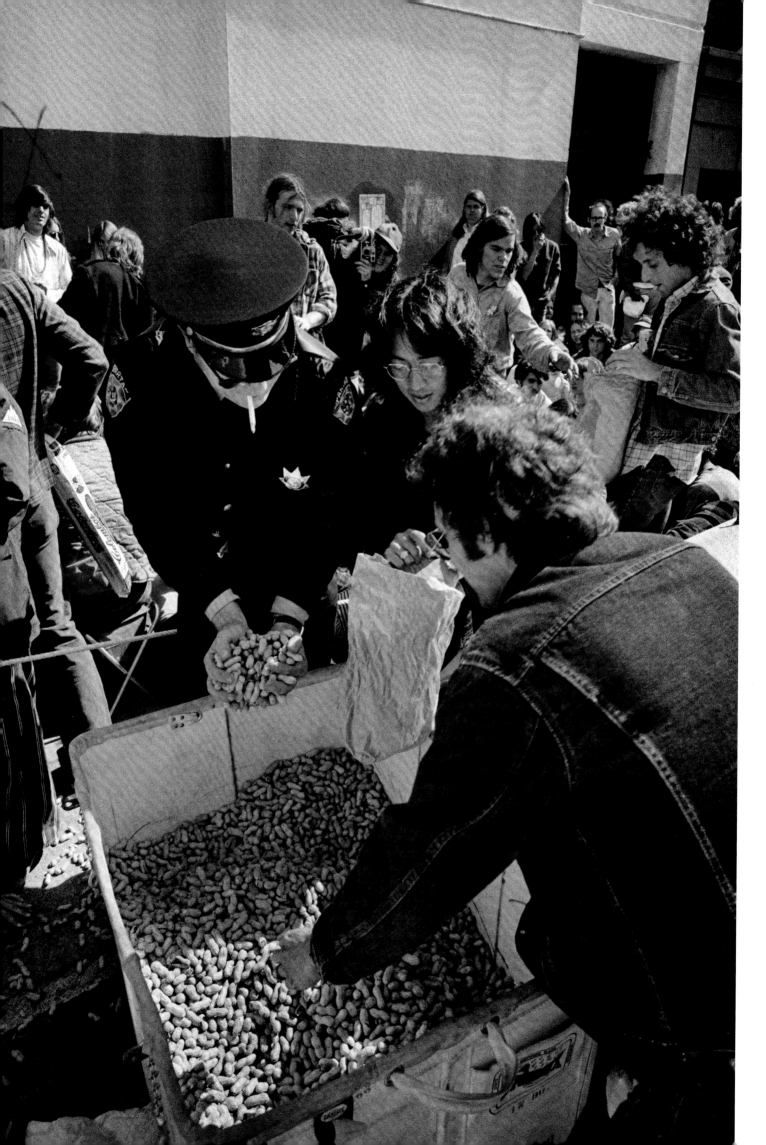

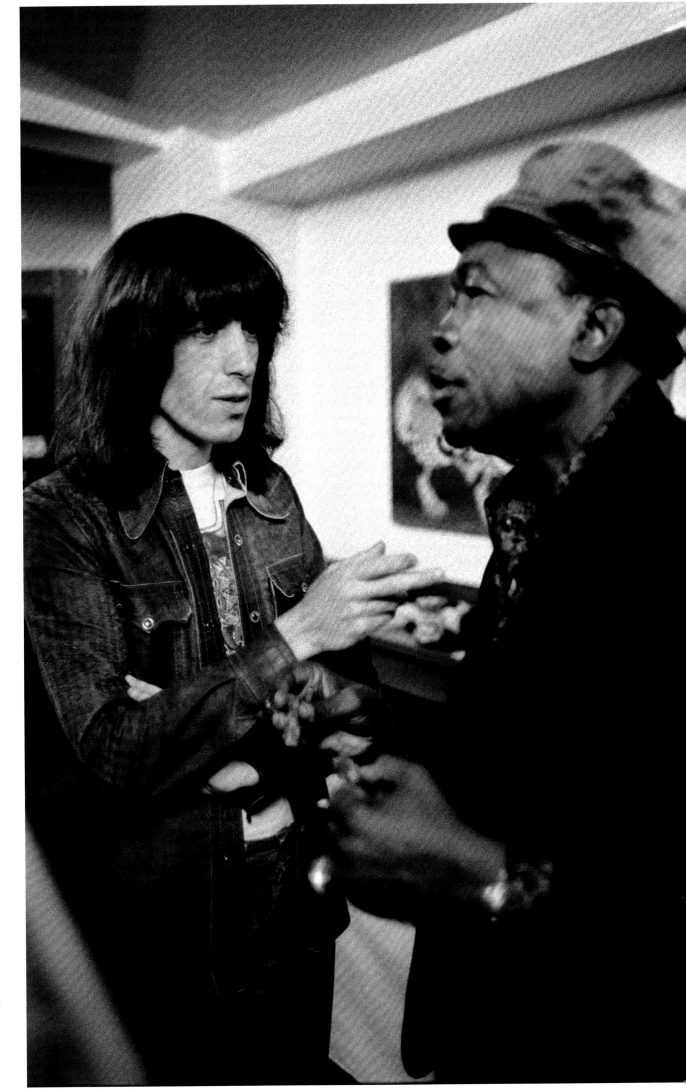

Bill Wyman and blues legend John Lee Hooker backstage at the Winterland, San Francisco, California.

a small theater on Sunset Boulevard, broadcast home of the ancient *Lawrence Welk Show*, and rocked the house Saturday at the Long Beach Municipal Arena, an old barn on the seaside, finishing up with two shows on Sunday at the 18,000-seat Forum (home of basketball's Los Angeles Lakers) that ran by the clock, as opposed to the long delays common on the 1969 tour. The band made the short flight to San Diego the next morning. Marshall shot the Los Angeles shows, traveled with the band on the plane to San Diego, and photographed that show as well.

Throughout his entire career, Marshall battled for access. Without free access, he couldn't do what he did—breathe in the moments and freeze them on film. The Stones knew Marshall. Even without the clout of the *Life* assignment, Marshall was a formidable figure. Like Jagger and Richards, he walked around armed and hammered: a pistol somewhere on his person, a shot of bourbon or scotch near at hand, and more than his ration of coke up his nose, if he could manage it. Marshall could be querulous, abrasive. He didn't fit into the Stones' inner circle with the same ease as patrician Ethan Russell, who had been little more than an amateur photographer when he first hopped aboard the Stones' touring party in 1969, and who was also along for parts of the 1972 ride.

Nothing escaped Marshall's penetrating eye. Even in the short time and limited space accorded him, Marshall harnessed the essence of this band. His photograph of unshaven Keith Richards, cigarette between his lips, strumming an acoustic guitar at Sunset Sound, has been published many times (although it wasn't in the original *Life* article). He caught Jagger backstage before a show, in a pink dressing gown, peach ascot around his neck, leaning on a cane talking to Mrs. Mick Taylor—one of the greatest candid portraits of Jagger ever. Even standing next to a beautiful woman in an impossibly short skirt, Jagger dominates the landscape. He radiates star quality, his electrifying presence glowing even with his engine running at idle.

*Life* hit the streets in early July with Marshall's Mick Jagger leaping off the cover. It was not the kind of press coverage the bad boys of rock and roll were used to; the story by longtime staff contributor Tommy Thompson, though, was more like what they expected.

"The Rolling Stones!
"Are they still among us?

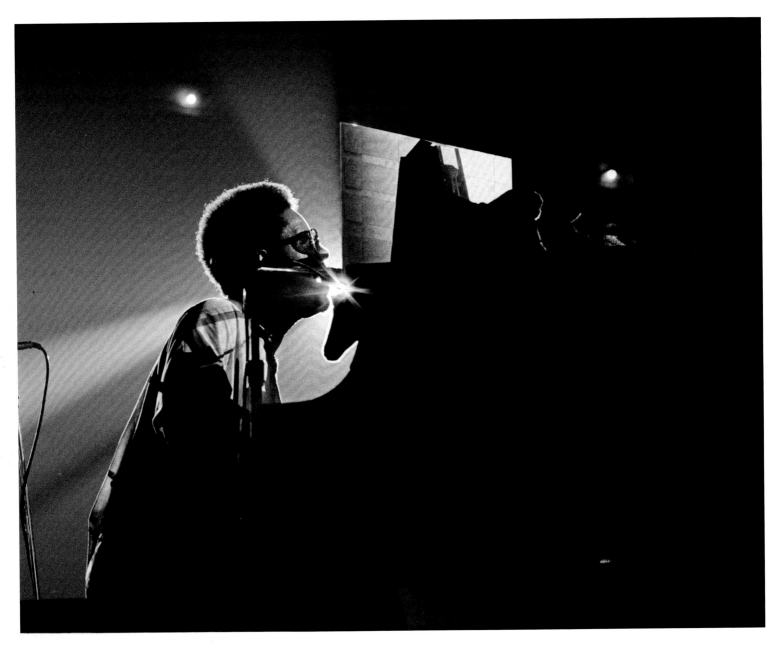

Twenty-two-year-old Stevie Wonder opened for
the Rolling Stones throughout the 1972 tour;
he frequently performed his new release and
number-one hit "Superstition."

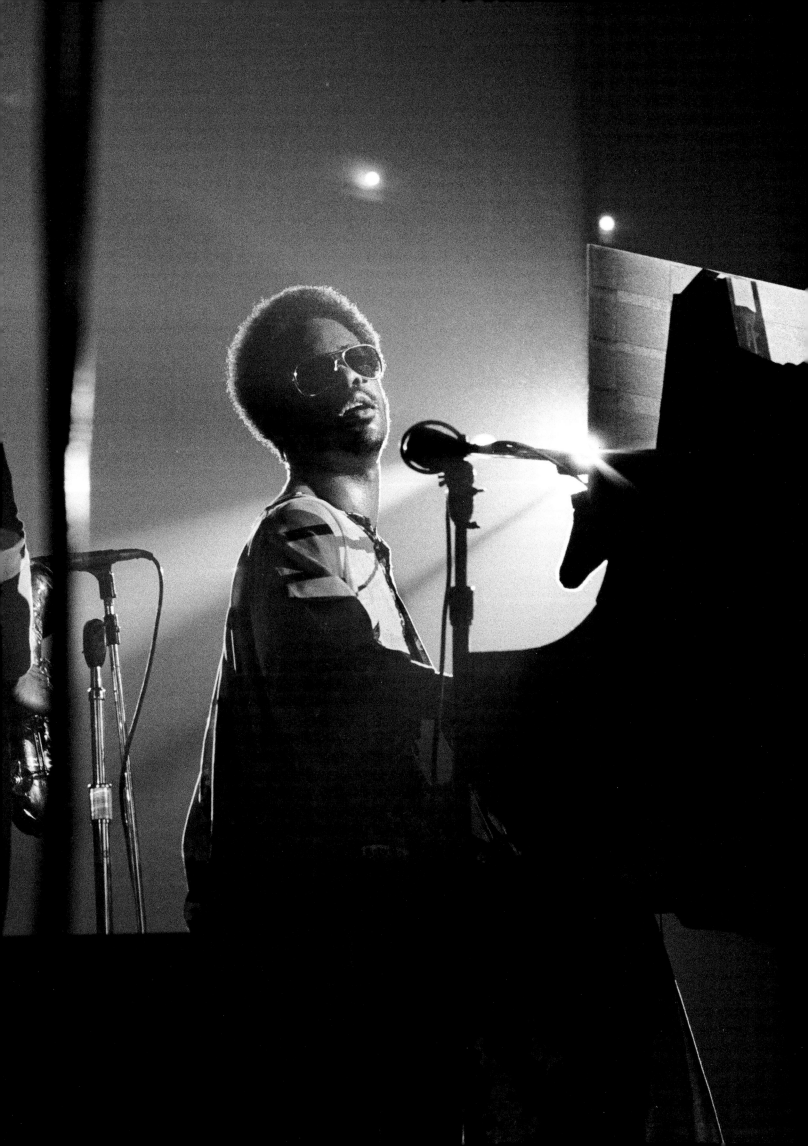

"How can they be? In history's first disposable society, where everything from graceful landmarks to diapers to rock groups is used and thrown away, how can the Stones survive? In a decade—ten years!—of performing, they have earned some of the worst press clippings since Mussolini. To read them is to scan the underside of a rock. One would gather that the Stones began their journey on the River Styx. Their official trademark—on record labels, posters, jeweled pins—is a taunting, devil's-red tongue stuck out at the world. Their spoor is scandal, dark, rumor, divorce, adultery, illegitimate children, drugs (when Jagger [sic—it was really Richards] wears the trademark 'Coke' sewn into his jacket, he is not endorsing cola), even blood and violent death."

Same old "Would You Let Your Daughter Marry a Rolling Stone?" stuff that had been circulating since their hustler manager first planted that angle with the Fleet Street press in the United Kingdom, who were only too glad to play along. Marshall's photographs, however, were a different matter.

Splashed across six pages in full color, Marshall catches the Stones backstage in anonymous concrete bunker basements, Richards daubing on makeup from a paint box full of colors, Jagger in pre-show repose. The concert action shots show Jagger poised to toss his basket of rose petals on the Winterland crowd and working up the crowd at the Forum in a white jumpsuit. Marshall elegantly details the power and majesty of the Stones. His photographs dwarf the snide, sniveling dismissal by Thompson.

Marshall's photographs are powerful because they tell the truth. He never tried to manufacture an image to suit a musician. He photographed them as he saw them and, in his eyes, these people looked larger than life, which is how he brought them to us. That is exactly what is so extraordinary about the photographs Marshall took those few days he was with the Stones—he shows them to us both as stars and as mere mortals, and they are all the more impressive because he does. Their steely magnificence shines back through Marshall's Leica.

His shots were always impeccably composed. He rarely cropped his images and never resorted to darkroom tricks. Once he clicked the shutter, the photograph was done. With Marshall, it was all about his eye. His finger may have been on the shutter button, but his gut pulled the trigger. In his images of the Stones onstage, you can

see the sound and hear the picture. In capturing the musicians offstage, Marshall shows us Olympians at rest. There is no mask to slip. Marshall sees the Rolling Stones as people.

The tour wound its way toward a conclusion on Mick Jagger's twenty-ninth birthday, July 26, at Madison Square Garden in New York. The guest list backstage ranged from Bob Dylan to Zsa Zsa Gabor—the Beautiful People meet the Rock and Roll Circus. Appearing on the cover of *Life* gave the Rolling Stones the imprimatur of cultural ascendancy. Rock and roll—only recently a music exclusively meant for teenagers—was reaching its majority. The Stones had given the music high style and grand drama. The band would never be any better; these were golden days for both the Rolling Stones and rock music.

Although many of the photographs are imbued with the everyday sensibility of the hours backstage and time on the road before the next ninety minutes under the floodlights, Marshall also captured the age of classic rock at its height in a few frames with the Rolling Stones in California those days and nights in June 1972. It was an era that was over before we really knew it was an era. If anyone ever asks about this moment in time, wants to know about what this special breed of men called British rock stars looked like at their peak, we have Marshall's 1972 photographs of the Rolling Stones. ★

# THE L.A. RECORDING SESSIONS

The Rolling Stones' *Exile on Main Street* double album included recordings made in three countries and at least four different locations. The final touches were completed at Sunset Sound in Los Angeles, and, in the first few months of 1972, Jim Marshall spent a week in Los Angeles to document the process. Of his twenty or so well-known and published photographs of the Stones, five of them stem from these studio sessions and the Palace Laundry portrait shoot with Jagger, which took place around the same time (p. 8, 28–29). The unforgettable black-and-white portrait of Keith playing his guitar (p. 26–27) has appeared in all four hardcover monographs of Marshall's rock-and-roll photographs.

In his autobiography, *Life*, Richards references testing out the recording mixes by sending a runner with dubs to a local DJ, then driving up and down Sunset listening to it played on the radio to judge the sound quality. The runner would bring the tape back to the studio, and they'd go to work again. *Exile on Main Street* was released in the United States on May 22, 1972, and reached number one on both the U.S. and U.K. charts. Since then it has been remastered and rereleased twice, most recently in 2010 as an eighteen-track CD, a double-vinyl edition, and two deluxe issues. Jagger and Richards have expressed differing opinions on the album itself, but over its fifty years in existence it has continued to speak to fans internationally. —MDM

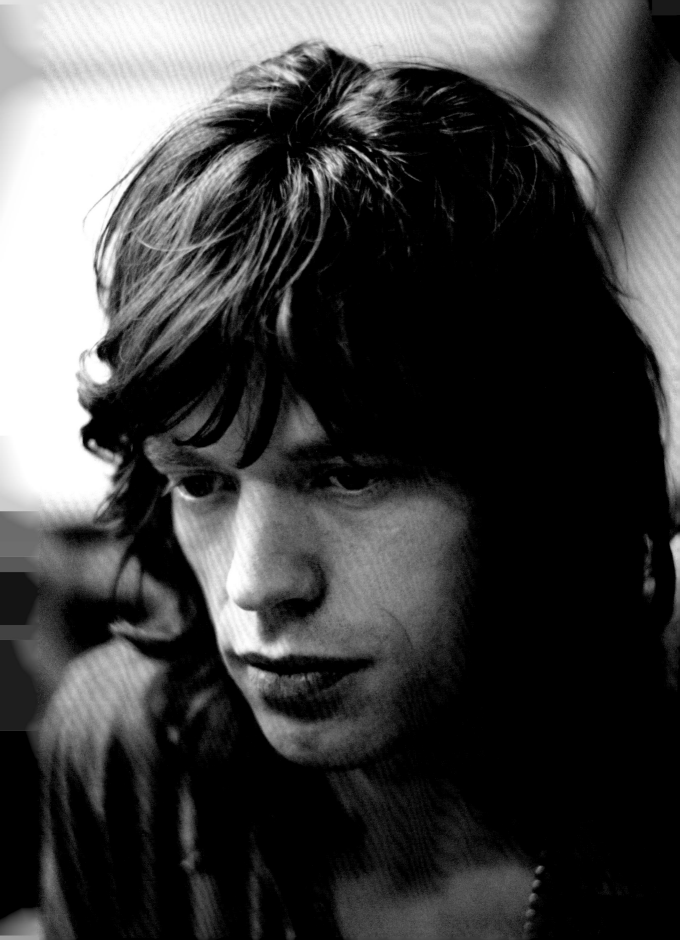

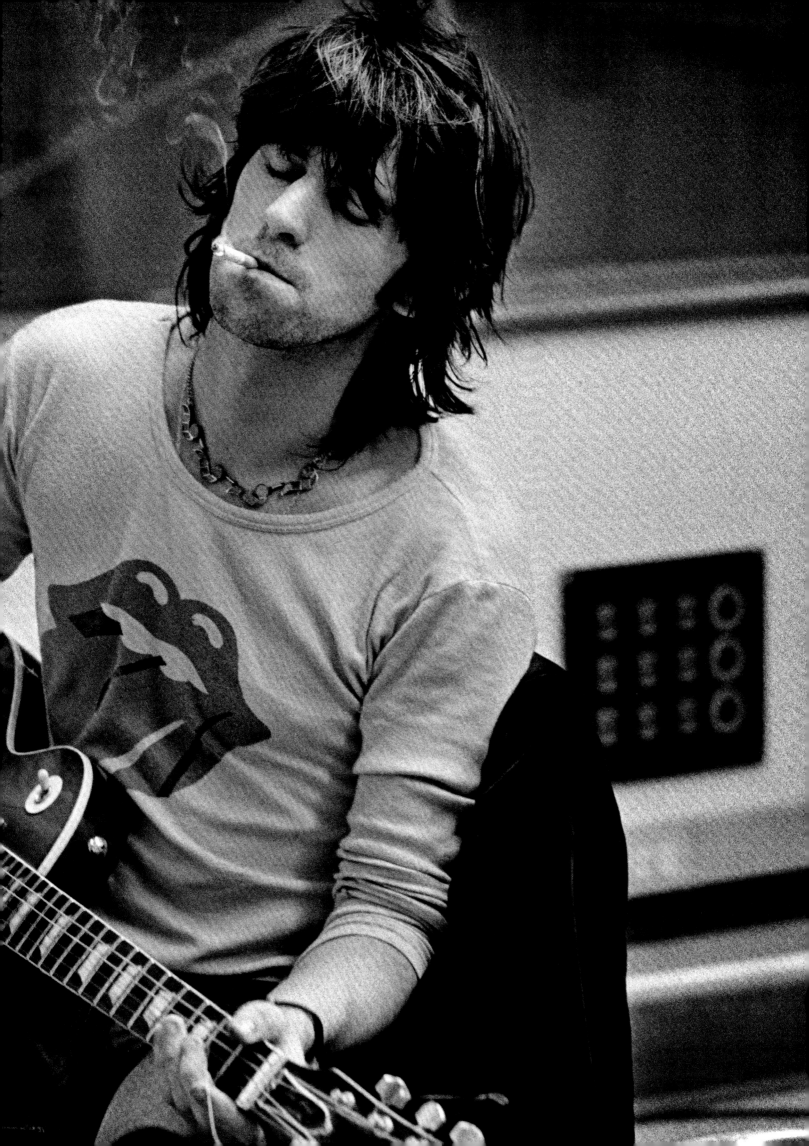

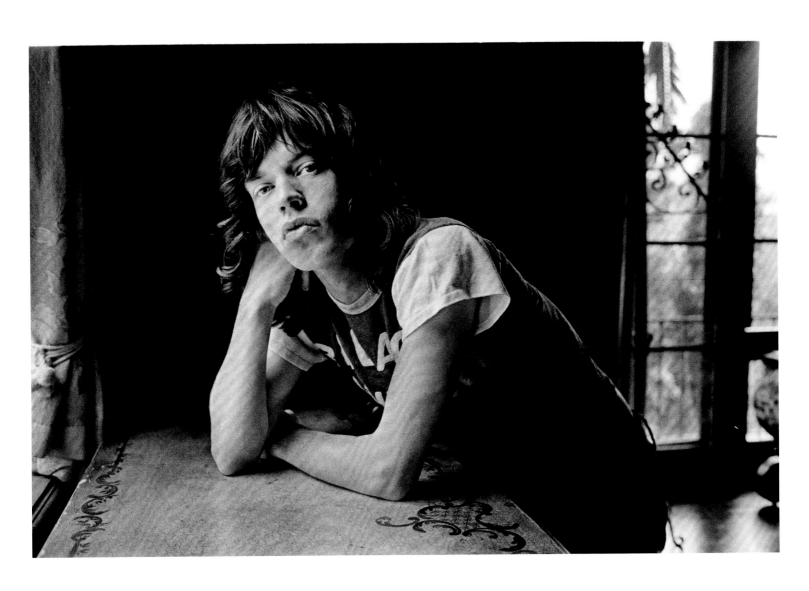

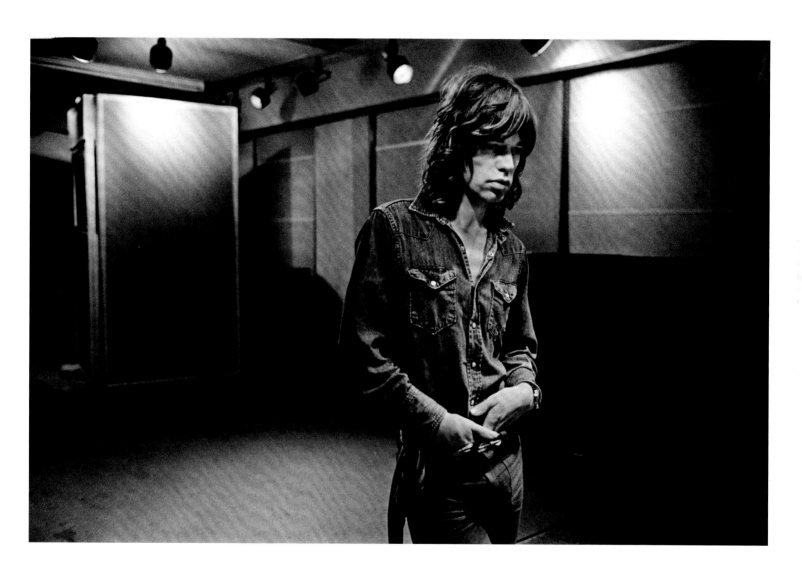

Mick Jagger at Sunset Sound, the L.A. Recording
Sessions, spring 1972, Los Angeles, California.

< Mick Jagger at a publicity shoot, spring 1972,
Los Angeles, California.

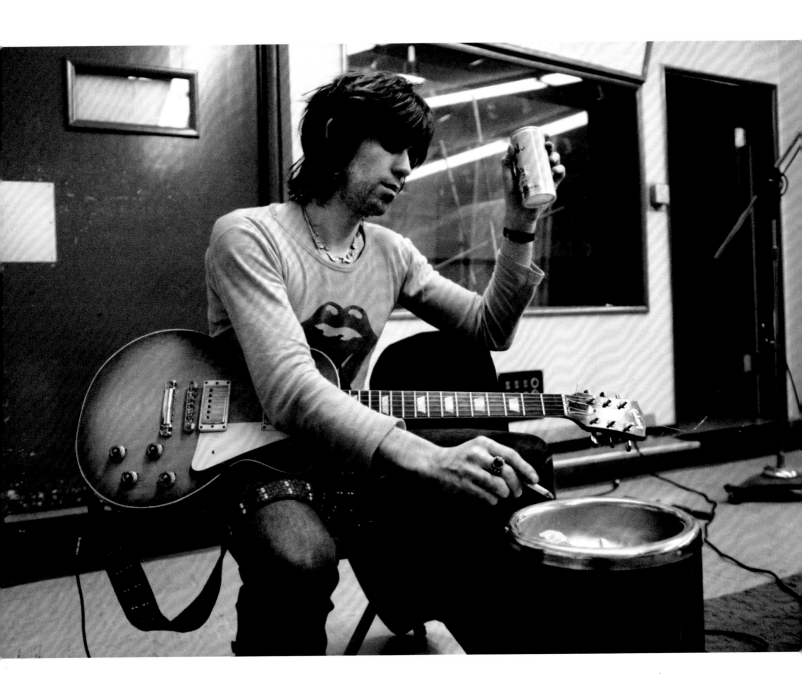

Keith Richards at Sunset Sound, the L.A.
Recording Sessions, spring 1972,
Los Angeles, California.

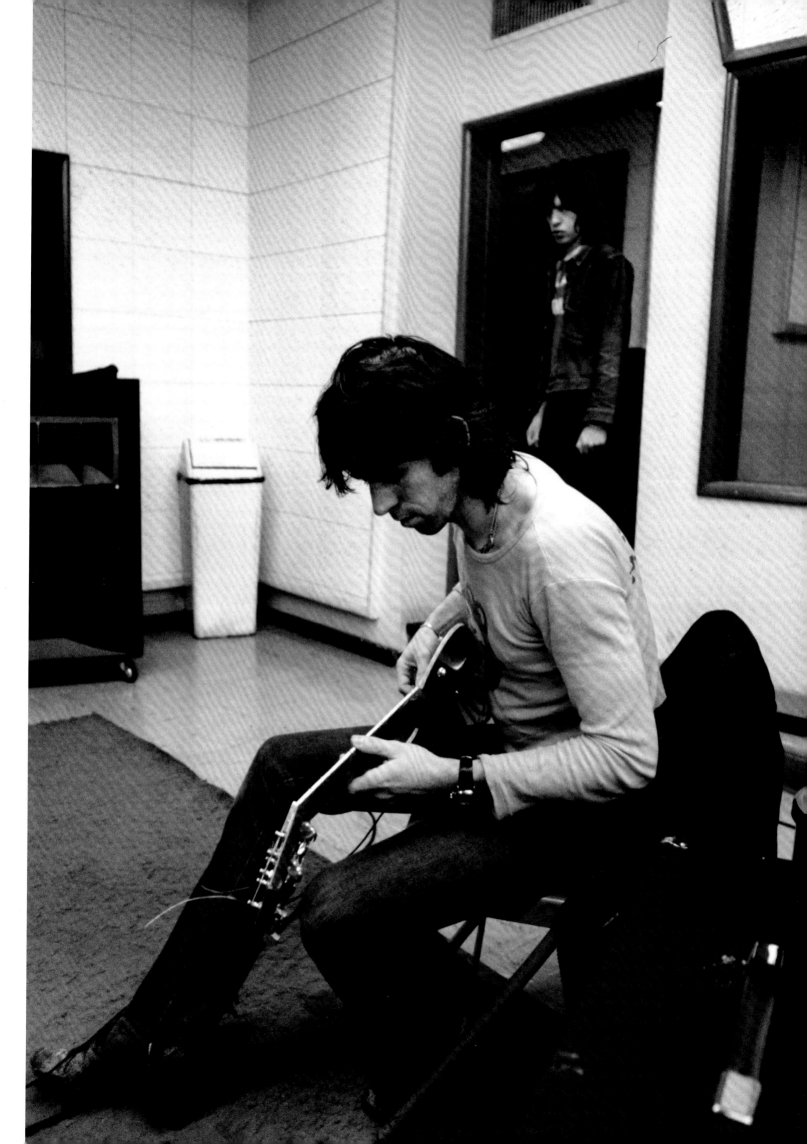

# A FLY ON A STONY WALL

There is a lingering regret I have, and that is that I discovered the full width and depth of Jim Marshall's work late. The book *Show Me the Picture* is a wonderful display of that work and a must-have for anyone interested in documentary photography. In any case, it made me super excited to see the book you now have in your hands, which is filled with the shots he took of the Rolling Stones during their 1972 U.S. tour.

The opportunity to be a fly on the wall during that really exciting time, when access to the Stones was still possible for some, and when the Stones had the grace and foresight to have Jim on board, is something to be grateful for. Jim, with his larger-than-life persona and his razor-sharp eye, documented the exhilaration, the boredom, the audiences and the guests, and the sheer power of the Stones on tour. The 1972 tour was about the music and the performers rather than an elaborate stage design: It was the ultimate Rolling Stones tour in that sense.

And Jim's images really reflect the magic between band members, on and off stage, at the height of the Rolling Stones' career at that point. It is so good to see images of Mick and Keith together, working on songs or discussing something. They are a unique and dynamic duo, not just in regard to their talents, but also in terms of their looks, which comes in handy for a photographer!

Jim Marshall was a pioneer in music photography and a great example to me. He realized that to get the right or different kind of shot, you needed to be there up close, so you needed to have the access. And he made sure he had that access. You needed to become part of the family and the furniture, as it were. I am sure he could be a bully in that sense, but thank God he was. He was a wonderful documentary photographer, which is what is needed to create something in these situations; you must move fast and still compose an interesting image. I get the impression that, where many photographers rely on getting the light right or fuss about, Jim made whatever light there was look right.

These photographs offer a rare insight into the world of musicians at work, at play, and on the way to their next port of call. Some are doing just that (in a really astonishing way!), and some rise even above it. I particularly love the shots in the dressing rooms. They are like orchestrated chaos. I love Jim's craft, and that craft is on display here. This book chronicles an era gone, obviously, but it also shows that we will miss that era more as time goes by and we'll come to realize just how perceptive Jim Marshall's eye was. And I, for one, miss his eye.

*Anton Corbijn*
2021

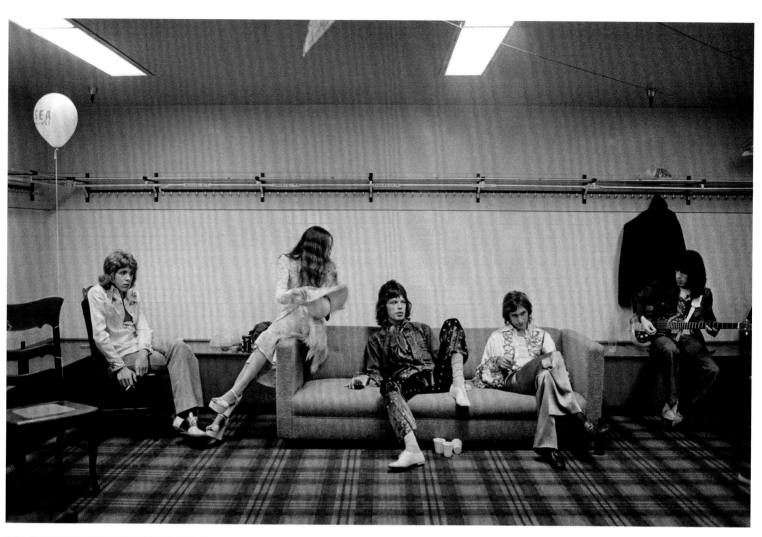

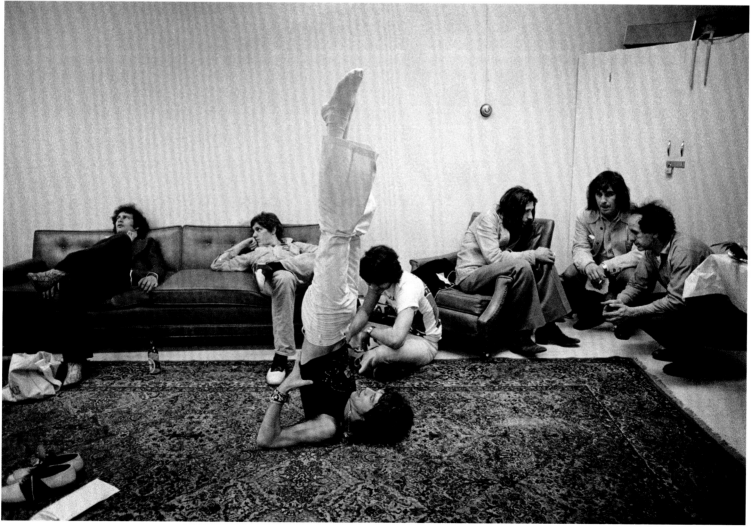

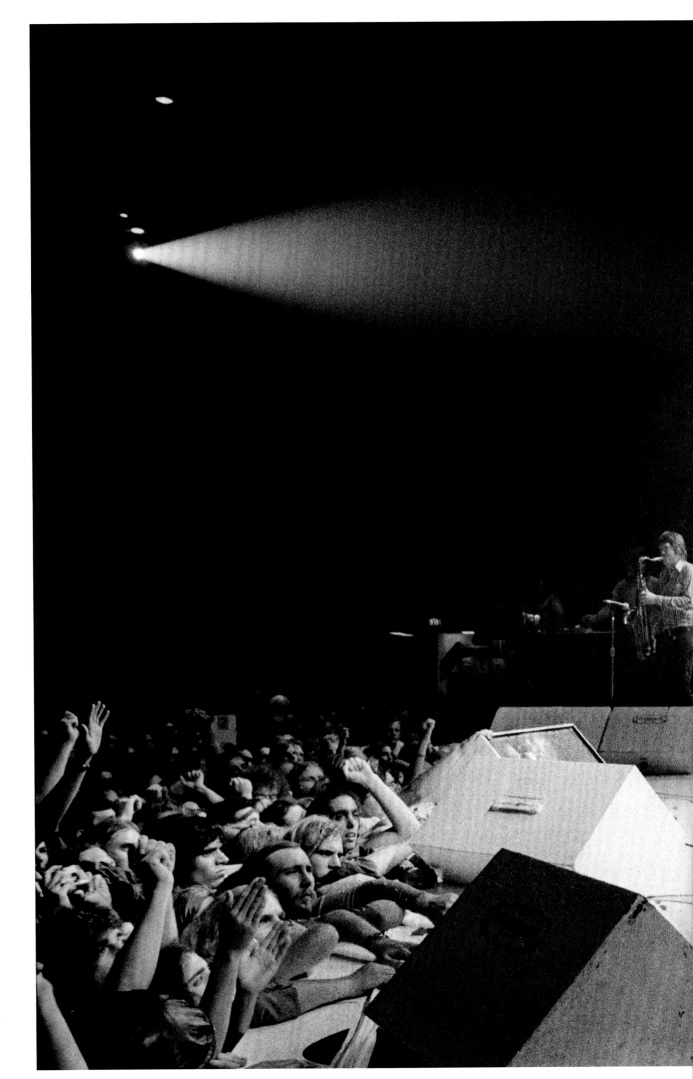

Jagger performing
"Midnight Rambler"
at the Forum, Los
Angeles, California.

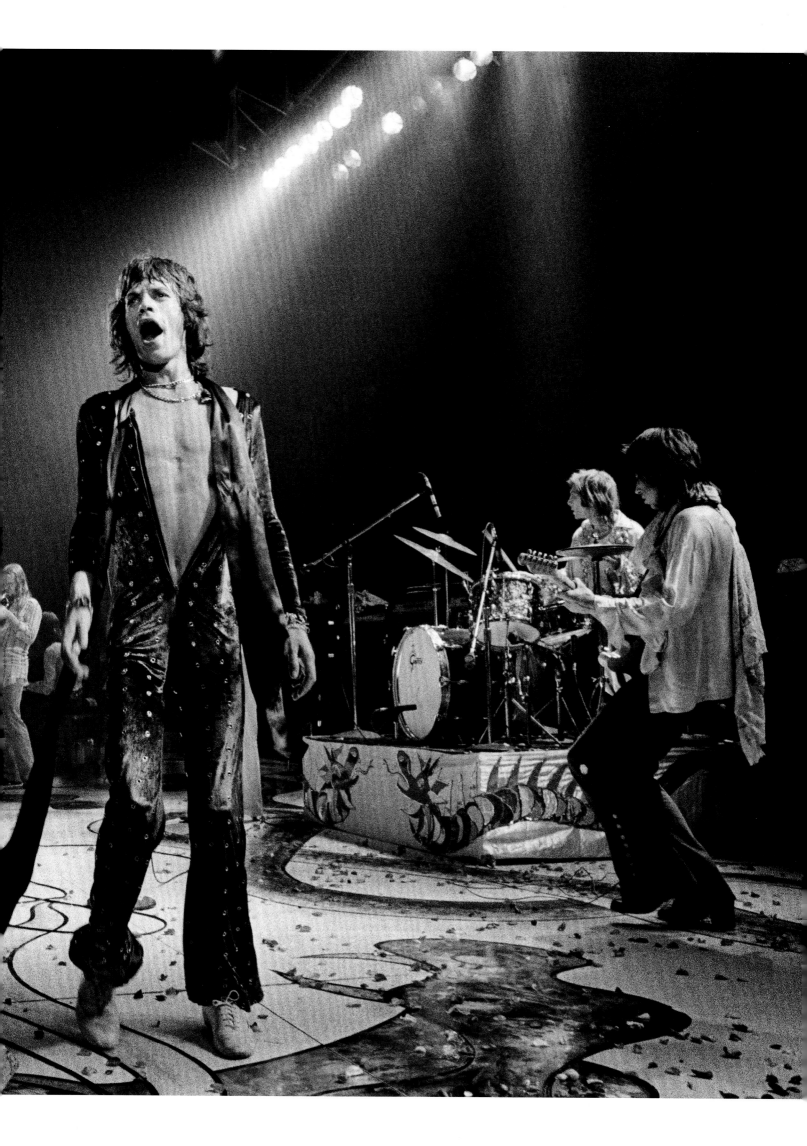

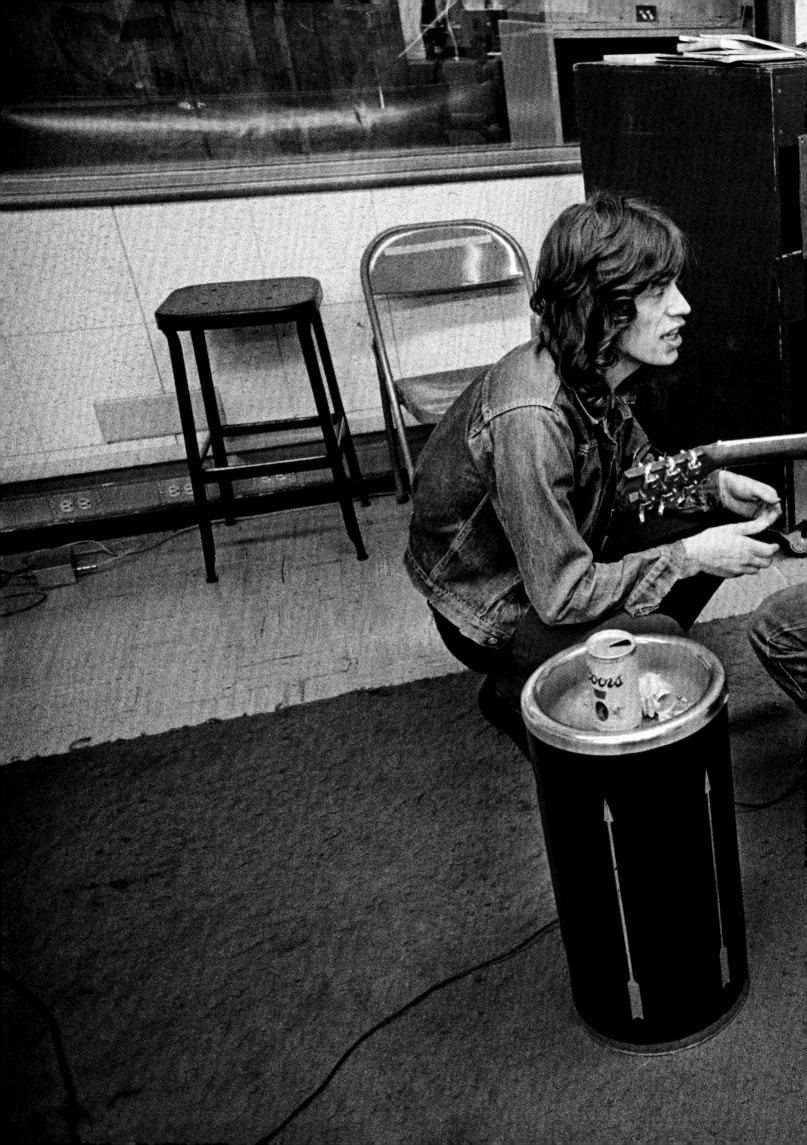

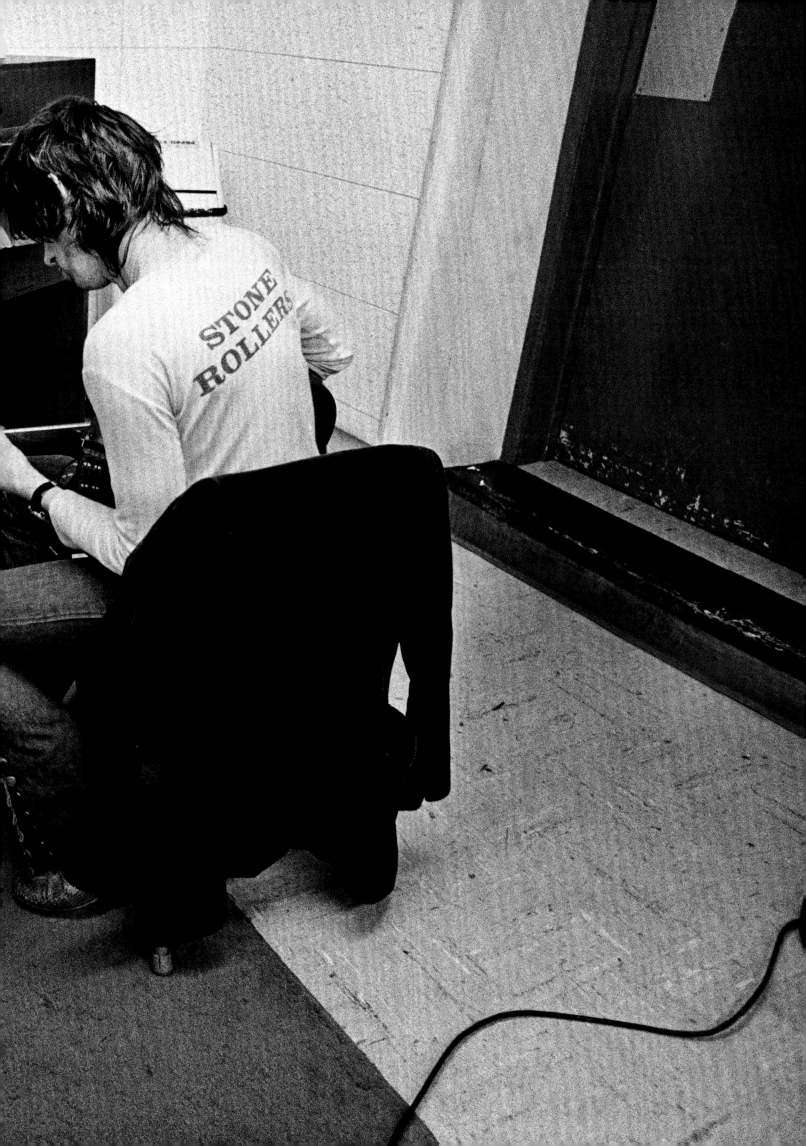

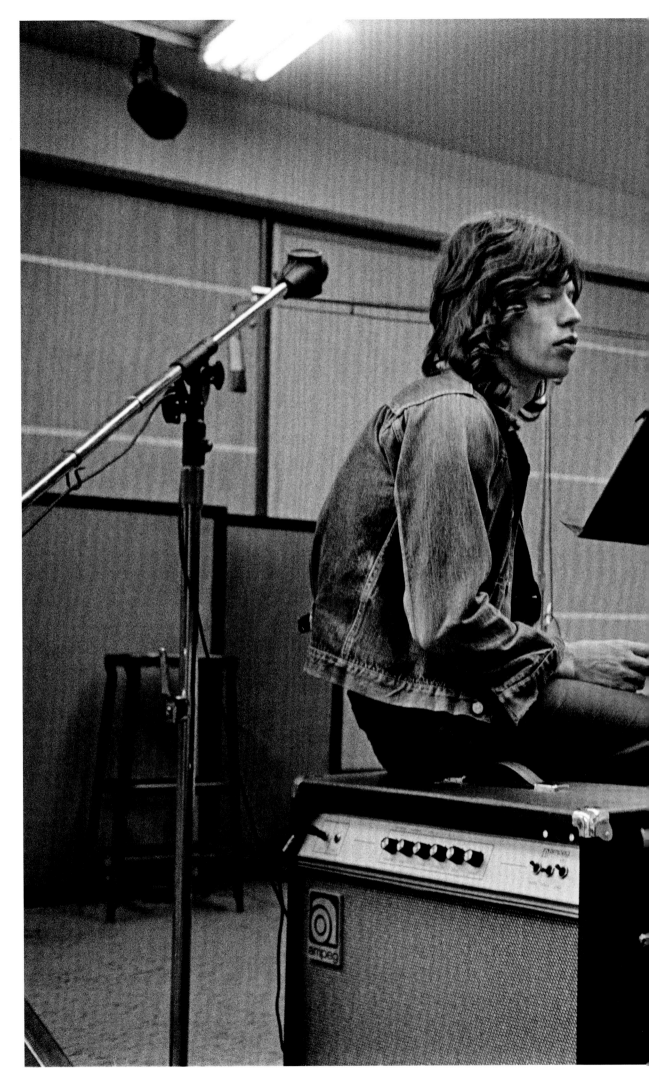

Mick Jagger and Keith Richards
at Sunset Sound, the L.A.
Recording Sessions, spring
1972, Los Angeles, California.

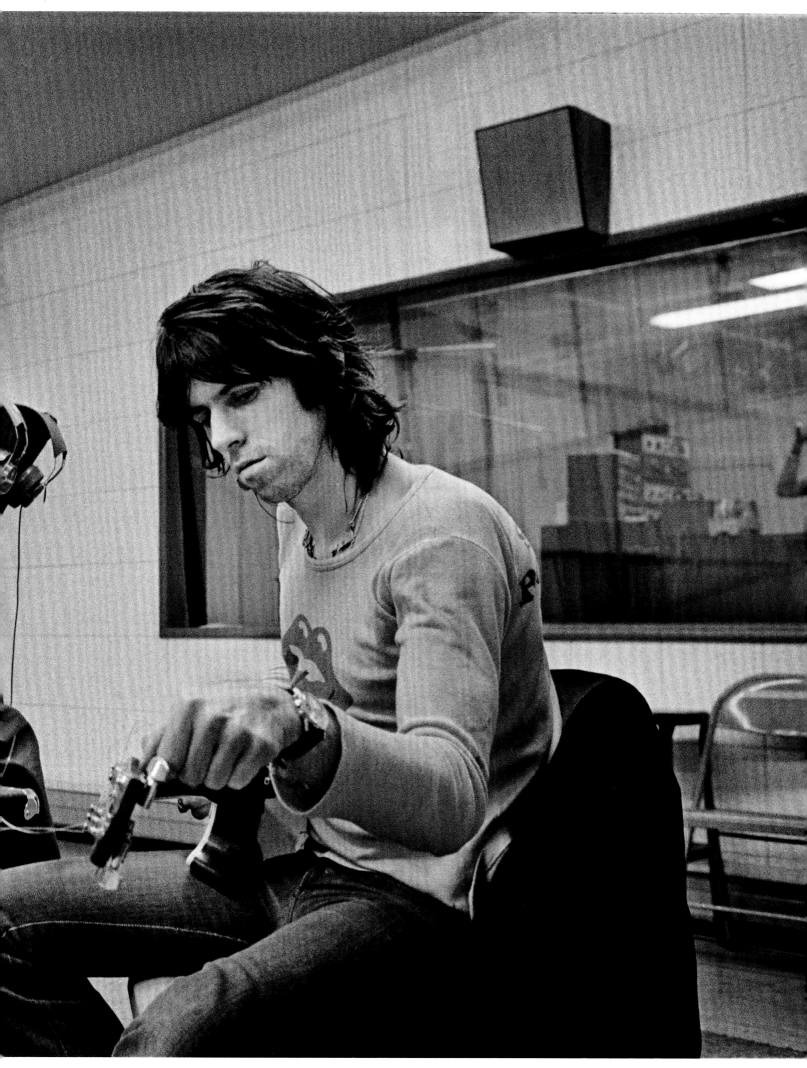

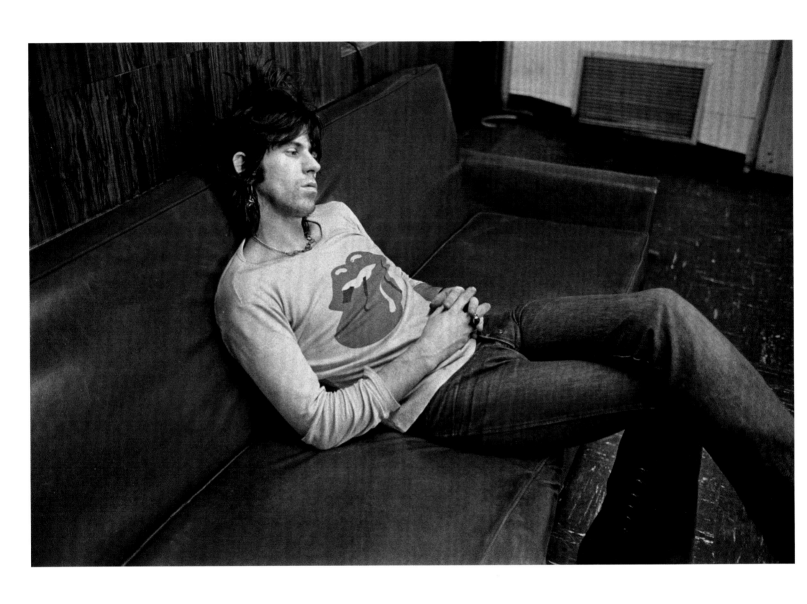

Keith Richards at Sunset Sound,
the L.A. Recording Sessions,
spring 1972, Los Angeles, California.

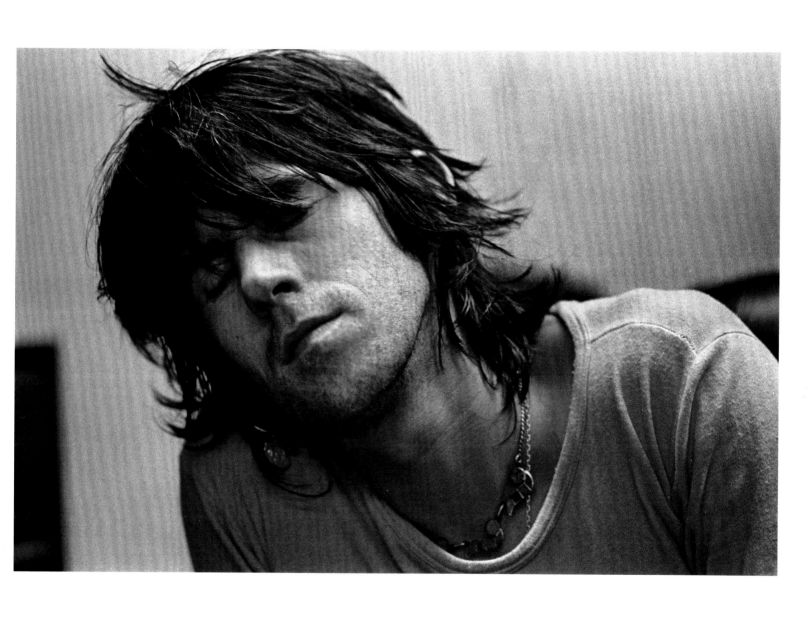

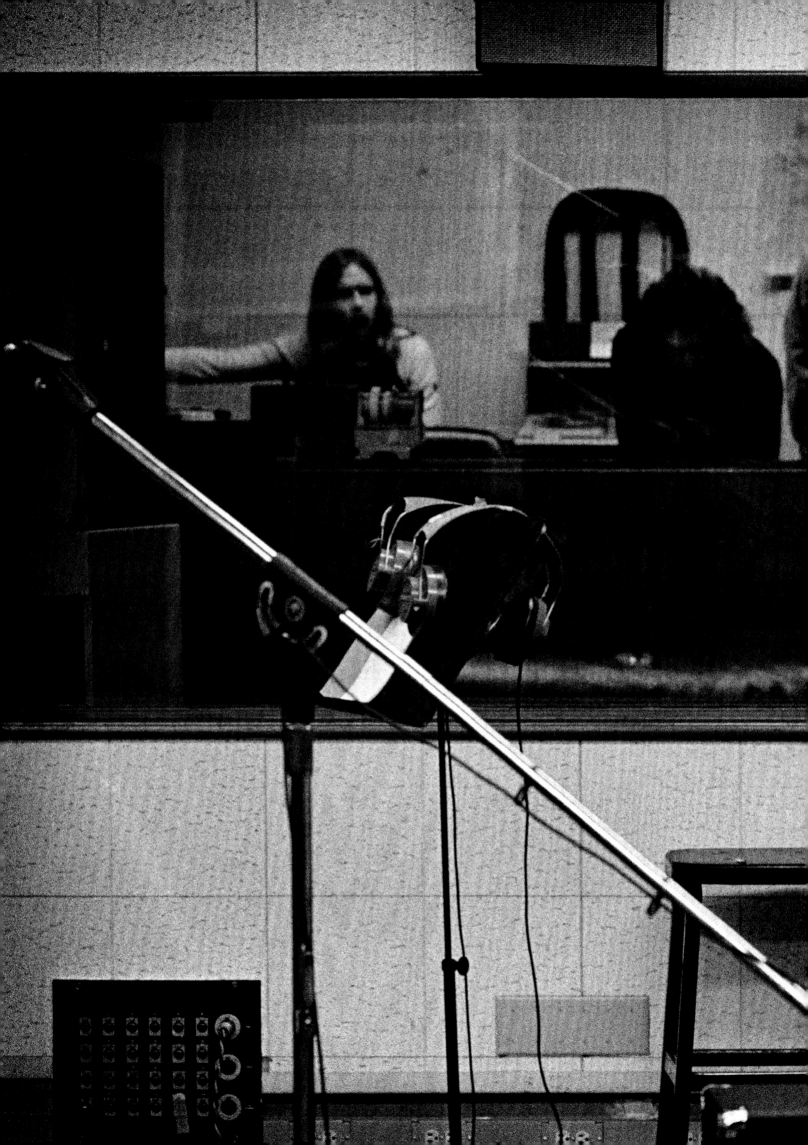

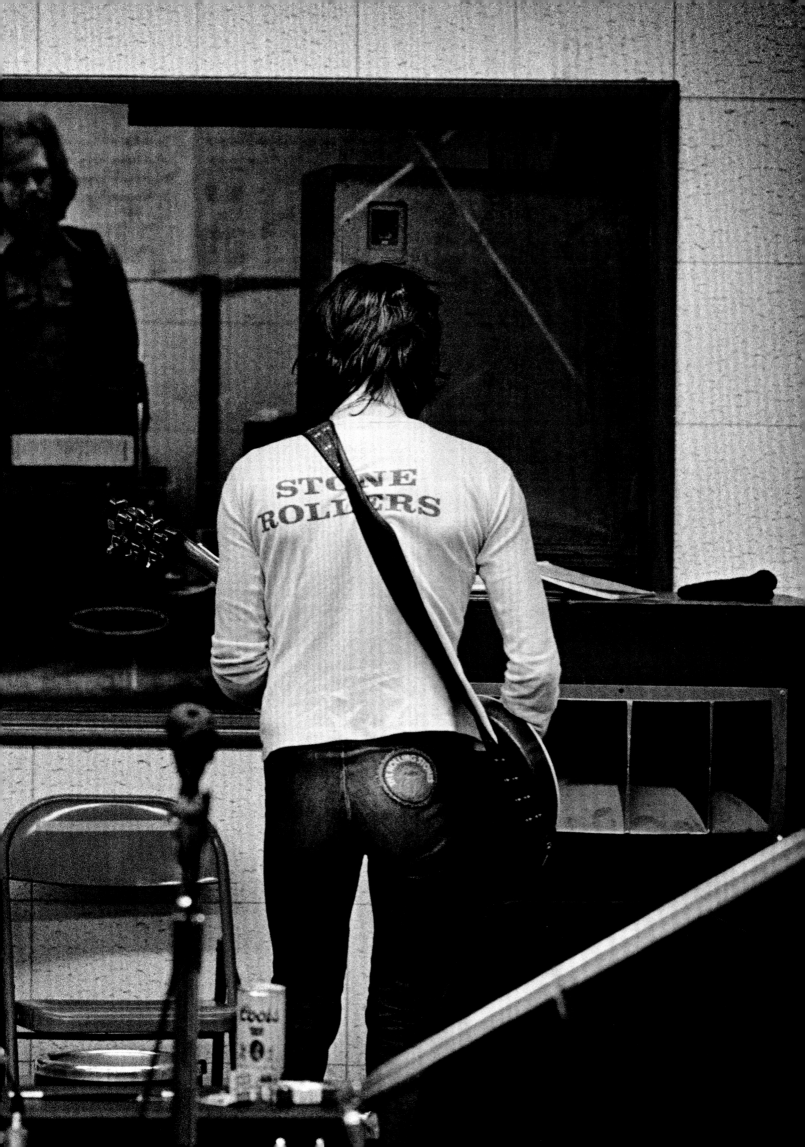

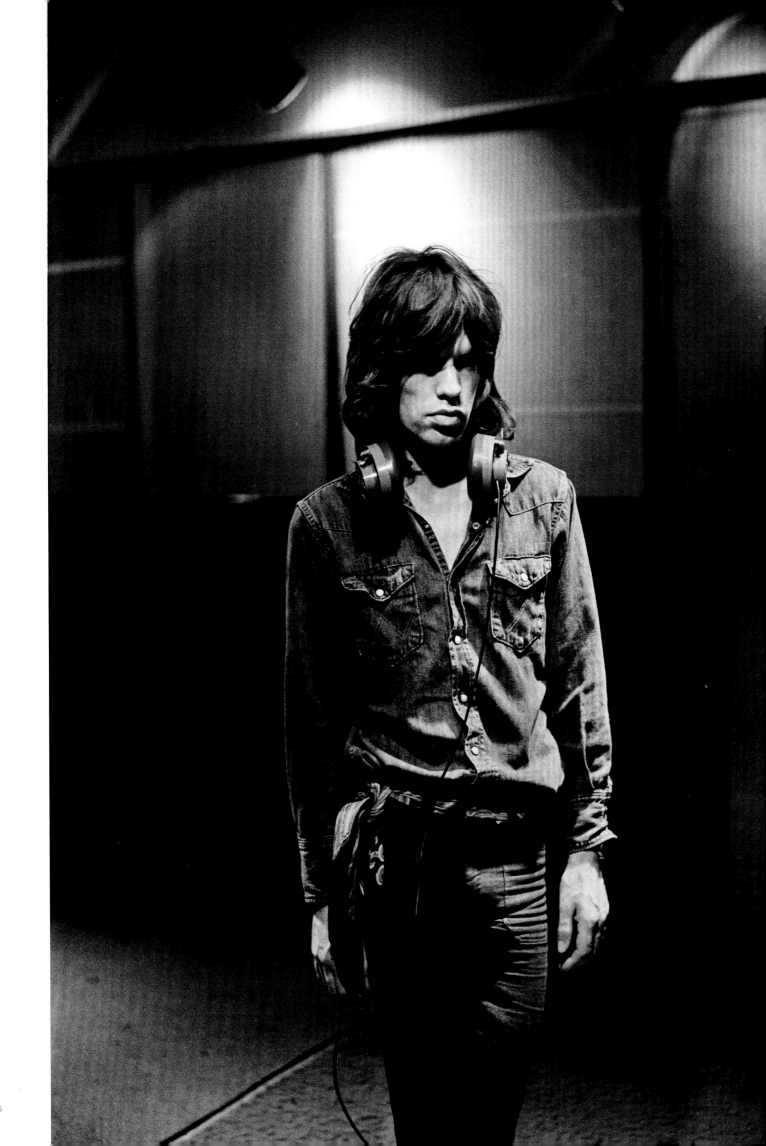

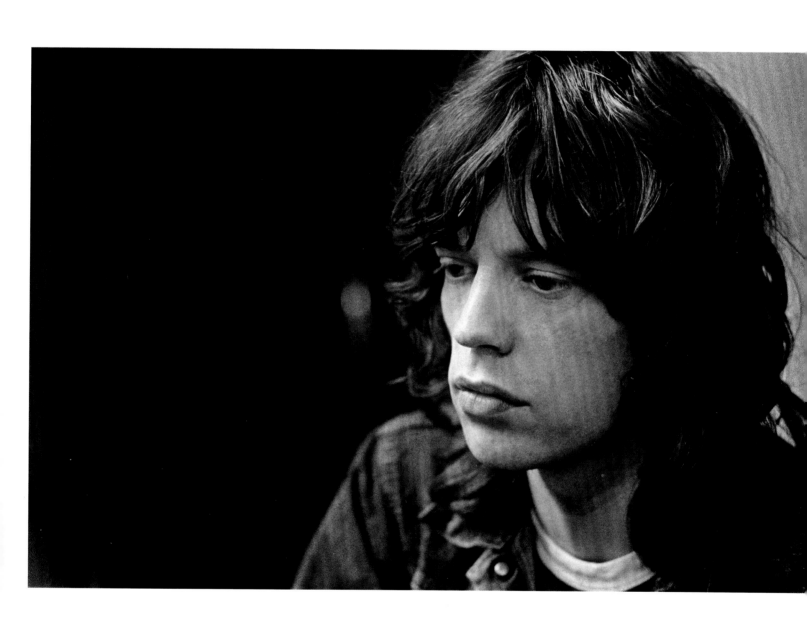

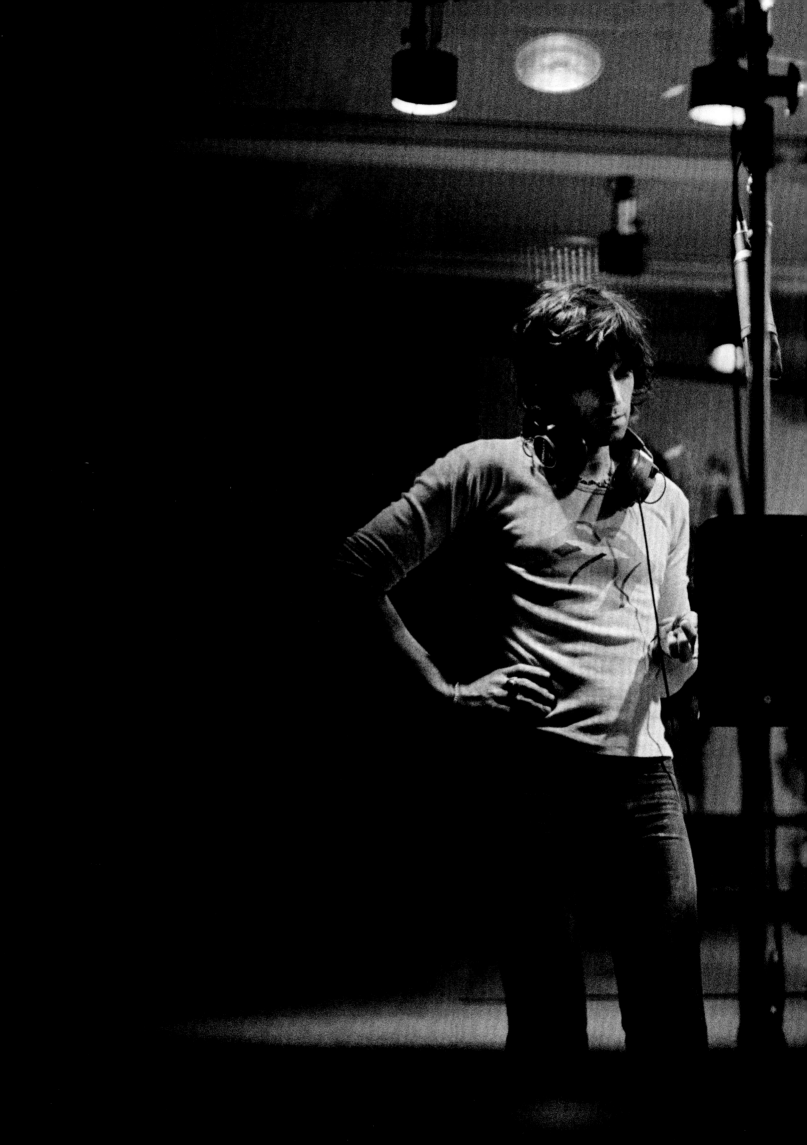

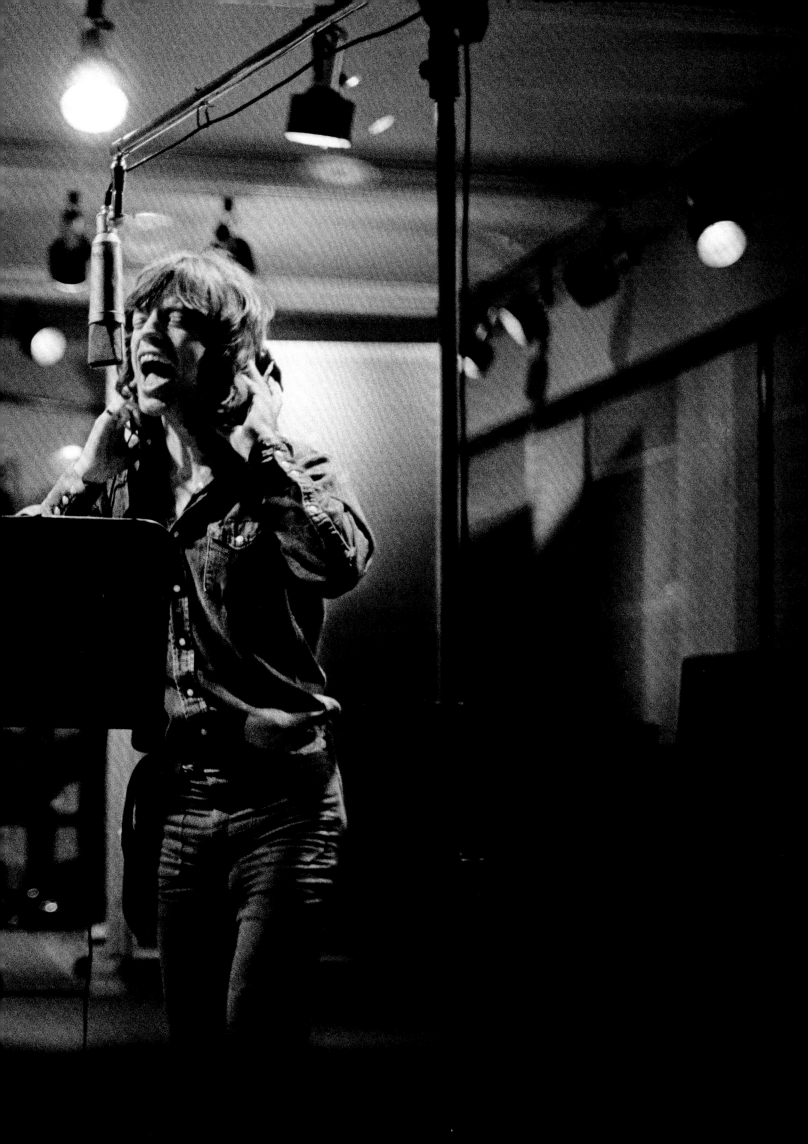

Mick Jagger at a publicity photo shoot, spring
1972, Los Angeles, California.

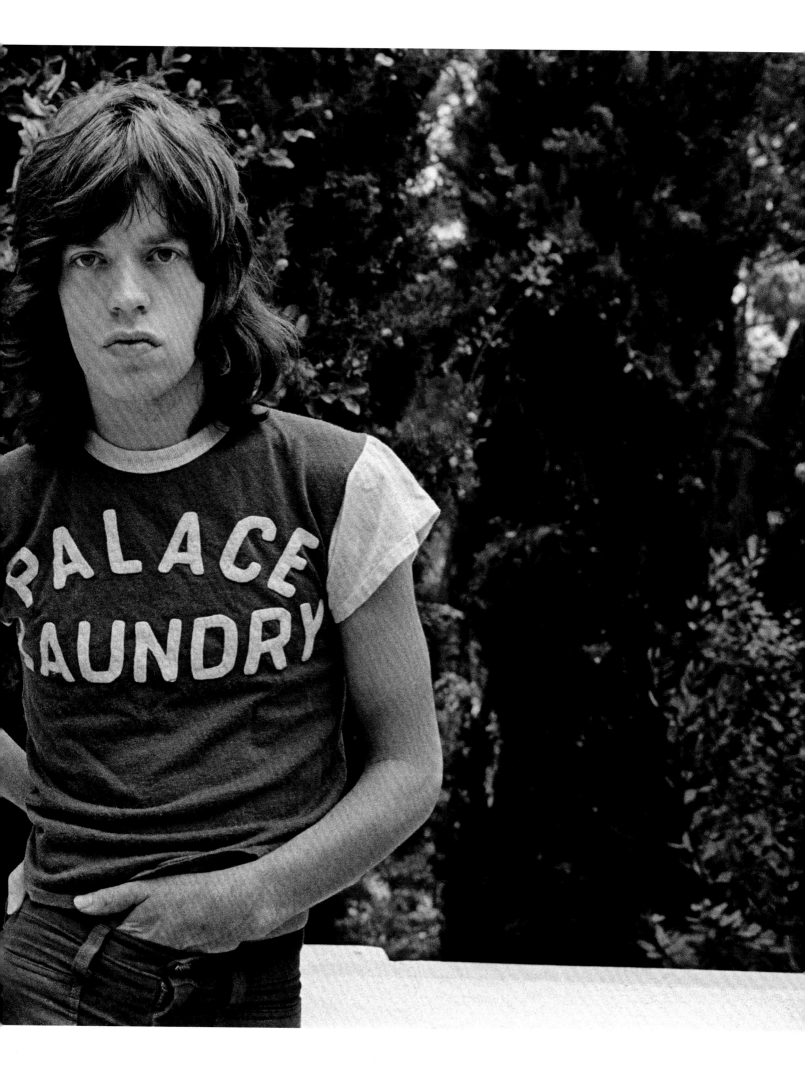

# BEHIND THE SCENES

On the Stones' previous U.S. tours in 1965–66, 1967, and 1969, Marshall photographed them at locations throughout Northern California, including the infamous concert at Altamont. He was selected to cover the 1972 tour for *Life*, a prestigious and remarkably mainstream assignment that was a coup both for the Stones and for Marshall himself. The PR team of Gibson-Stromberg targeted features in *Life*, *Time*, *Newsweek*, *Esquire*, and *Rolling Stone*—Jim was given one week on the tour, from June 6 through June 13, to get his shots. The July 14 issue, with Marshall's image of Jagger on the cover and nine additional photographs inside, was released as the tour proceeded east; the final concerts took place at Madison Square Garden in New York City July 24–26.

Marshall was present for the California leg—the Winterland in San Francisco, the Hollywood Palladium in Los Angeles, the Pacific Terrace Center in Long Beach, the Forum in Los Angeles, and the International Sports Arena in San Diego—of a tour that spanned about forty venues in two months. In over ten locations, including the Winterland and the Forum, the Stones played two sets in one day and were frequently unable to leave the location in between due to security concerns.

Though this tour is legendary for its raucous, at times unbelievable offstage behavior, something else is documented here—the camaraderie formed through hours spent waiting in antiseptic greenrooms as a brief calm before the storm of performance; conversations to fill the hours of lounging, waiting to take the stage; the availability of food and, more importantly, liquor; and the lonely, less-glamorous reality of long hours traveling to a location for a brief but powerful ninety minutes in front of the fans. In less than one week, Marshall captured this reality through images both of and beyond their time. —MDM

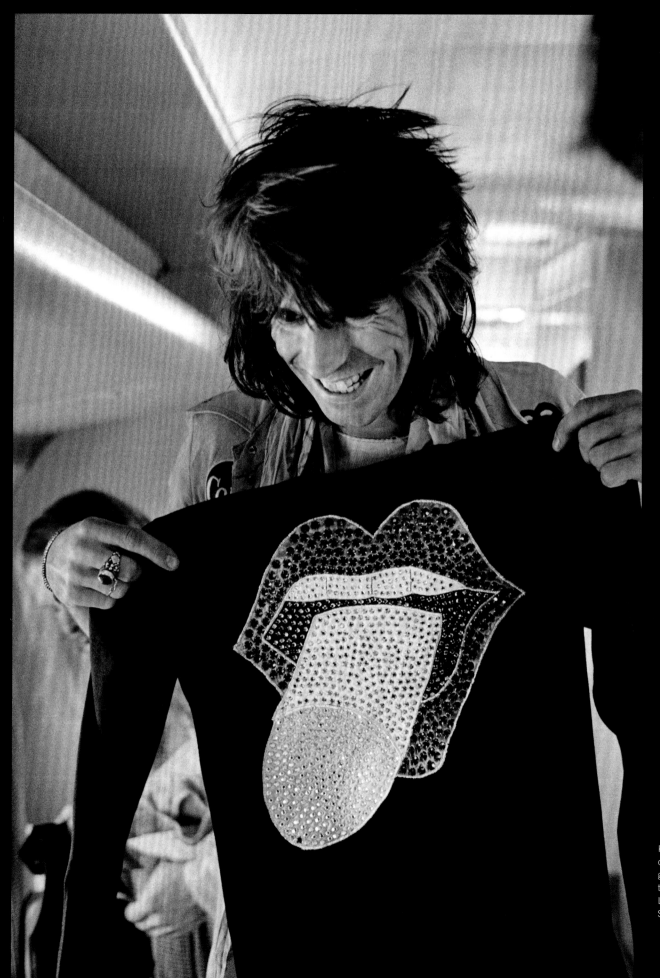

Keith Richards displaying a gift while on the flight from Los Angeles to San Diego.

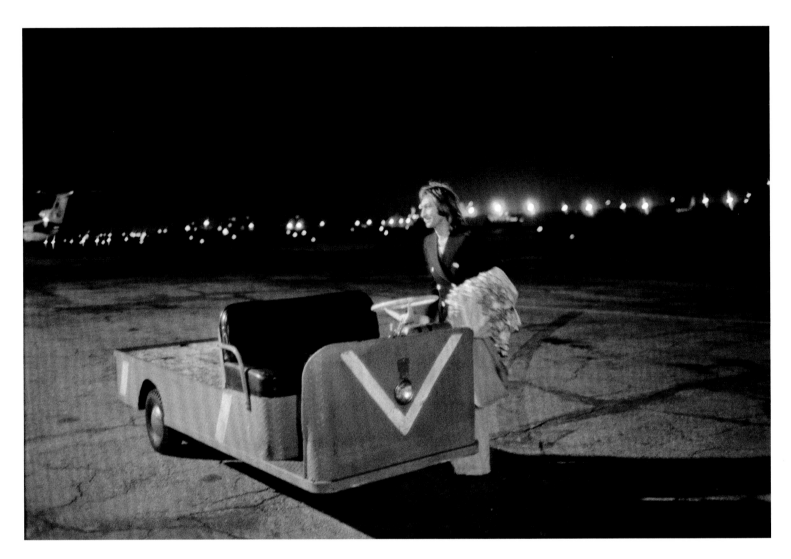

Charlie Watts at the airport, San Francisco, California.

> Astrid Lundström with Stones bassist Bill Wyman at the airport, San Francisco, California.

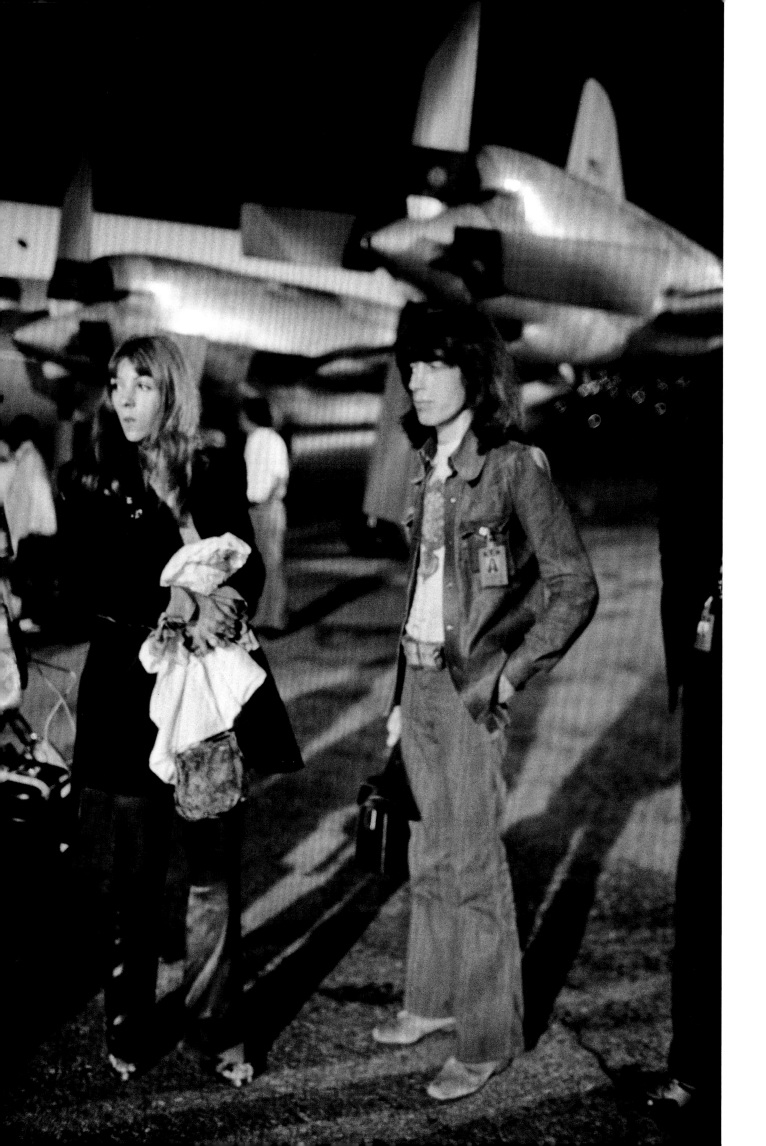

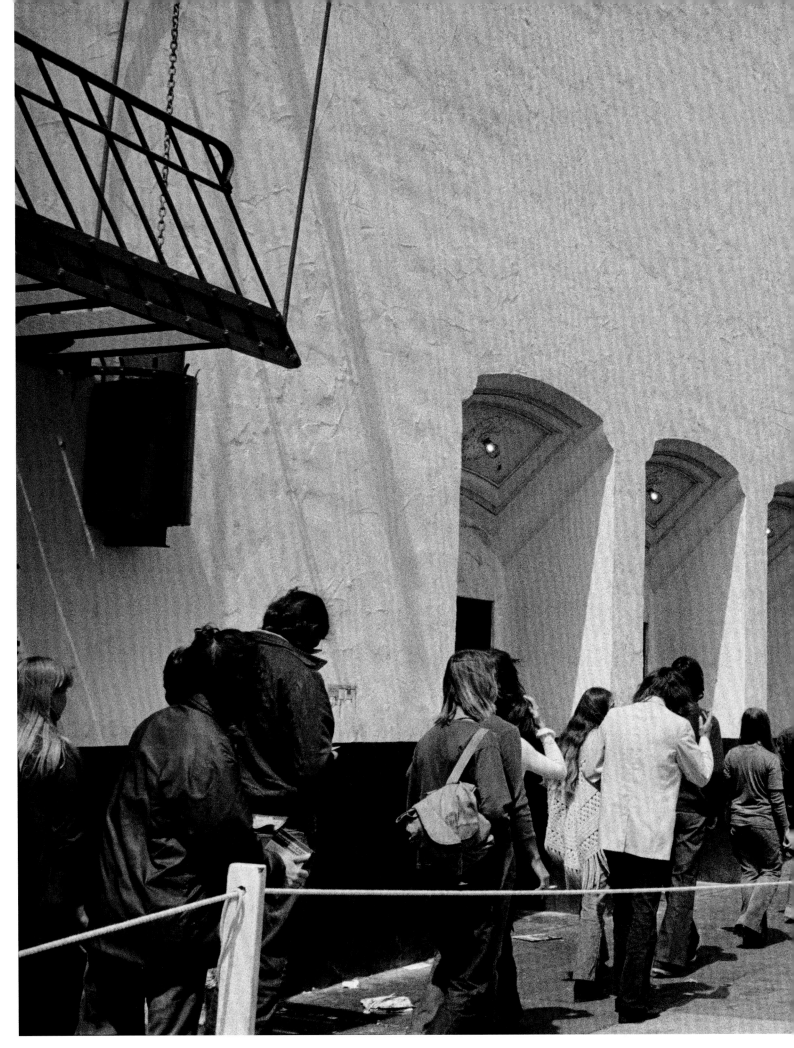

Fans spent hours waiting in line for
the afternoon show at the Winterland,
San Francisco, California.

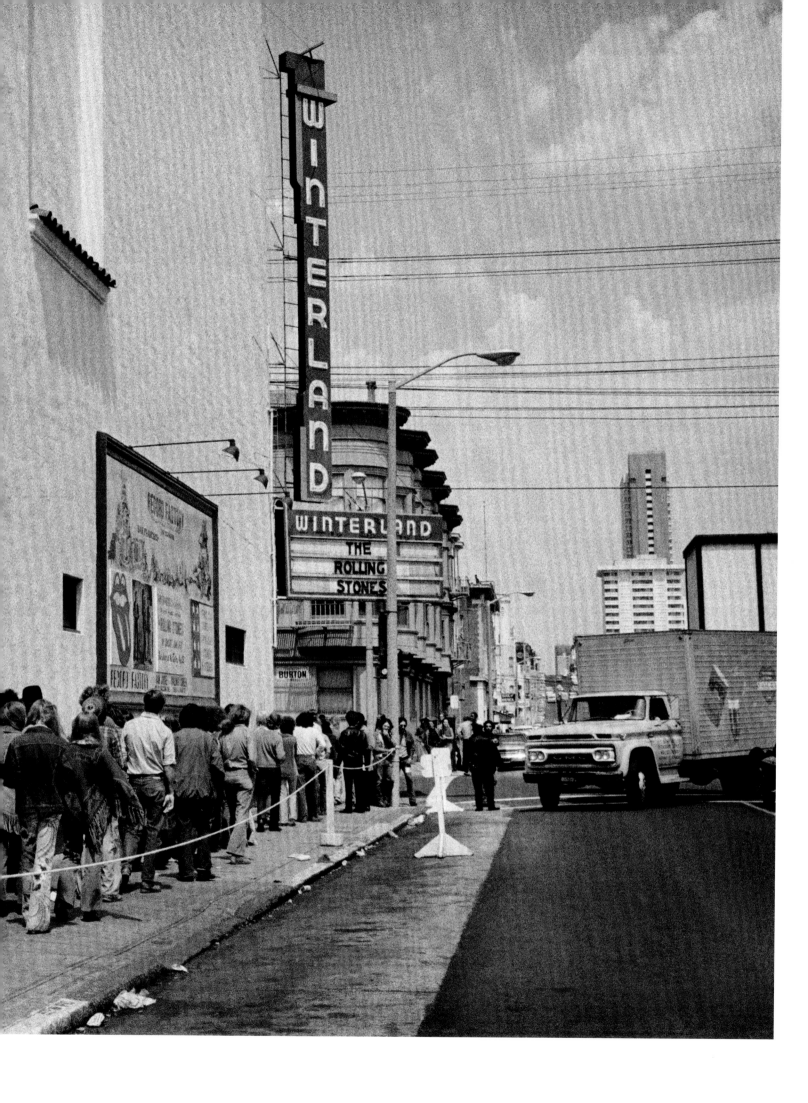

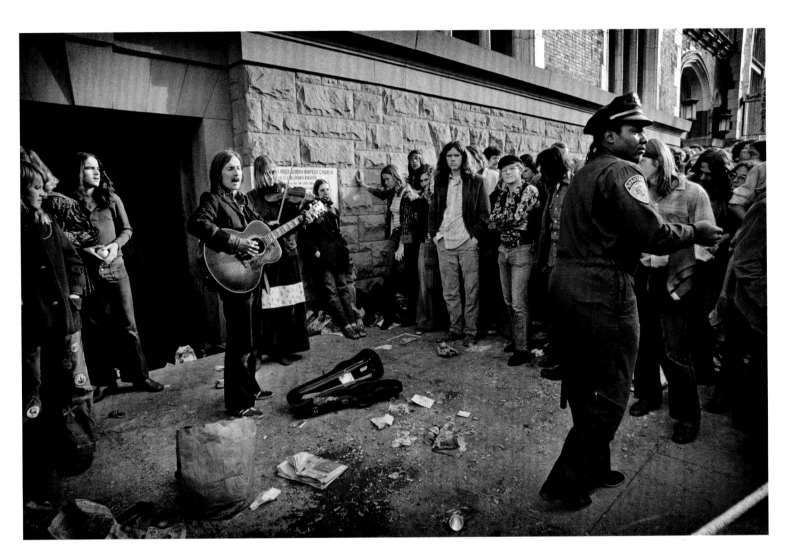

Private security was hired to assist with crowd control control, especially in San Francisco. The tour managers had received threats on Jagger's life after the 1969 concert at Altamont.

> The Western Addition neighborhood around the Winterland, San Francisco, California.

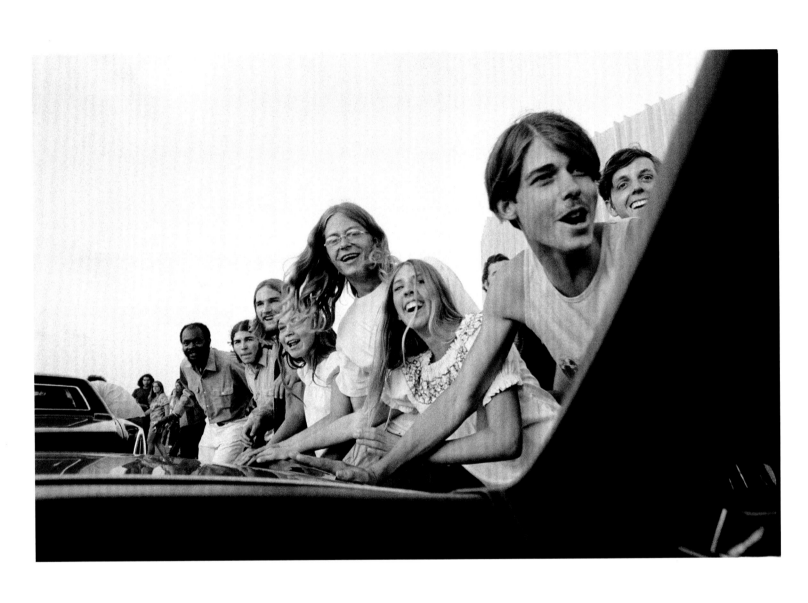

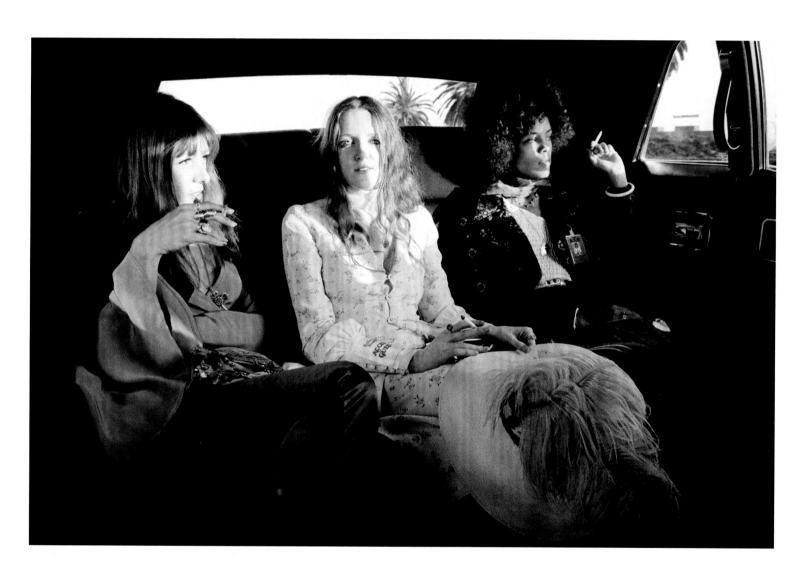

The ladies of the Stones, right to left: Jolie Jones
(Quincy Jones's daughter dating Keith Richards
at the time), Rose Taylor (wife of Mick Taylor),
and Astrid Lundström (girlfriend of Bill Wyman
at the time).

< Fans surrounding the Rolling Stones' cars going
to the Forum show, Los Angeles, California.

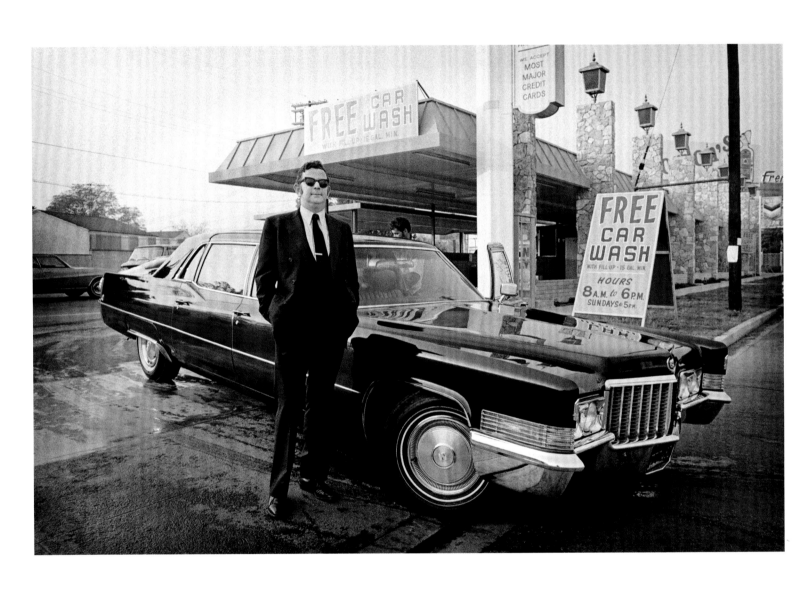

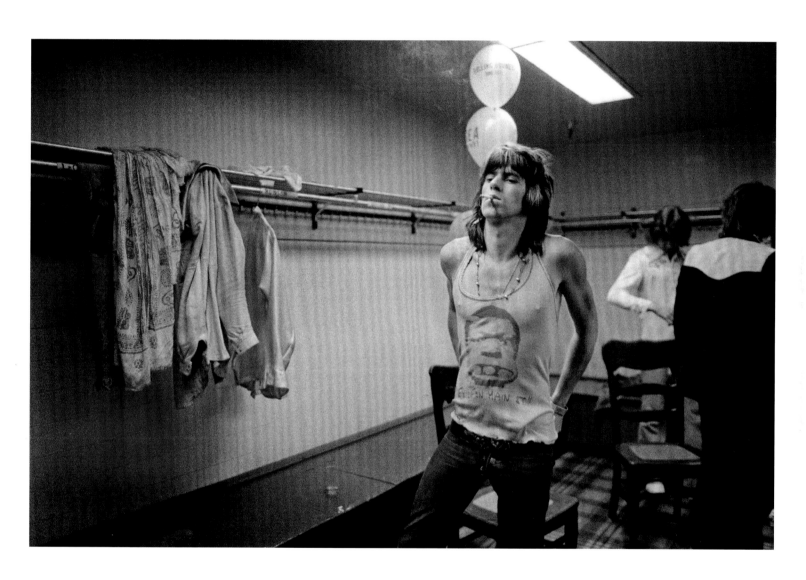

Keith Richards backstage, wearing a T-shirt with one of Robert Frank's photos from the *Exile on Main Street* album cover.

< The Rolling Stones' limo driver at the car wash: "Free Car Wash with Fill Up—15 Gal. Min."

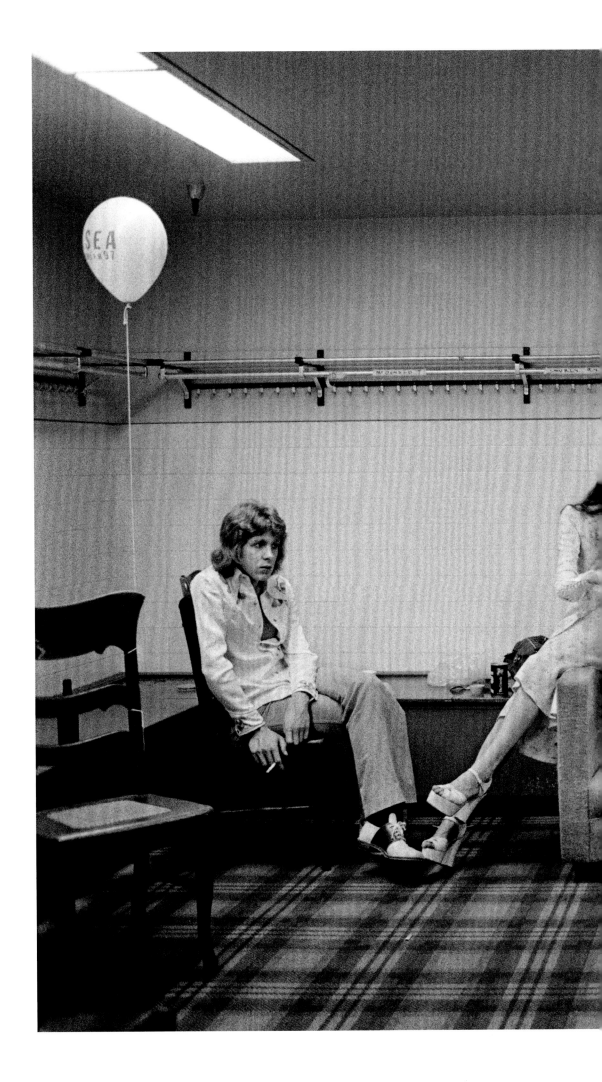

Mick Taylor; his wife, Rose; Mick Jagger;
Charlie Watts; and Bill Wyman backstage.

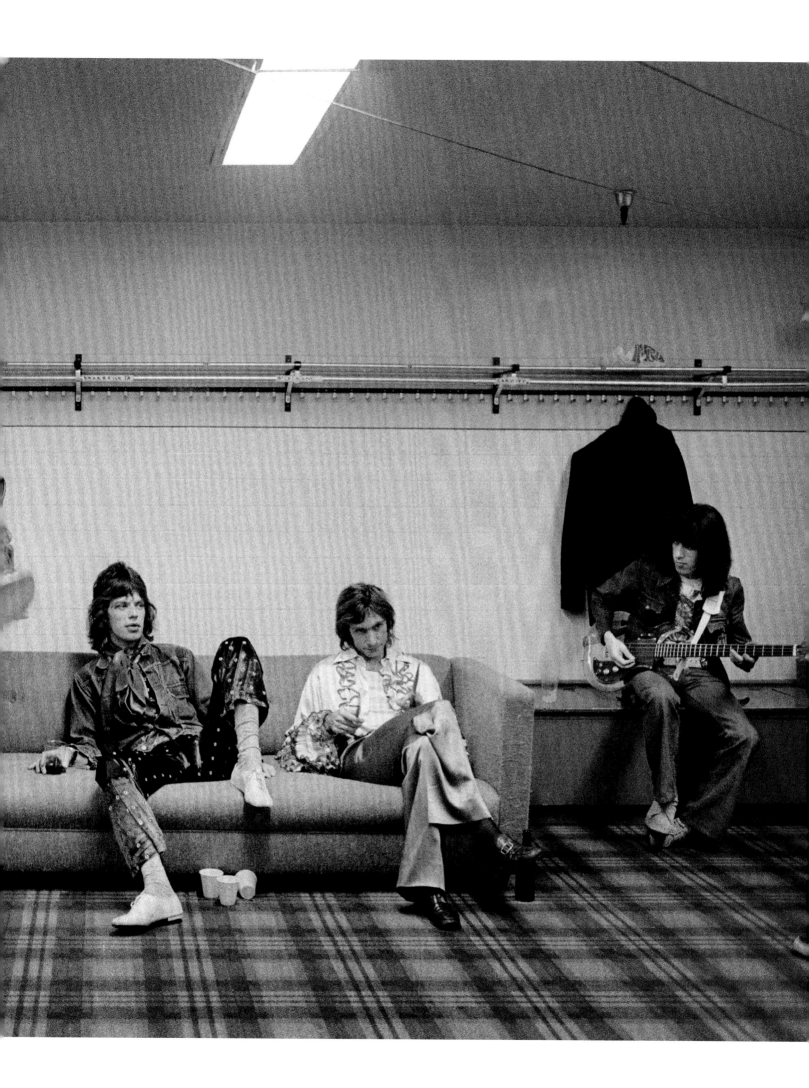

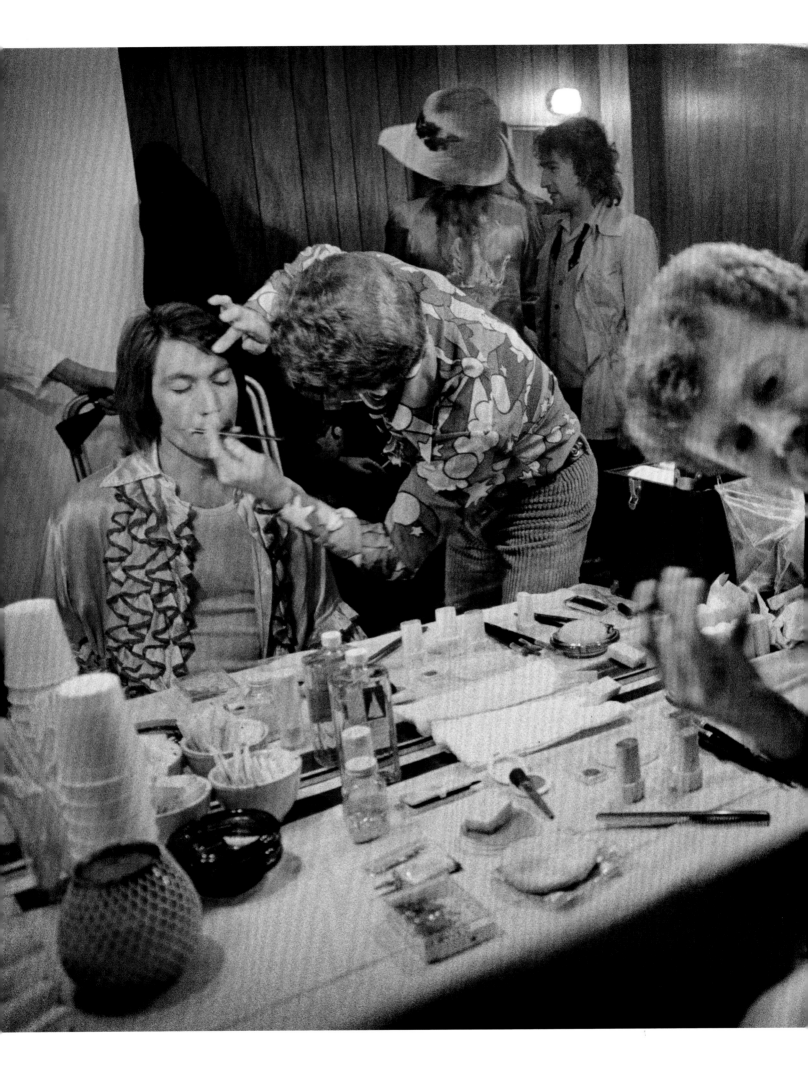

Steve Goekee, makeup artist for the tour, prepares Charlie Watts for the stage.

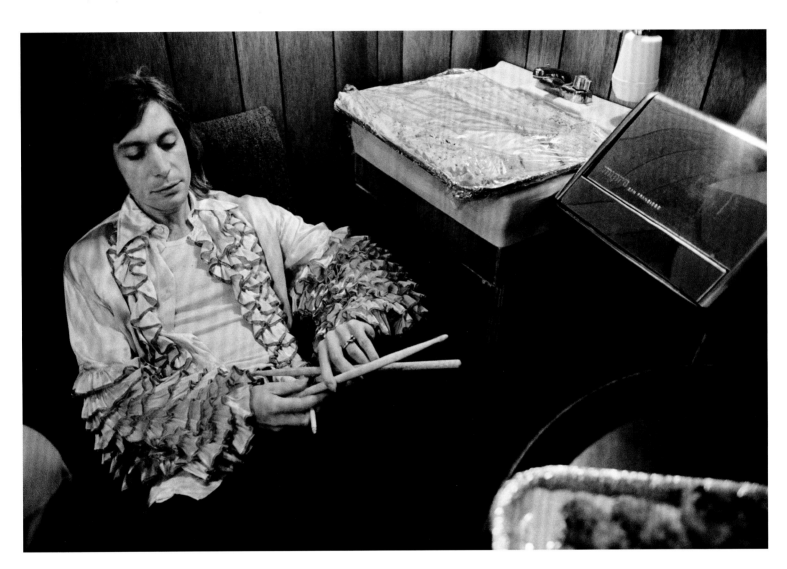

Charlie Watts.

> Makeup artist in the Stones' dressing room, doing touch-ups on the band members.

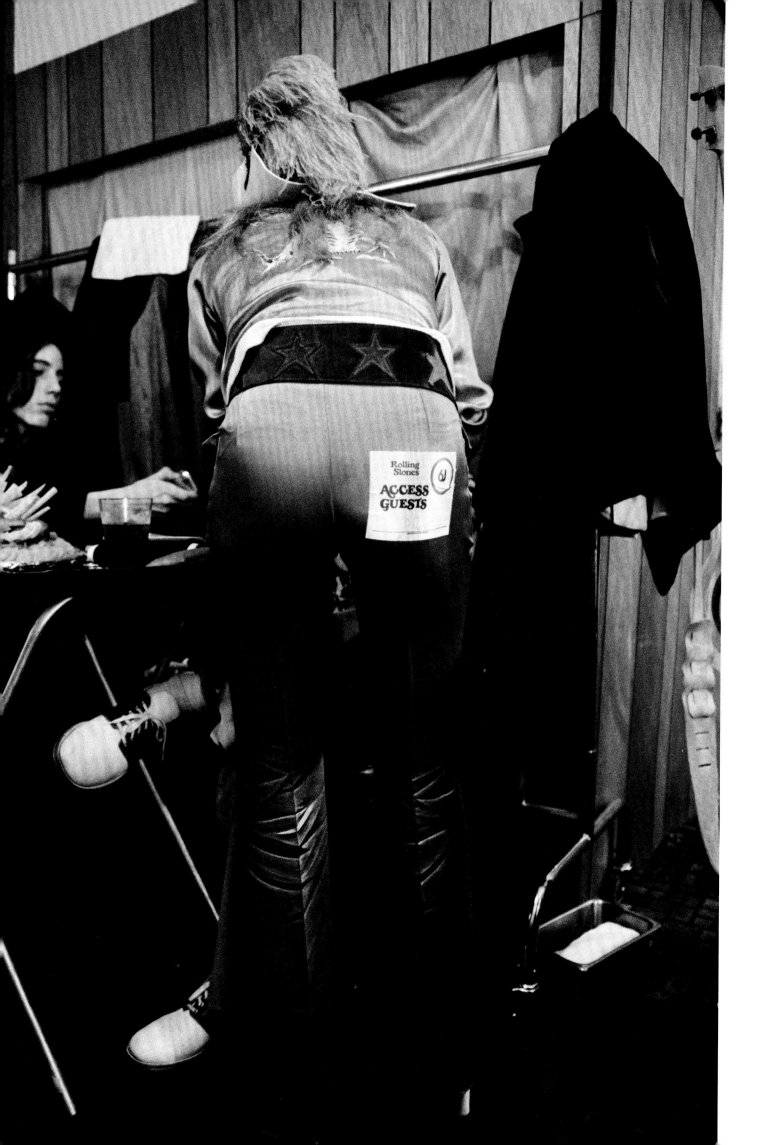

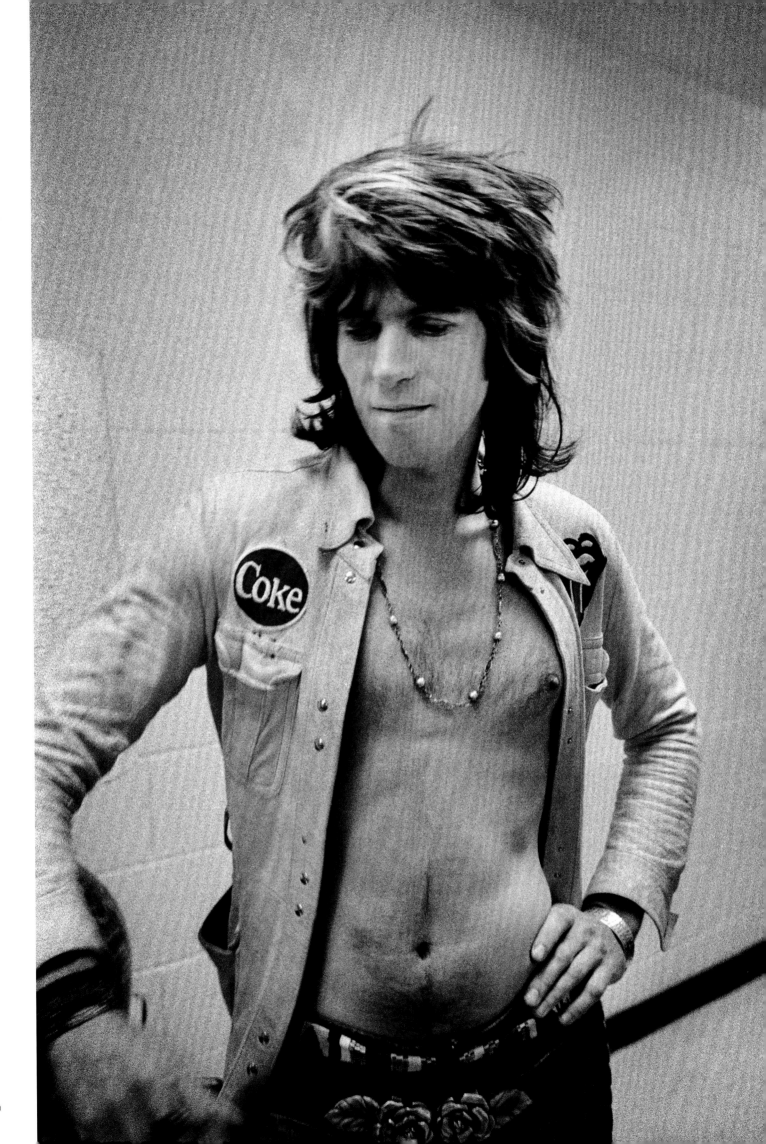

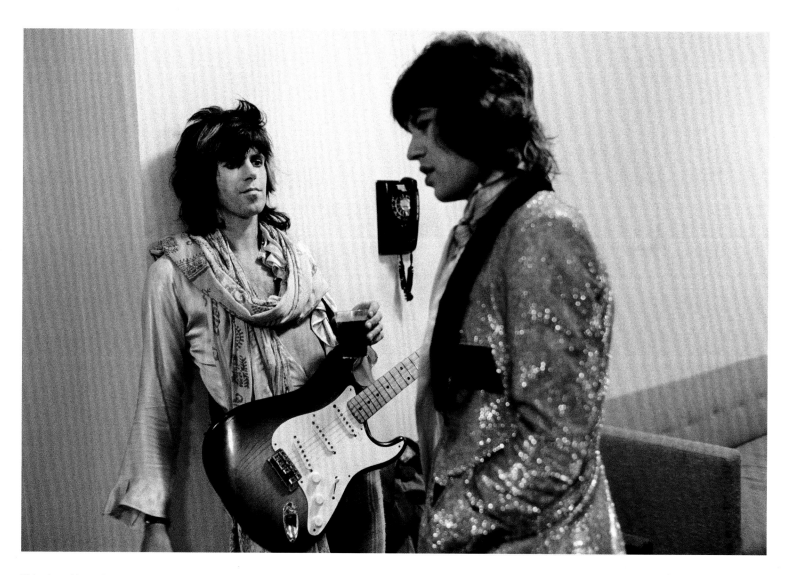

Richards and Jagger backstage.

< Richards's "Coke" logo was not simply a reference to the carbonated beverage.

Keith Richards.

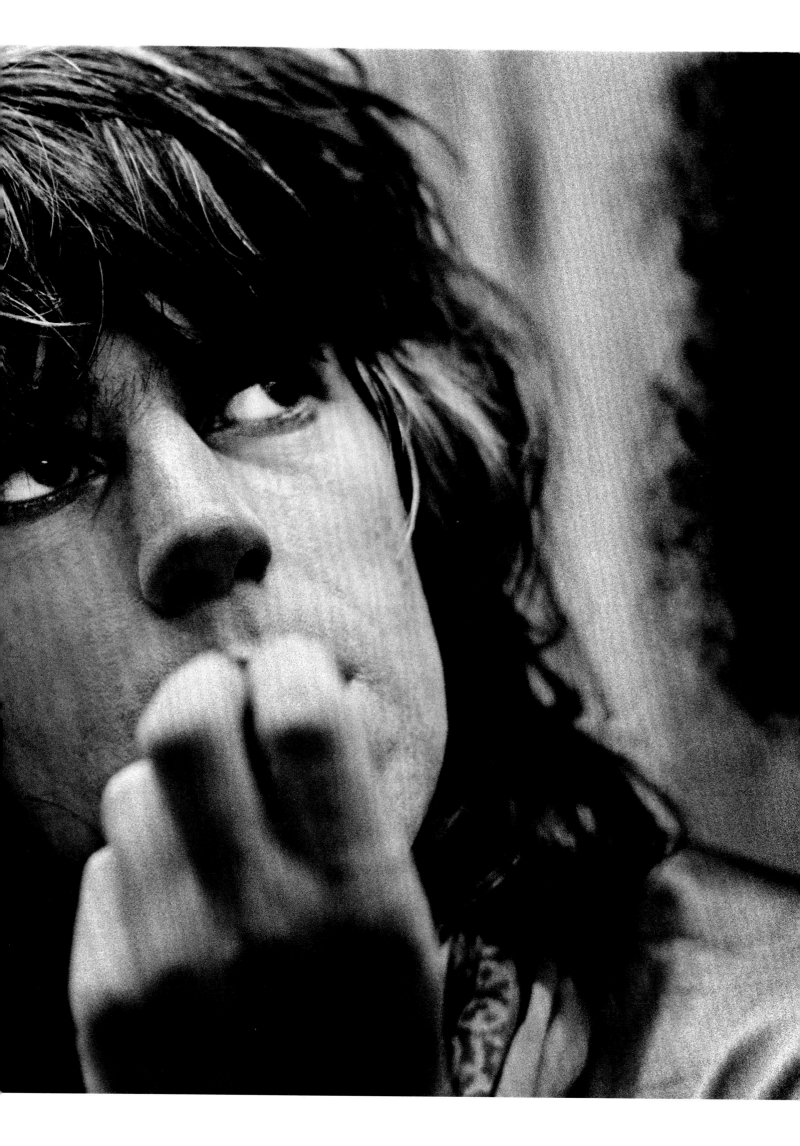

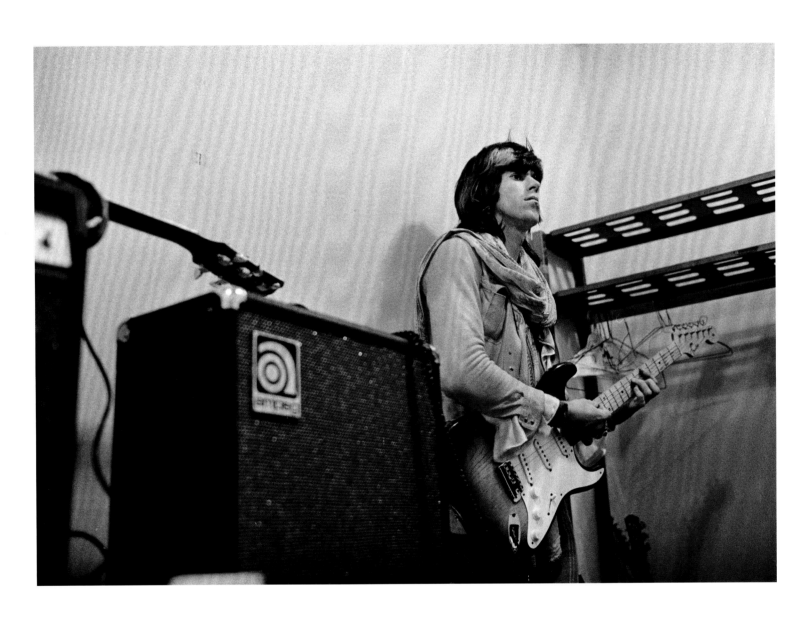

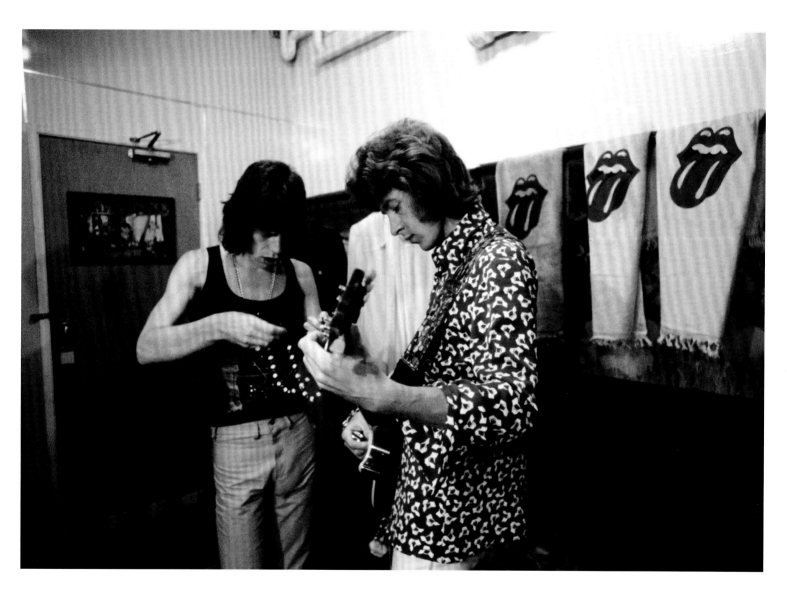

The Micks—Jagger and Taylor.

< Keith Richards tuning backstage.

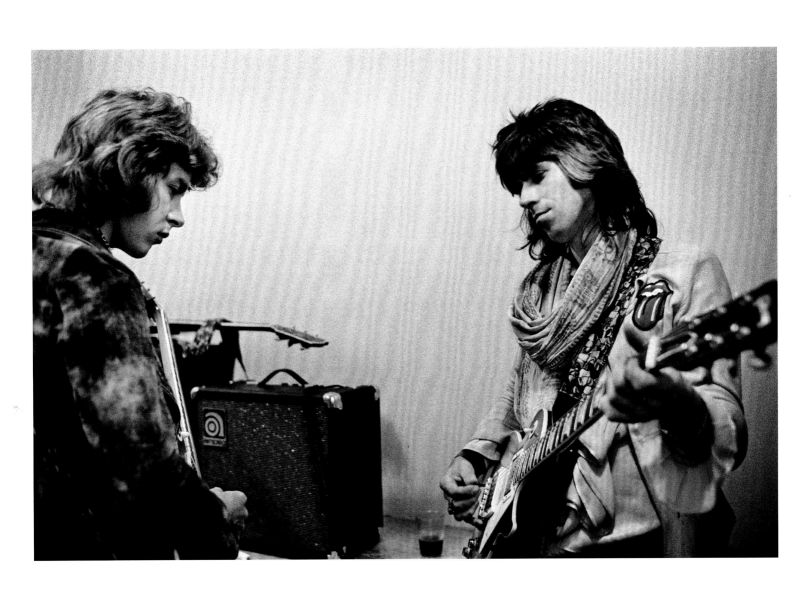

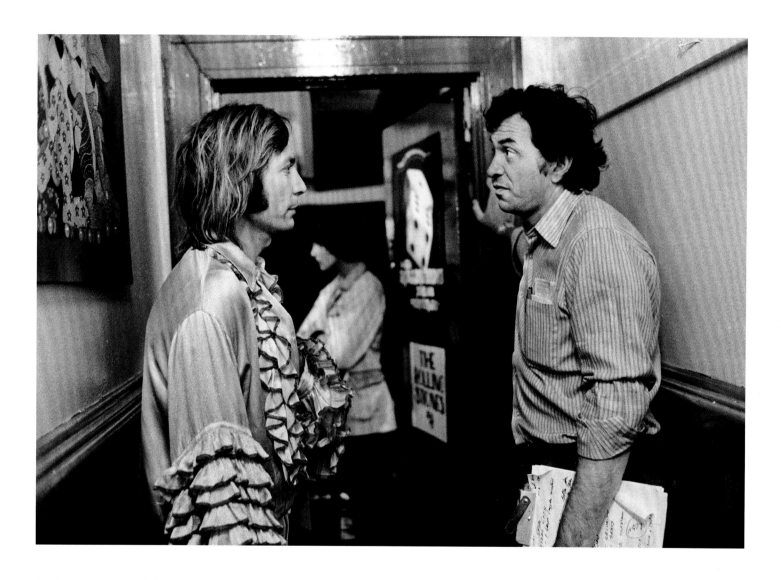

Bill Wyman talking with Bill Graham outside
Graham's office at Winterland, San Francisco,
California.

< Keith Richards and Mick Taylor tuning up back-
stage at Winterland, San Francisco, California.

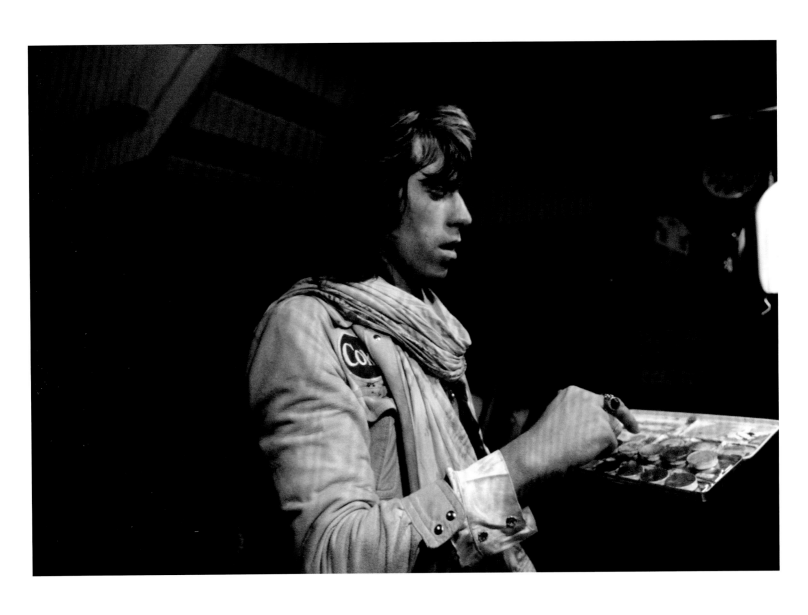

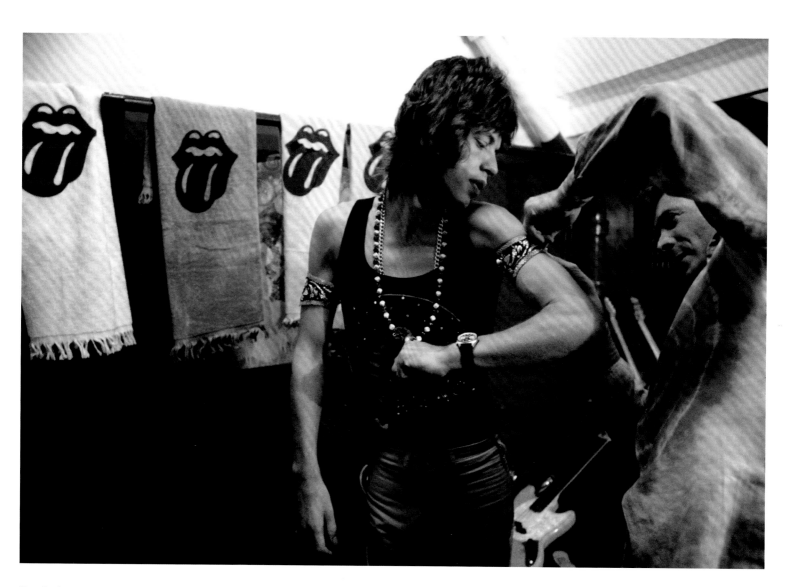

Steve Goekee adjusts accessories to Jagger's
outfit backstage.

< Keith Richards applying makeup backstage.

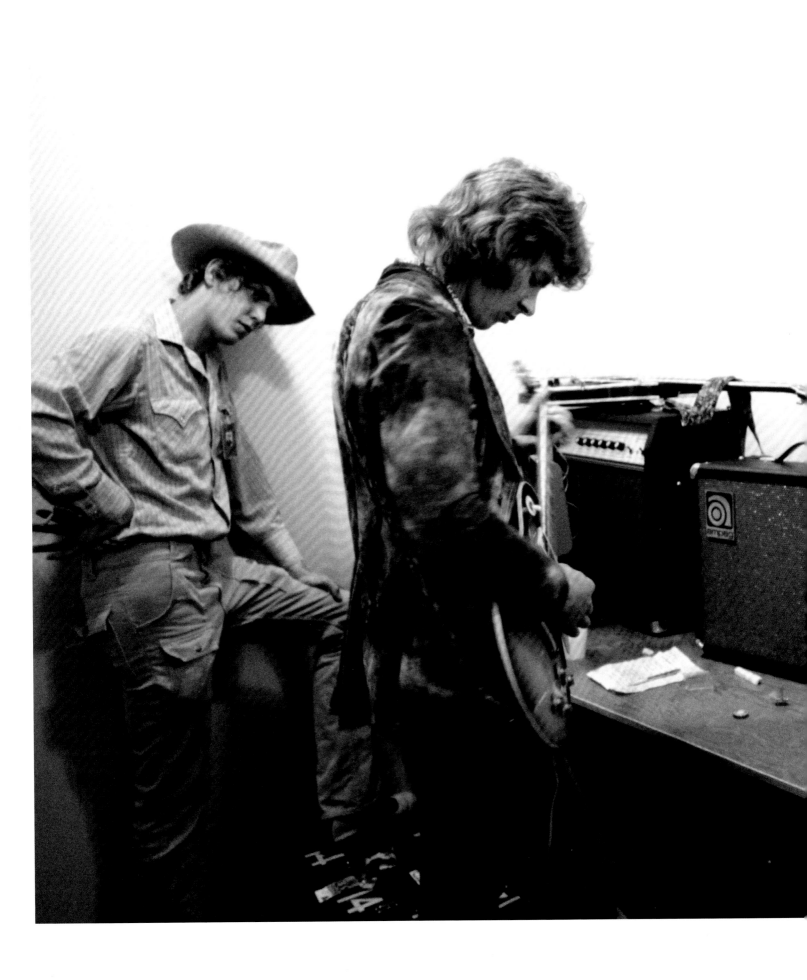

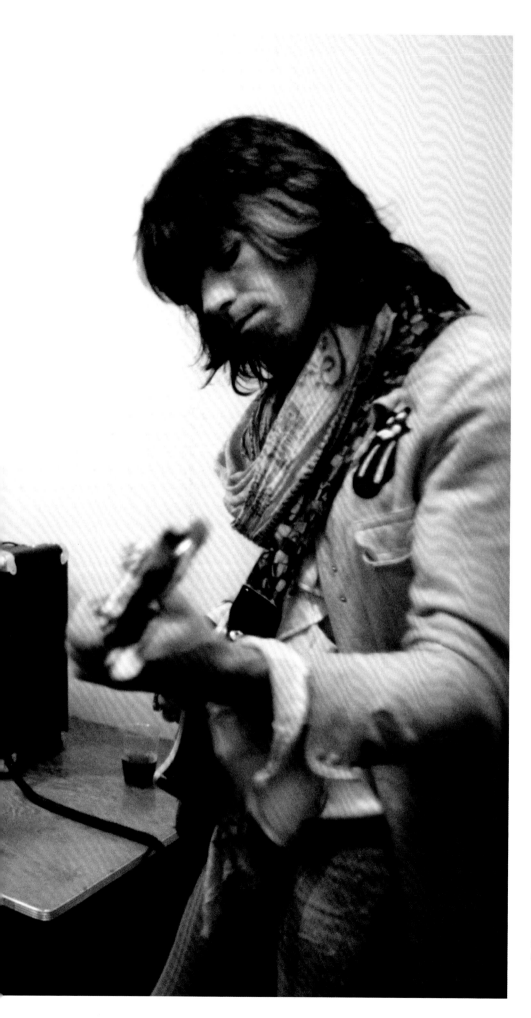

Guitar technician Newman Jones watches Mick Taylor
and Keith Richards tune up backstage.

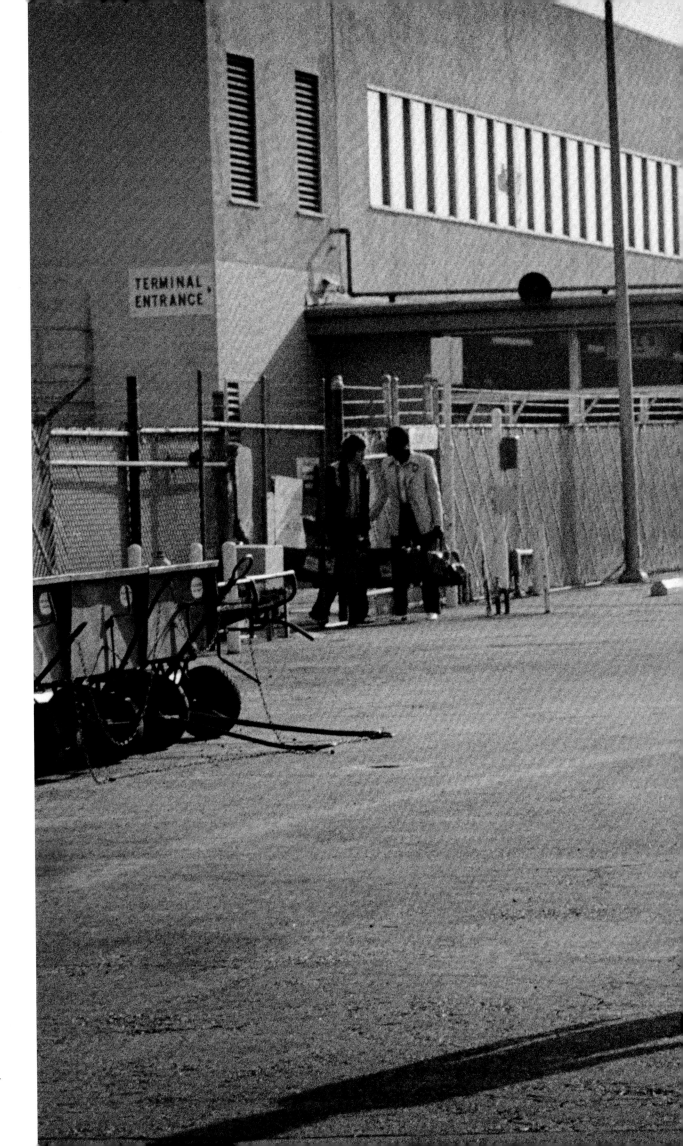

TERMINAL
ENTRANCE

Mick Jagger at the private airport terminal in Los Angeles, California.

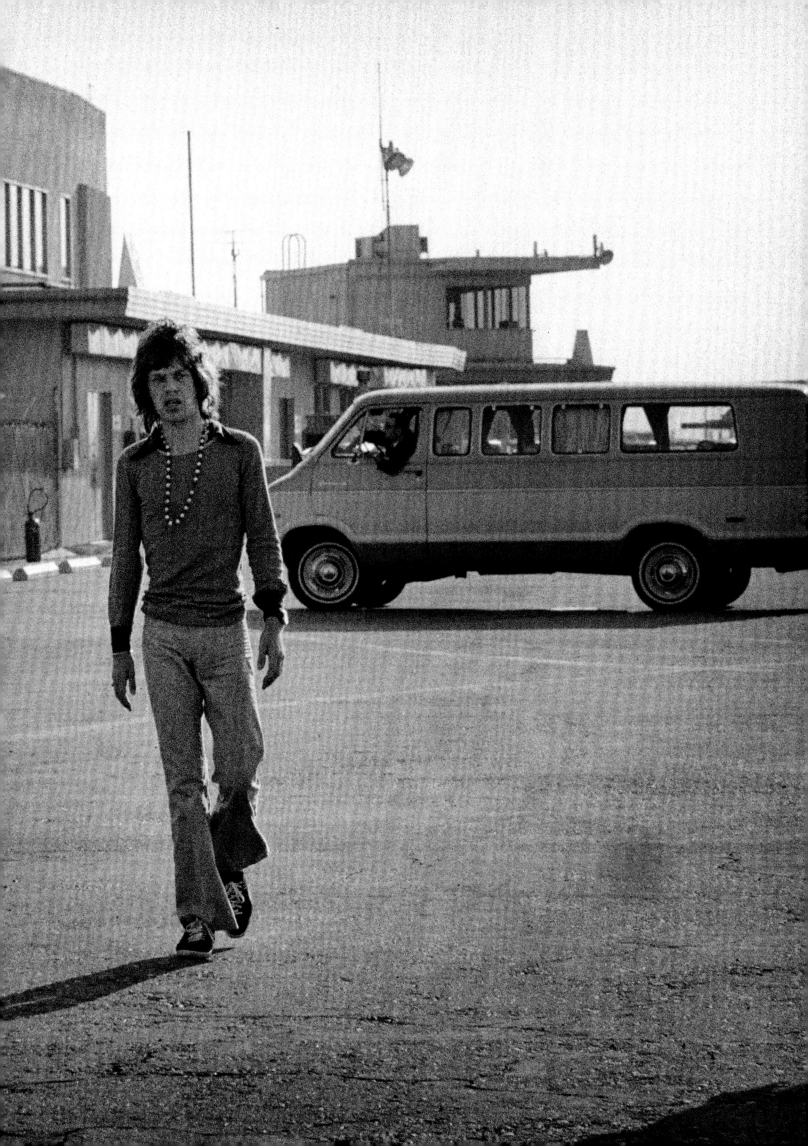

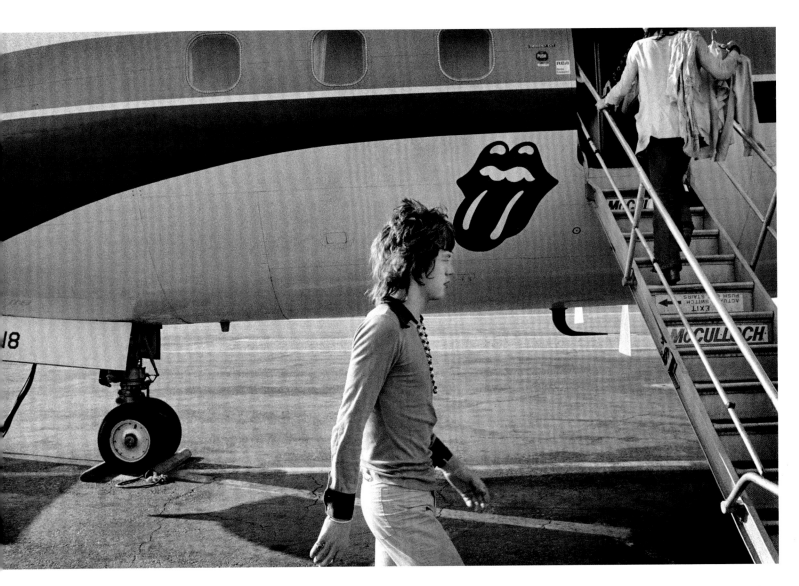

Boarding the Stones' private jet to head from Los Angeles to San Diego.

> Jagger reading over bassist Bill Wyman's shoulder on the plane.

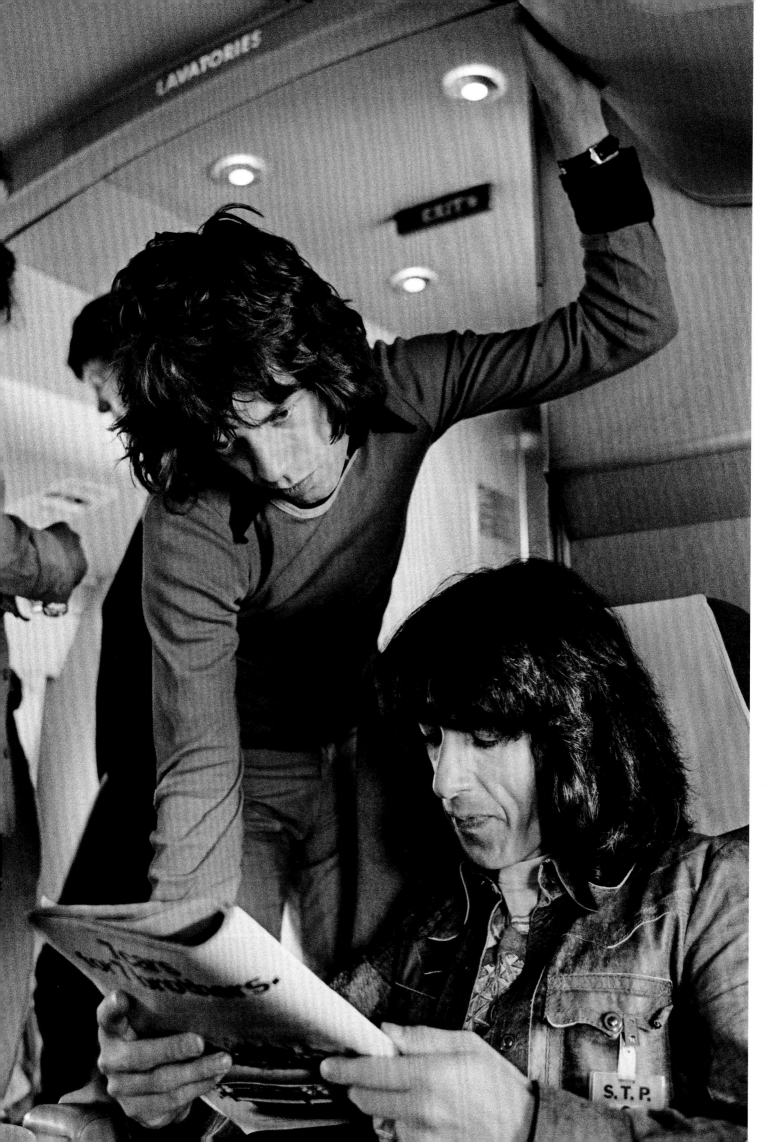

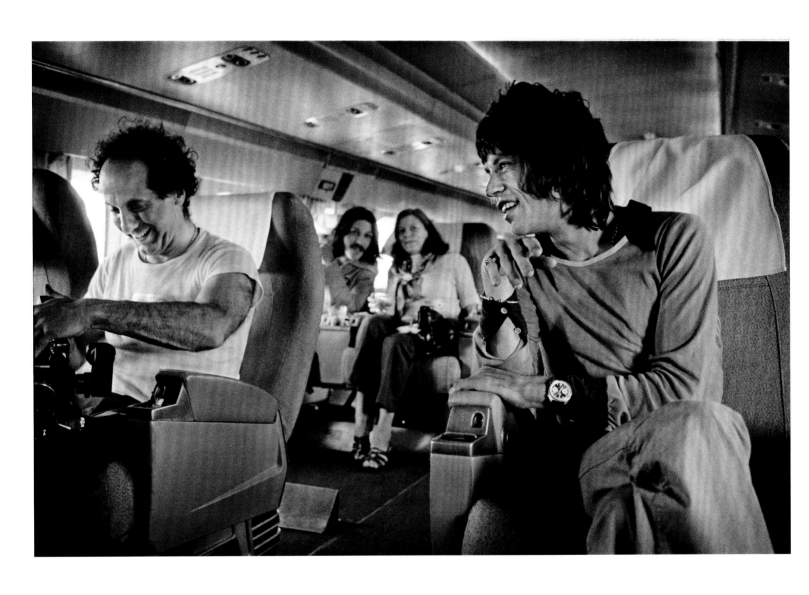

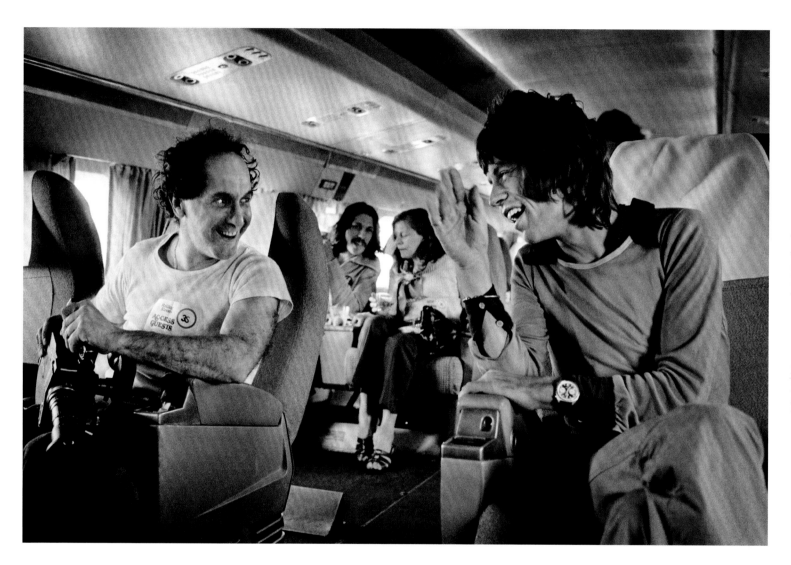

Photographer and filmmaker Robert Frank in conversation with Jagger, who hired him to document the tour. The resulting film, *Cocksucker Blues*, was never approved for public release, though Frank reserved the right to screen the film if he was present. Frank's photographs were used on the album cover for *Exile on Main Street*, which was designed by John Van Hammersveld and Norman Seeff.

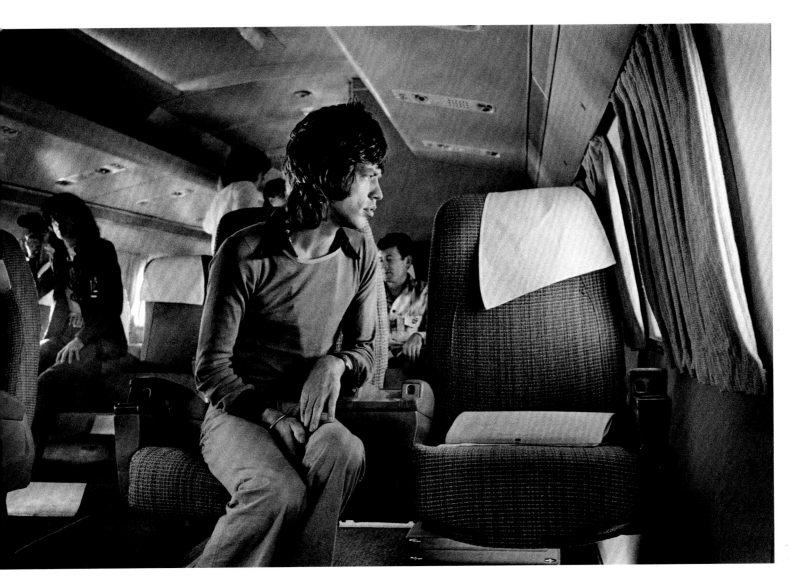

While Bill Wyman plays with one of Robert Frank's Super 8 cameras, Jagger settles in for the short ride between Los Angeles and San Diego. Frank encouraged the band to use his Super 8 cameras to get them comfortable with filming and being filmed.

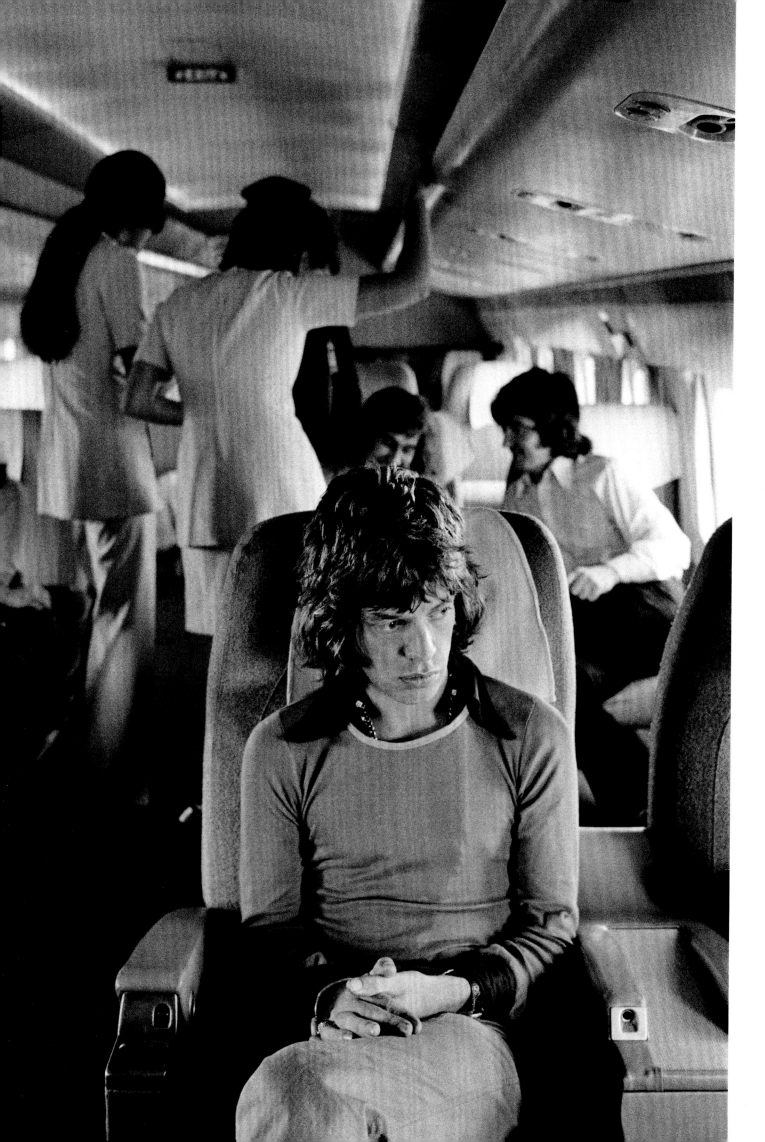

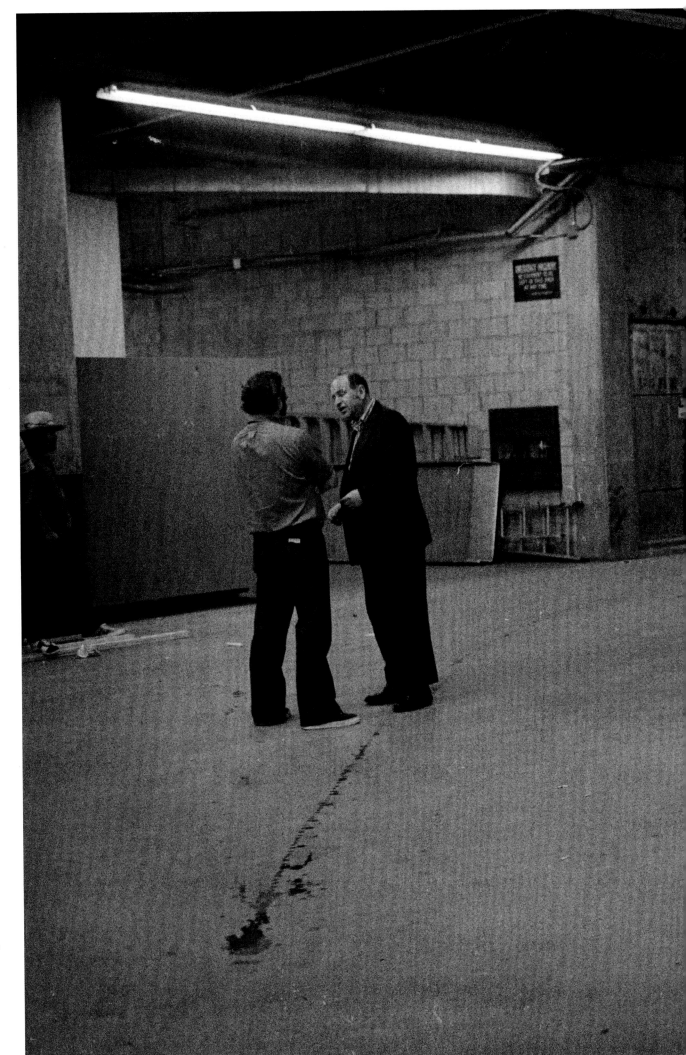

Jagger experiments with one of Frank's Super 8 cameras in the loading area of the Forum, Los Angeles, California. Jagger had already appeared in two or three movies as an actor and was interested in the filmmaking process.

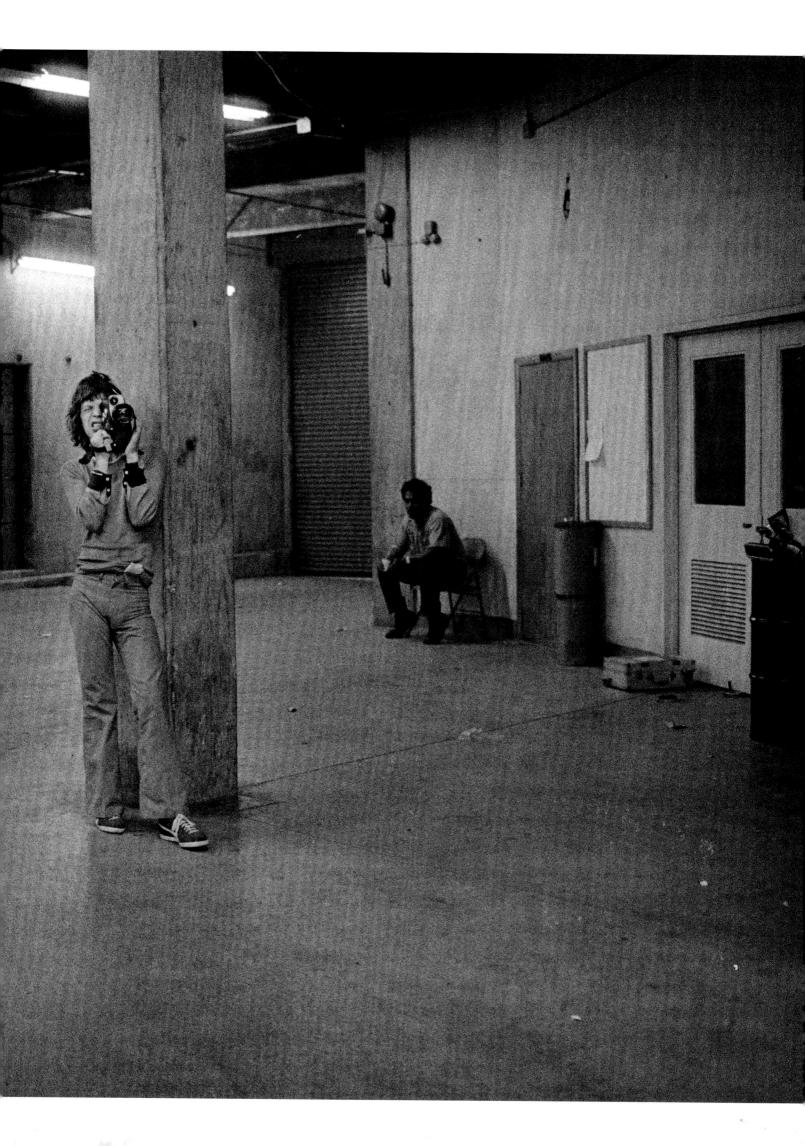

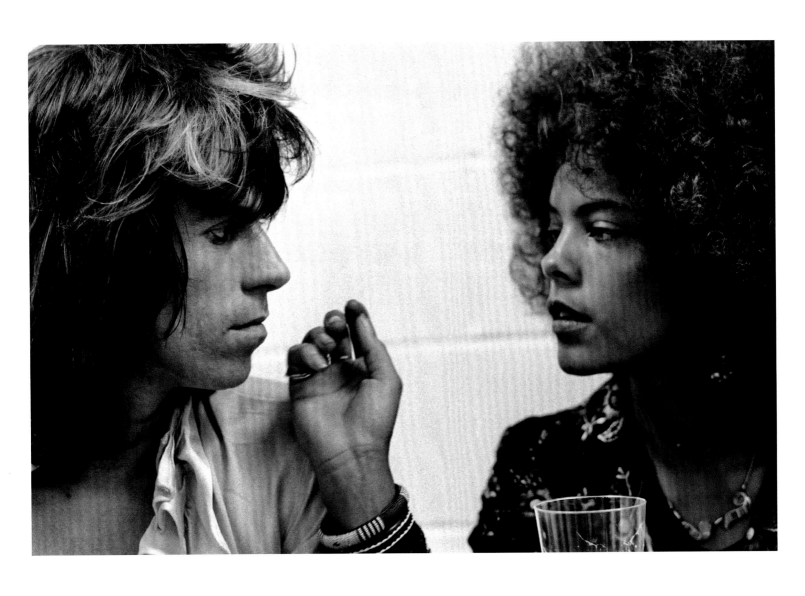

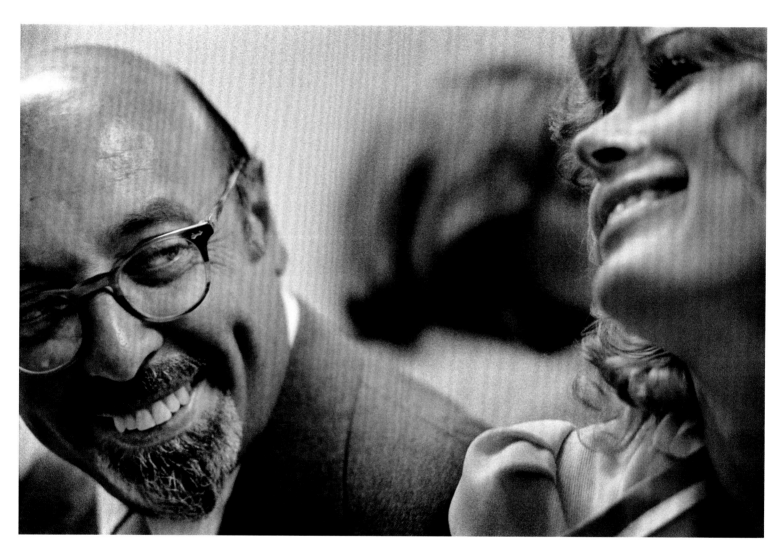

Ahmet Ertegun, Atlantic Records co-founder, with the actress Jill St. John, backstage at the Forum, Los Angeles, California. Atlantic was responsible for distribution of the newly formed and independent Rolling Stone Records, headed up by Marshall Chess.

< Keith Richards with Jolie Jones, daughter of musician and producer Quincy Jones, backstage at the Forum, Los Angeles, California.

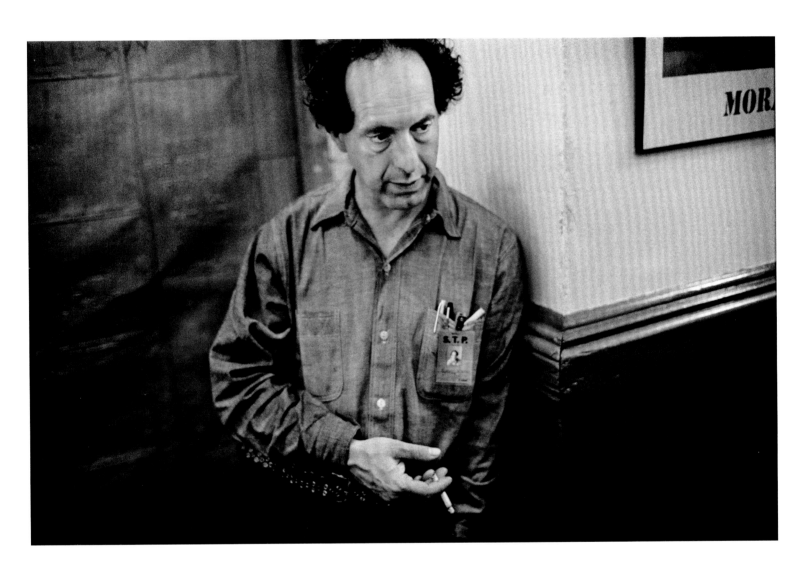

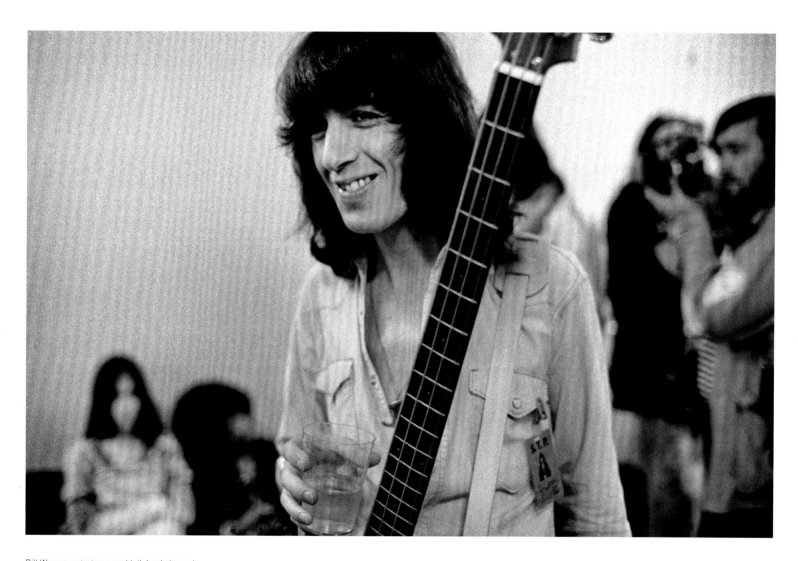

Bill Wyman enjoying a cocktail, backstage at
the Forum, Los Angeles, California. Photogra-
pher Ken Regan is seen behind Wyman.

< Robert Frank, also backstage at the Forum,
Los Angeles, California.

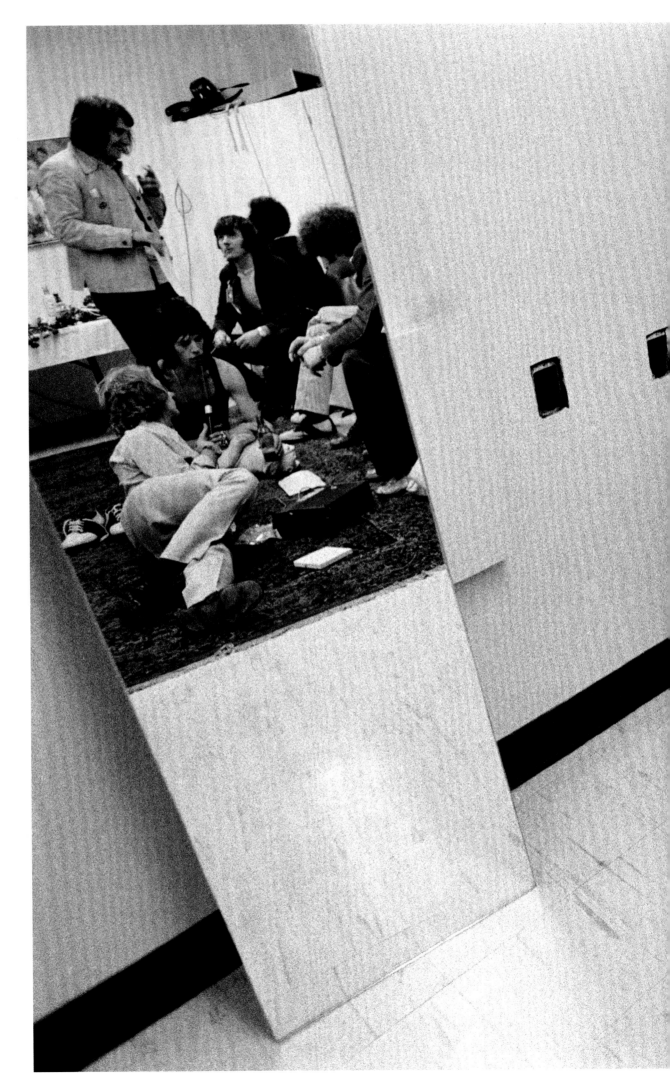

In mirror, tour manager
Peter Rudge stands
behind Jagger and others;
Robert Frank in conversa-
tion with Charlie Watts
backstage at the Forum,
Los Angeles, California.

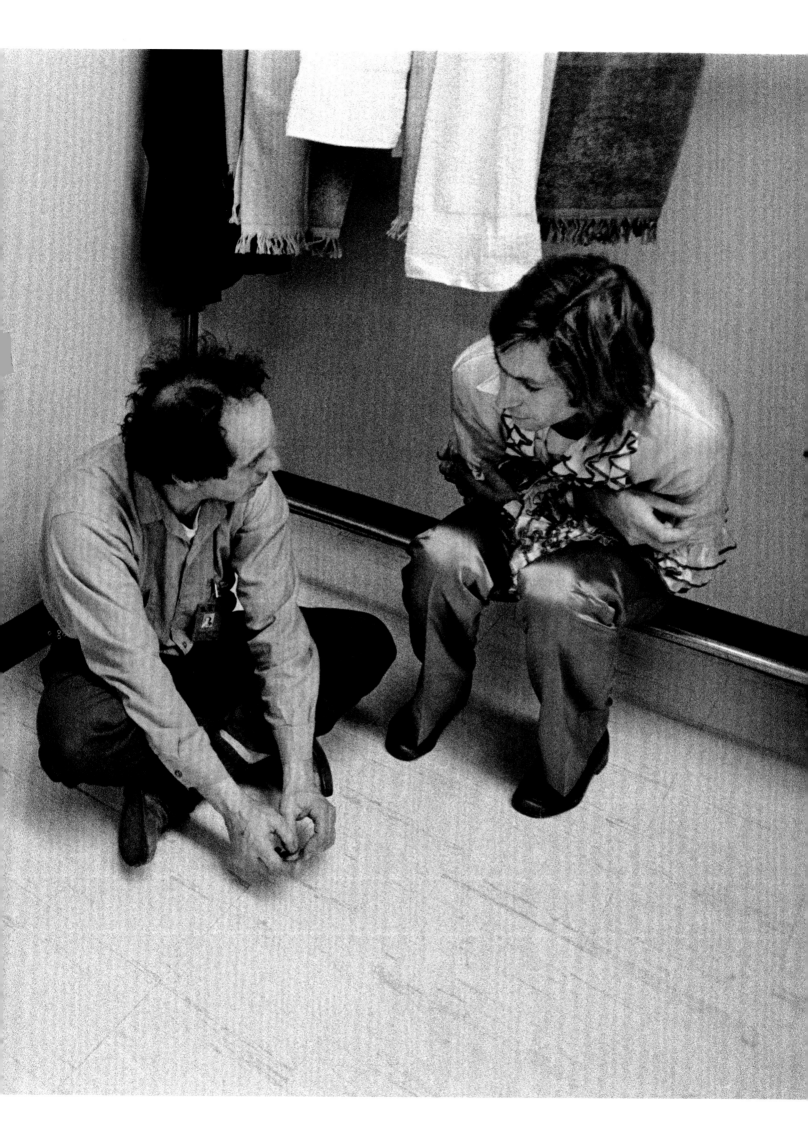

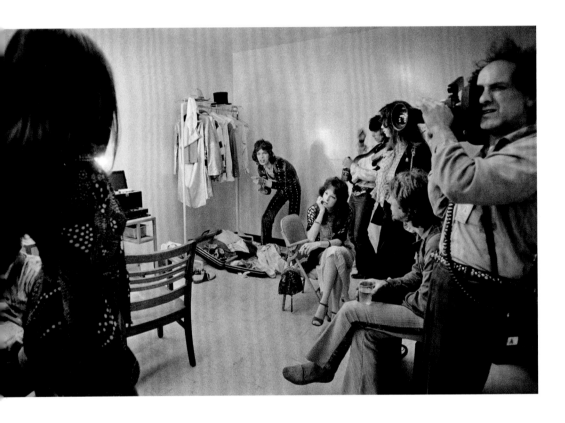

Robert Frank at work as Keith
Richards greets Tina Turner.

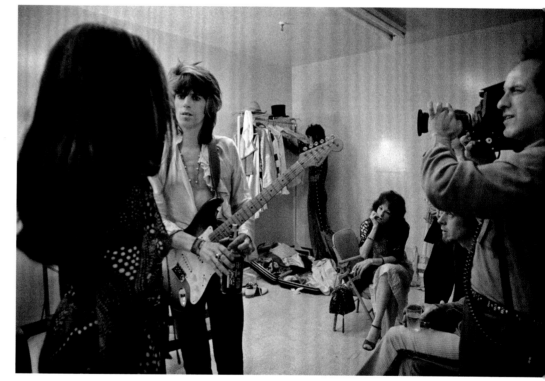

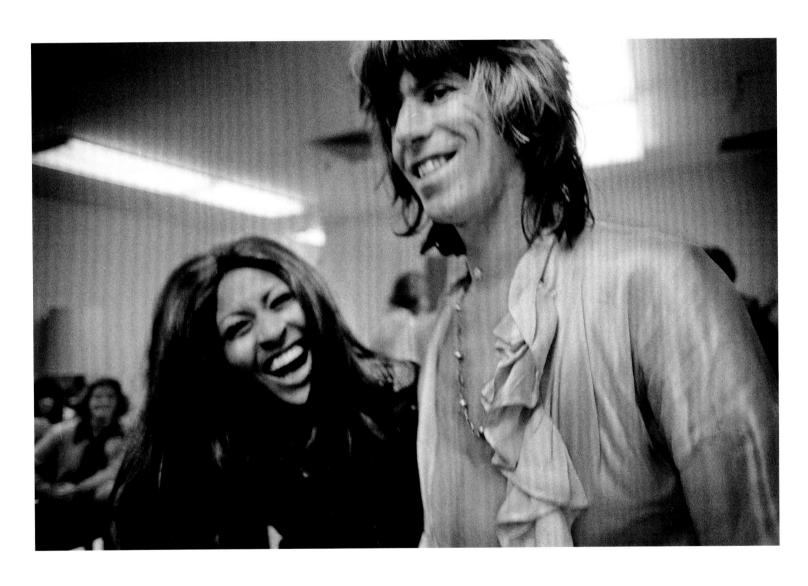

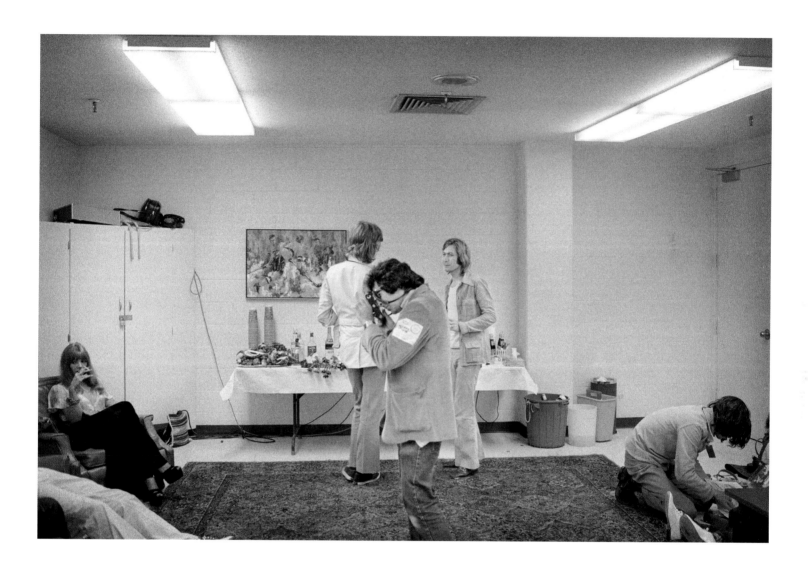

Jim Marshall backstage.

< Tina Turner and Keith Richards.

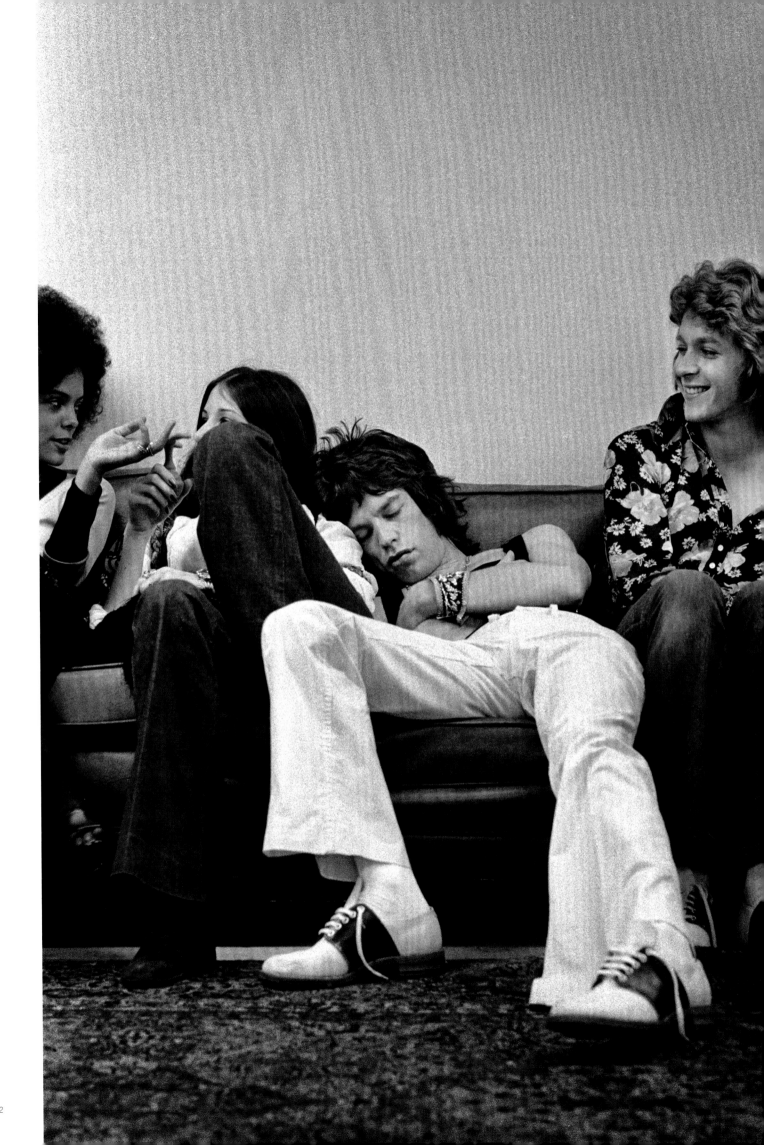

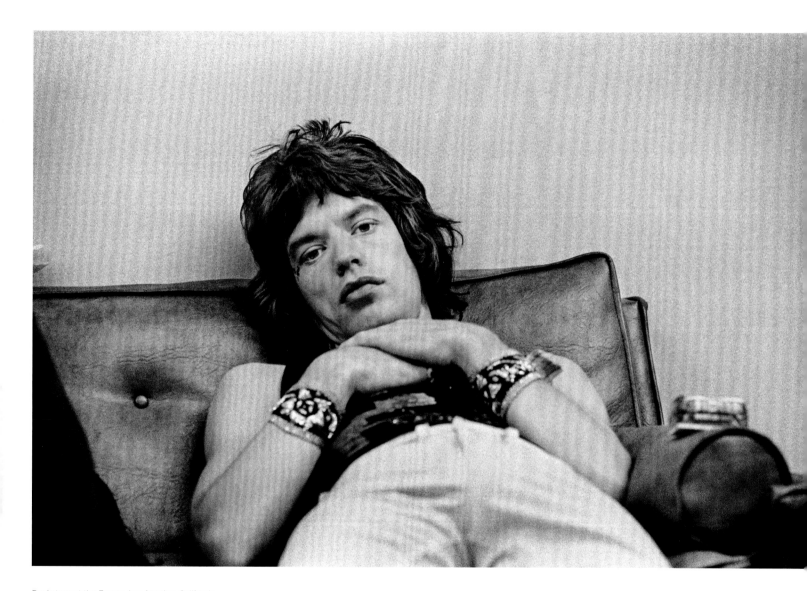

Backstage at the Forum, Los Angeles, California. Due to logistics and security concerns, the Stones stayed at the venue between the afternoon and evening shows on June 11.

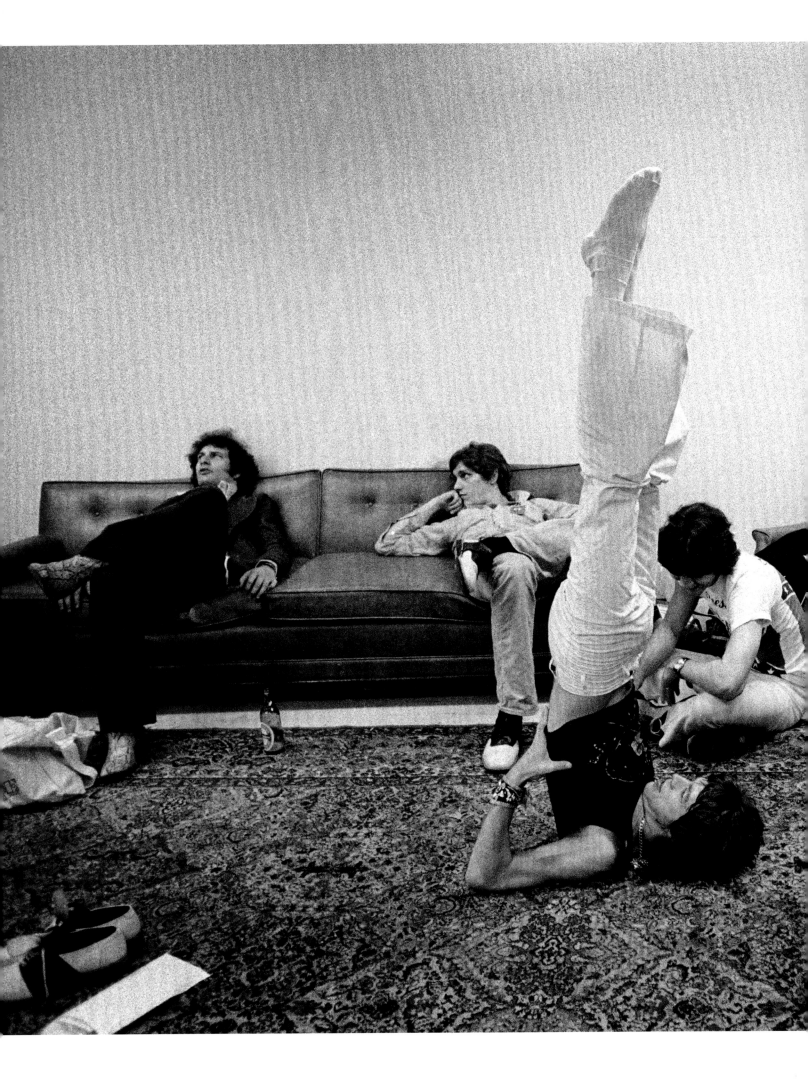

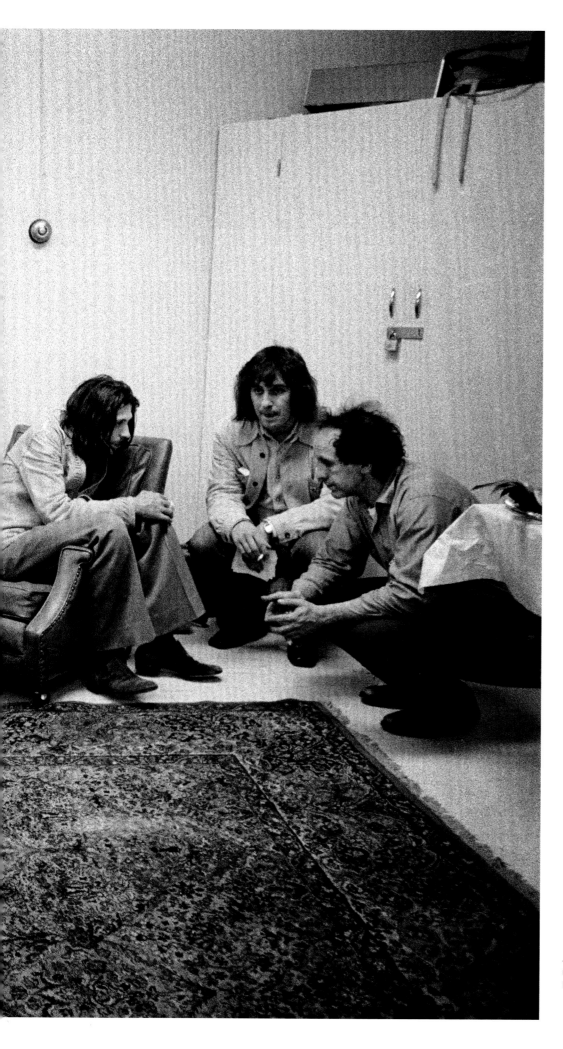

Jagger stretches backstage. To his right, tour manager Peter Rudge huddles with assistant Danny Arnold and Robert Frank.

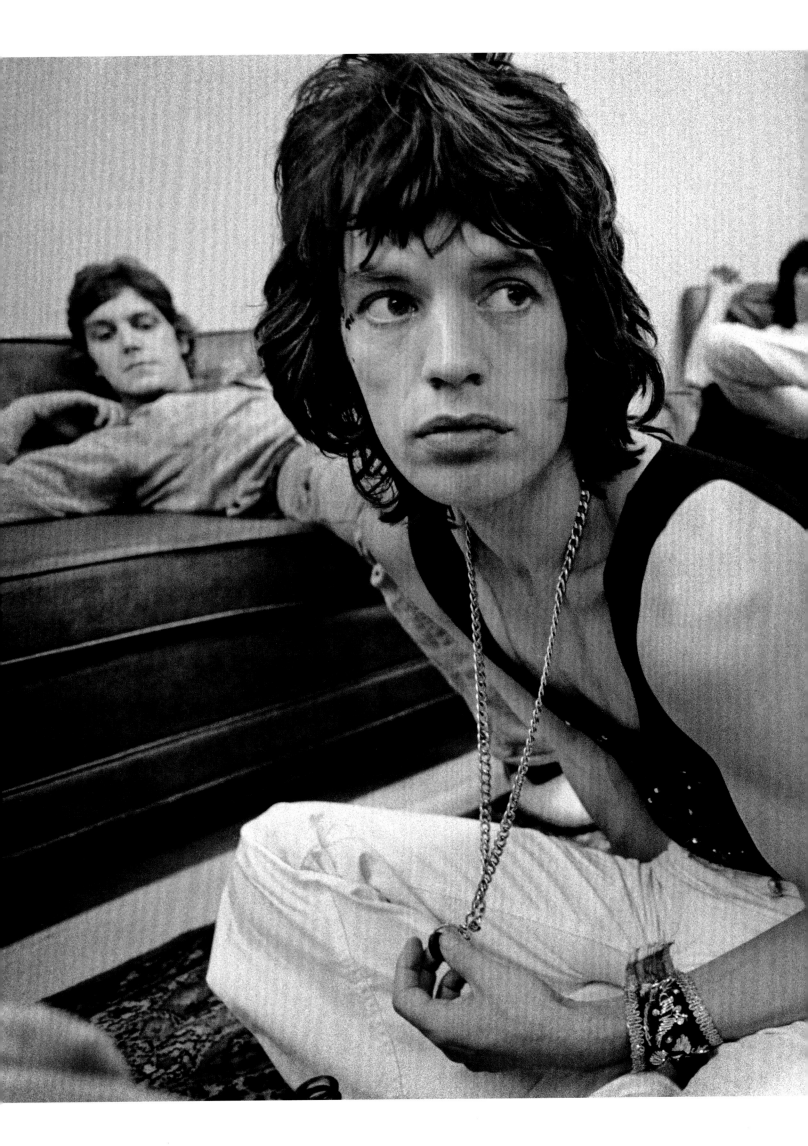

Mick Jagger
backstage at the
Forum, Los Angeles,
California.

Keith Richards
backstage at the
Forum, Los Angeles,
California.

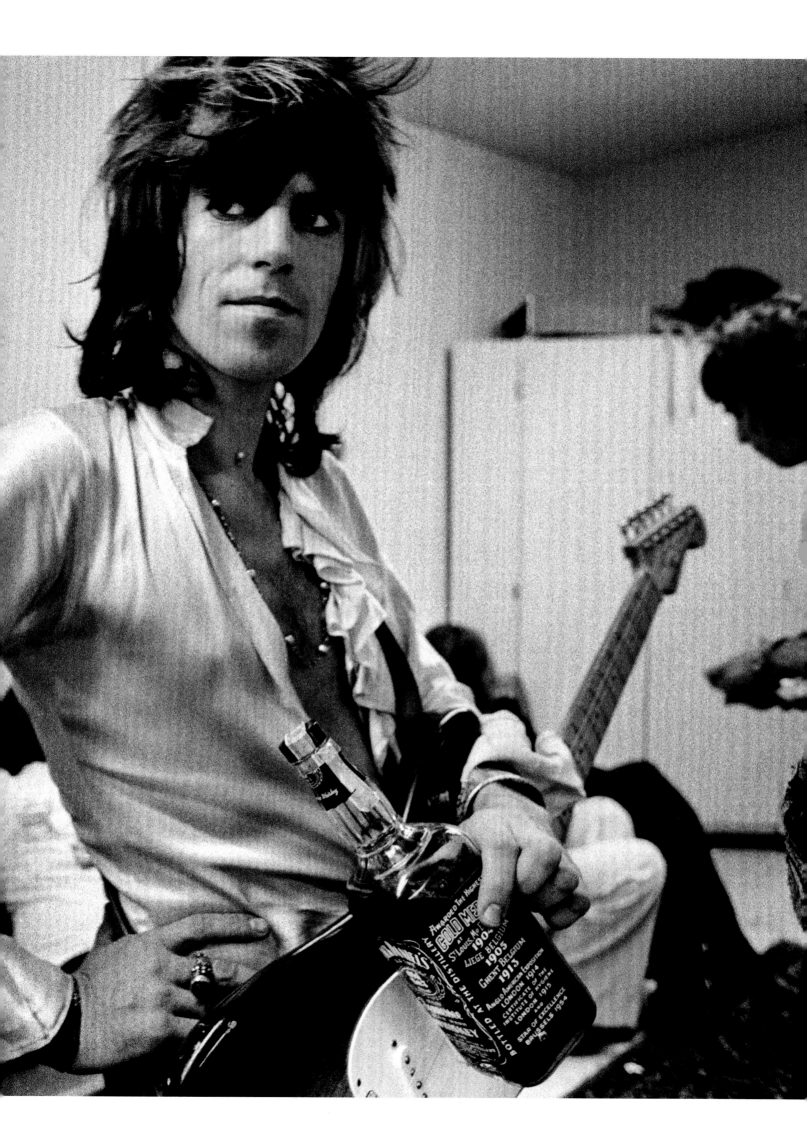

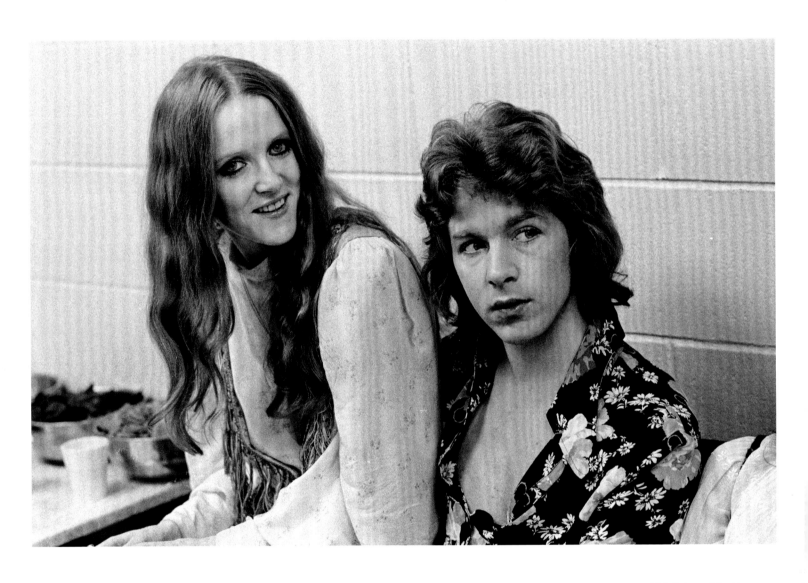

Mick Taylor and his wife,
Rose, backstage at the Forum,
Los Angeles, California.

> Mick Jagger backstage.

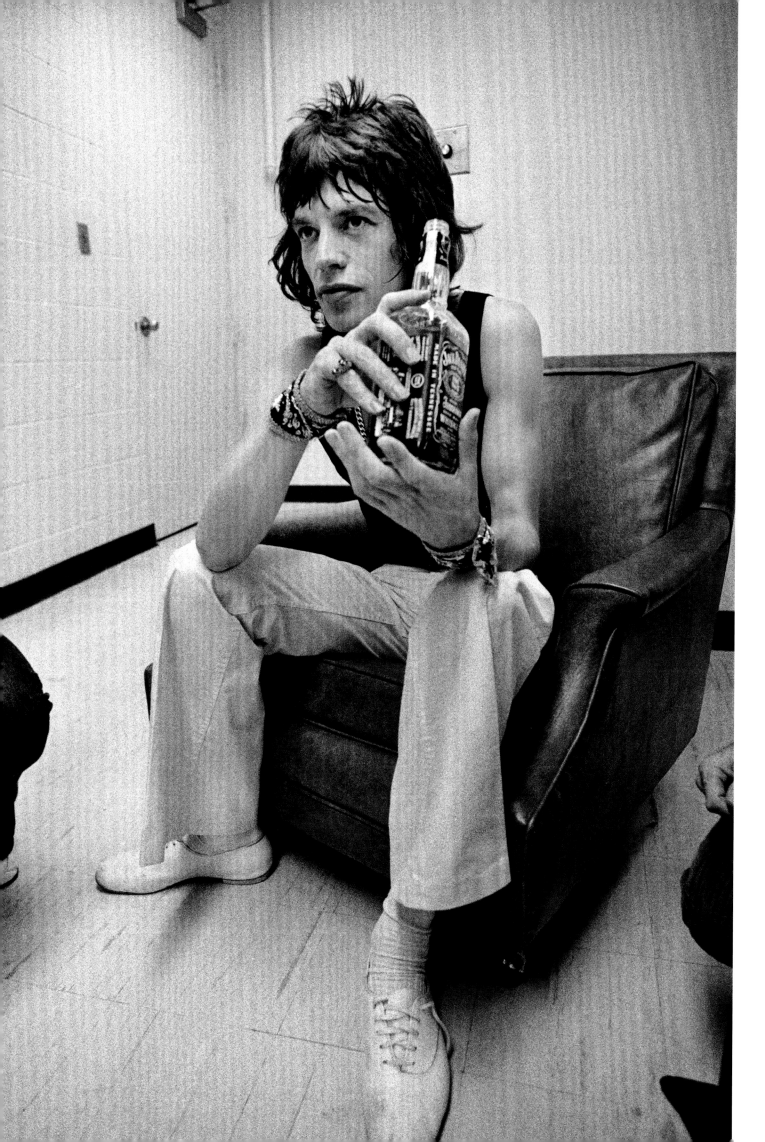

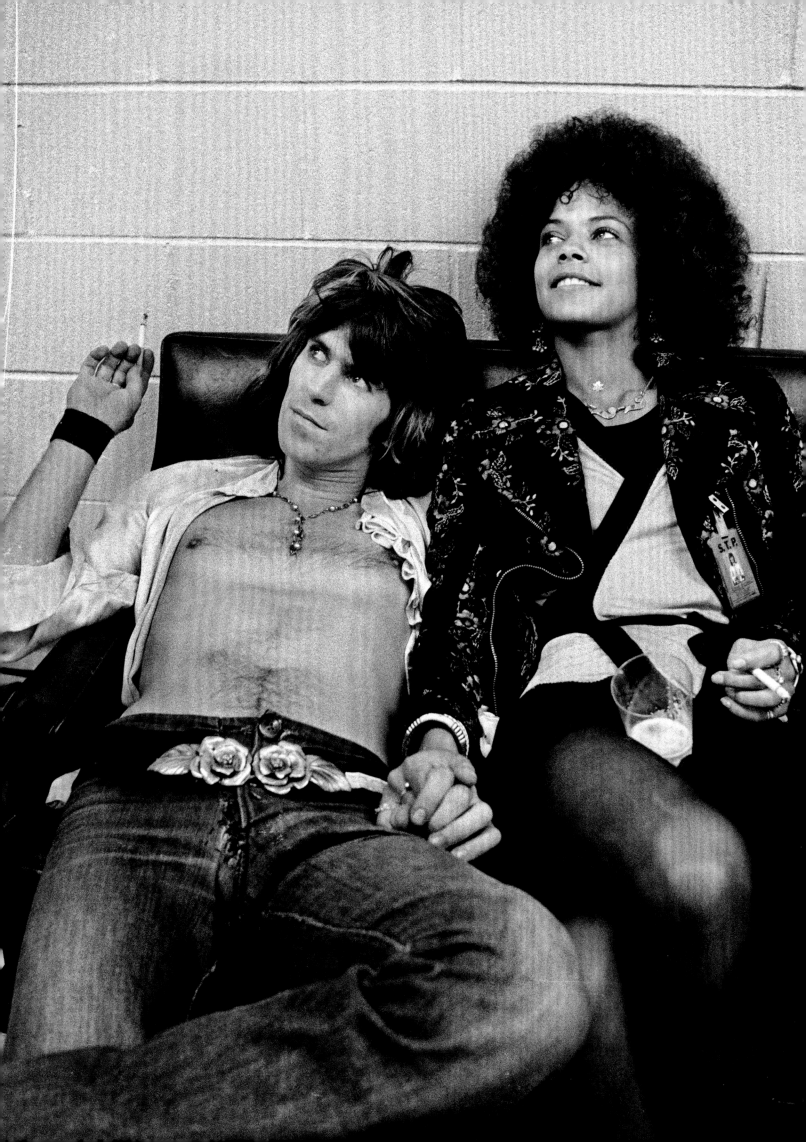

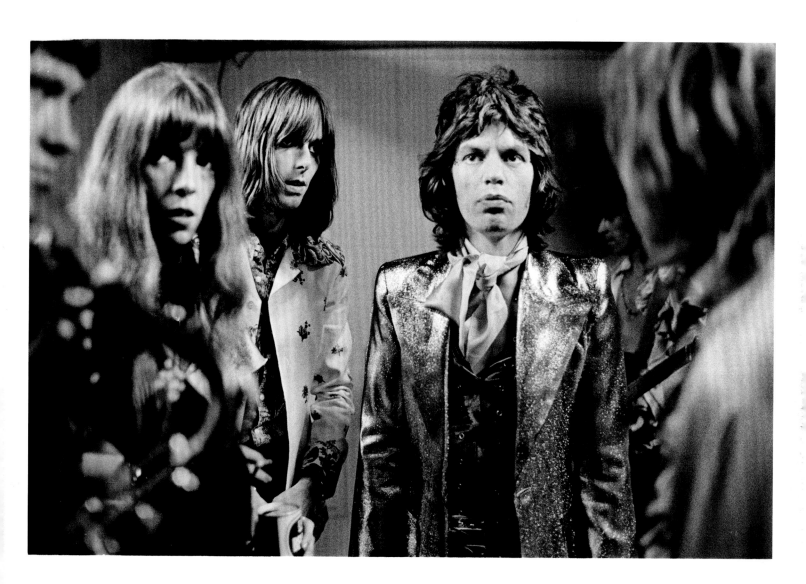

Mick Jagger and Nicky Hopkins backstage.

< Keith Richards and Jolie Jones backstage.

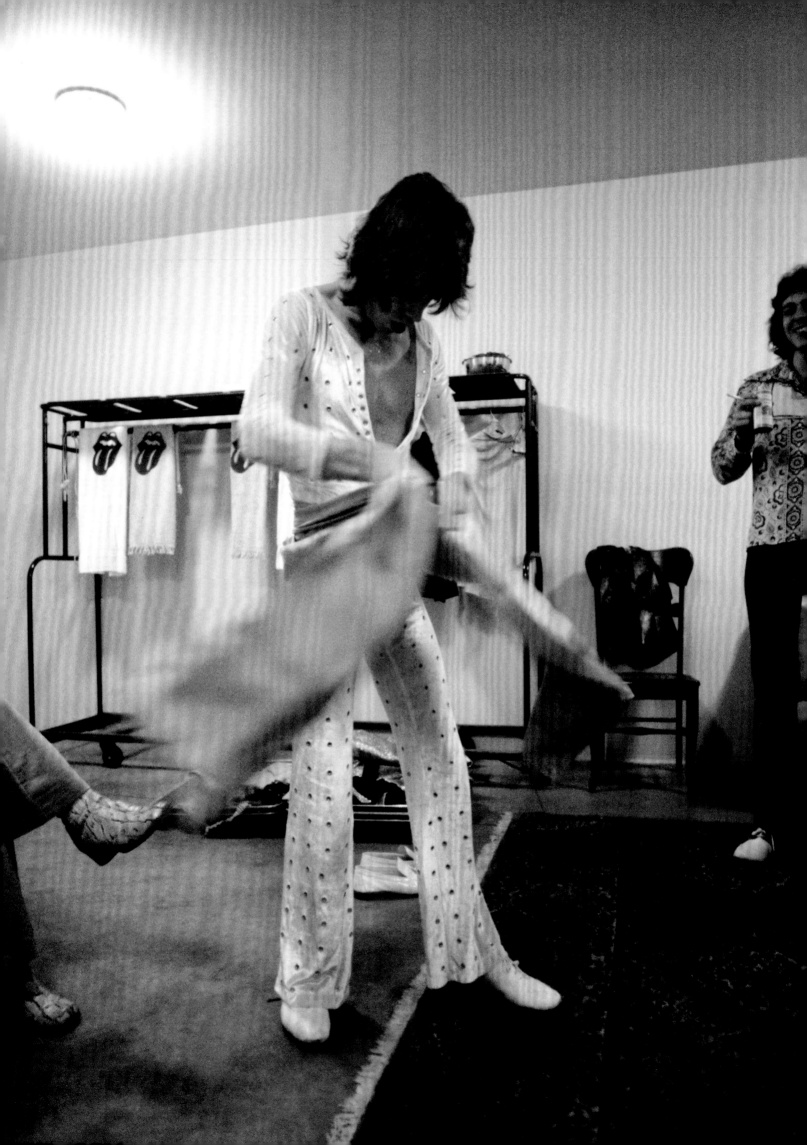

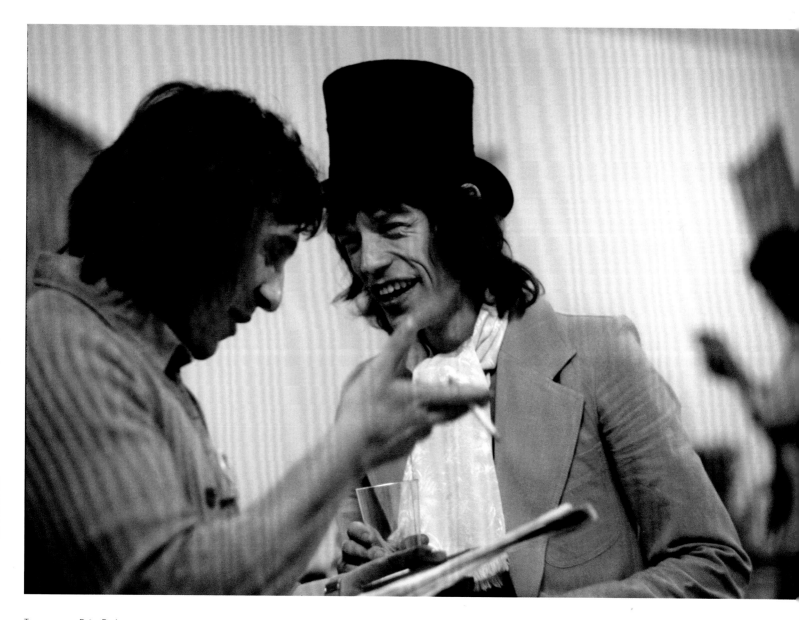

Tour manager Peter Rudge
consults with Jagger.

< Jagger dressing at the Forum,
Los Angeles, California.

The new tongue logo was heavily promoted throughout the 1972 tour, providing color to otherwise drab backstage areas.

> Rose Taylor, wife of guitarist Mick Taylor, in conversation with Jagger at the Forum, Los Angeles, California.

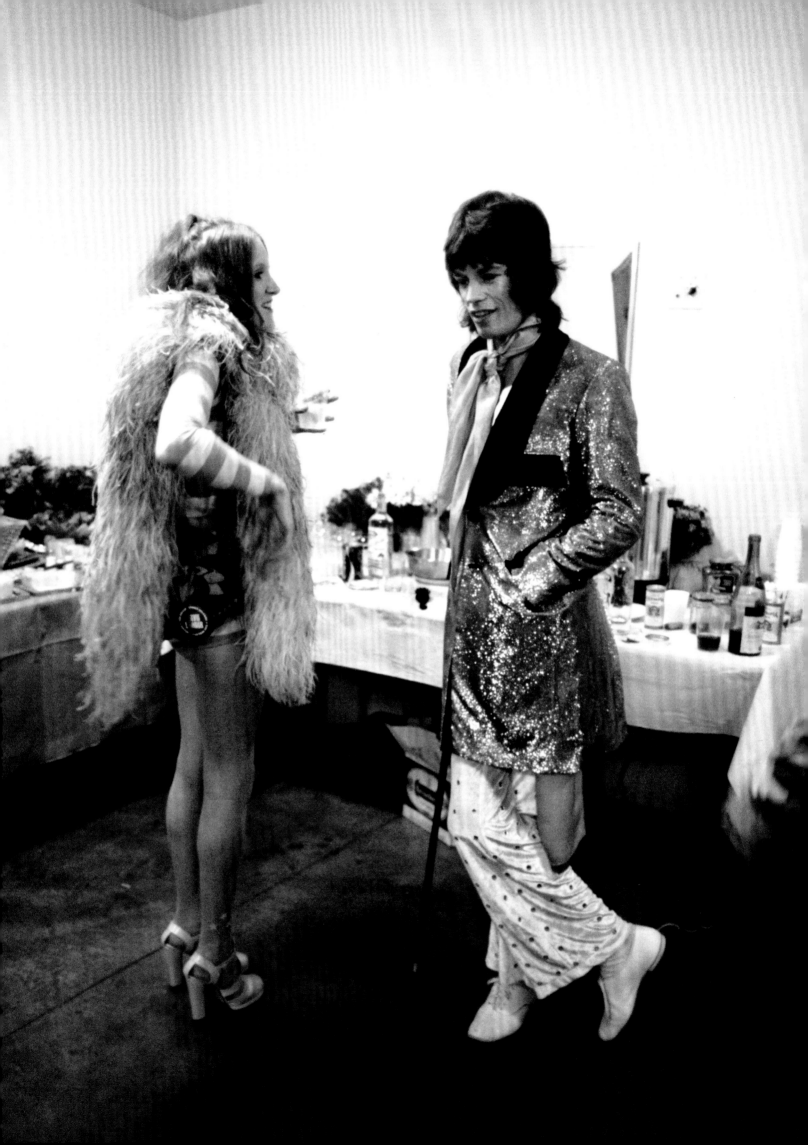

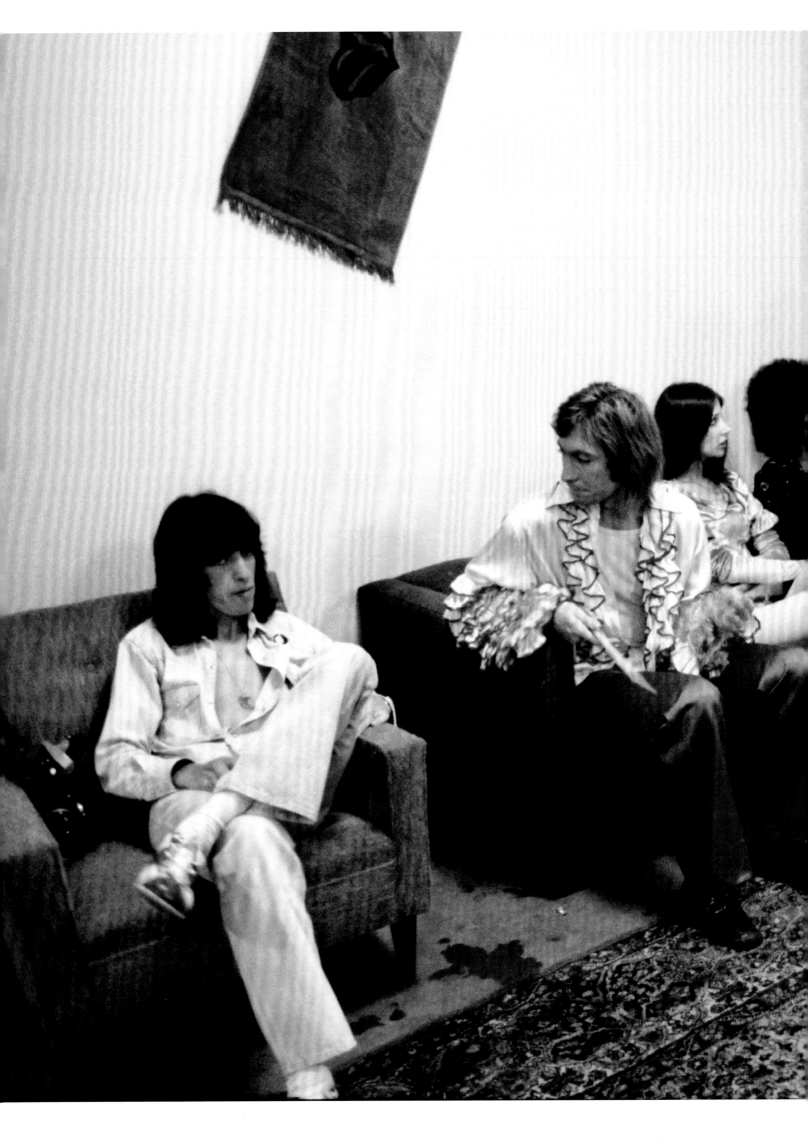

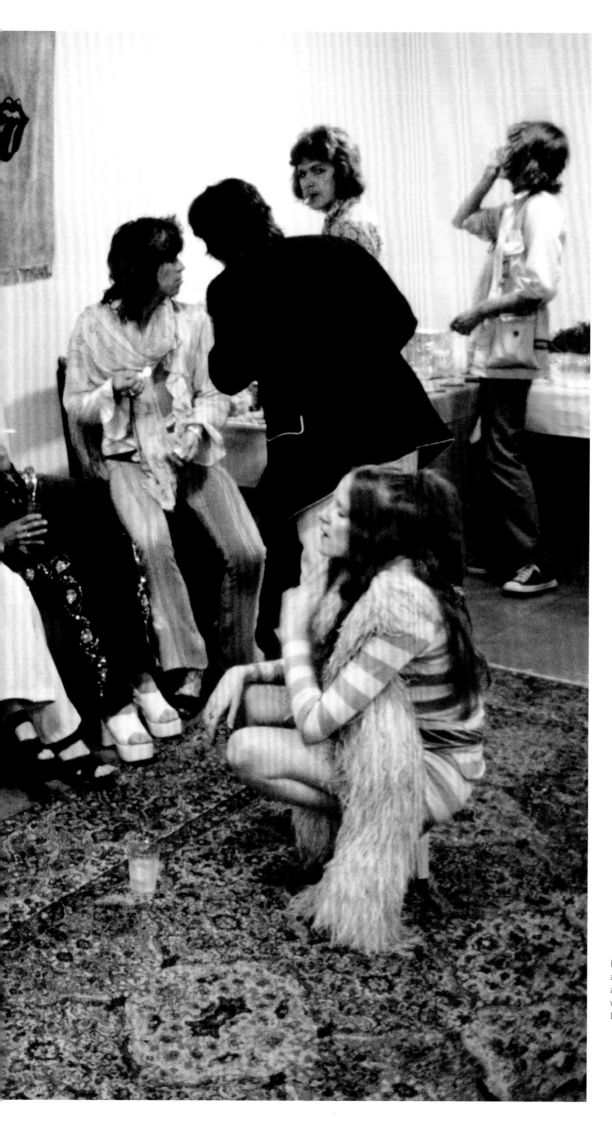

From left: Bill Wyman, Charlie Watts, a friend, Jolie Jones, Rose Taylor, and guitarists Richards and Taylor with others, backstage at the Forum, Los Angeles, California.

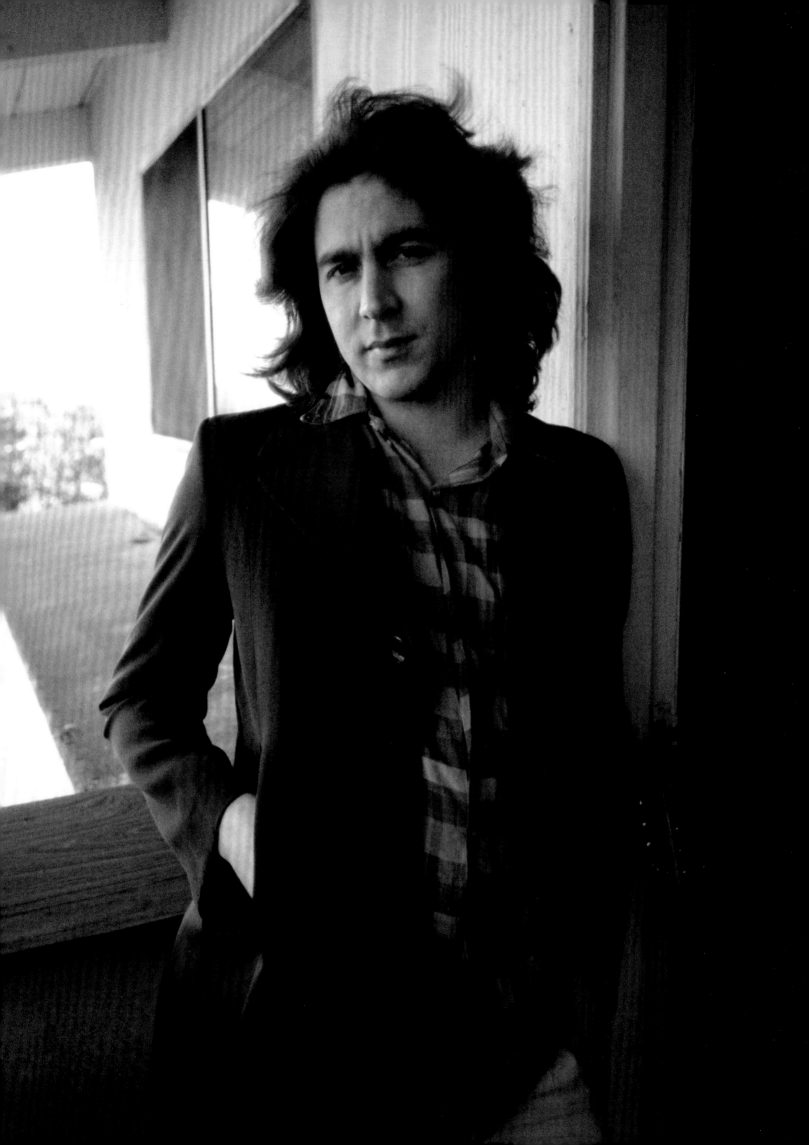

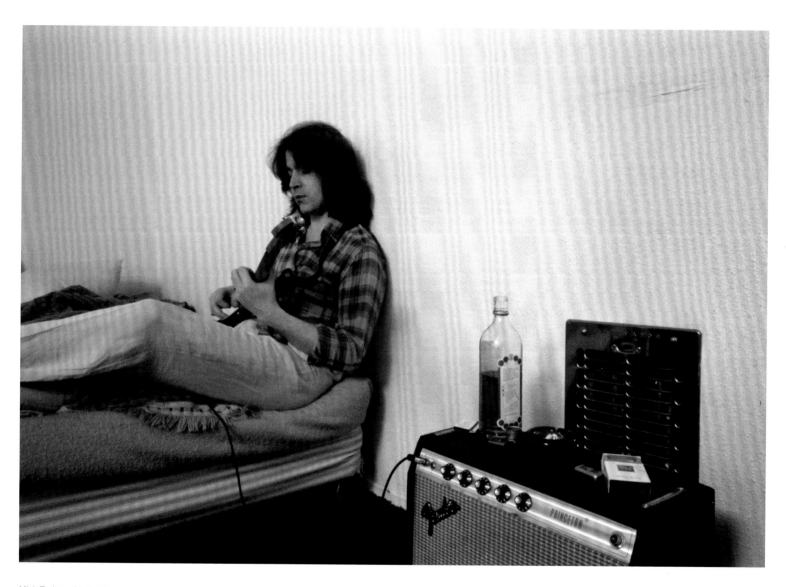
Mick Taylor at his hotel.

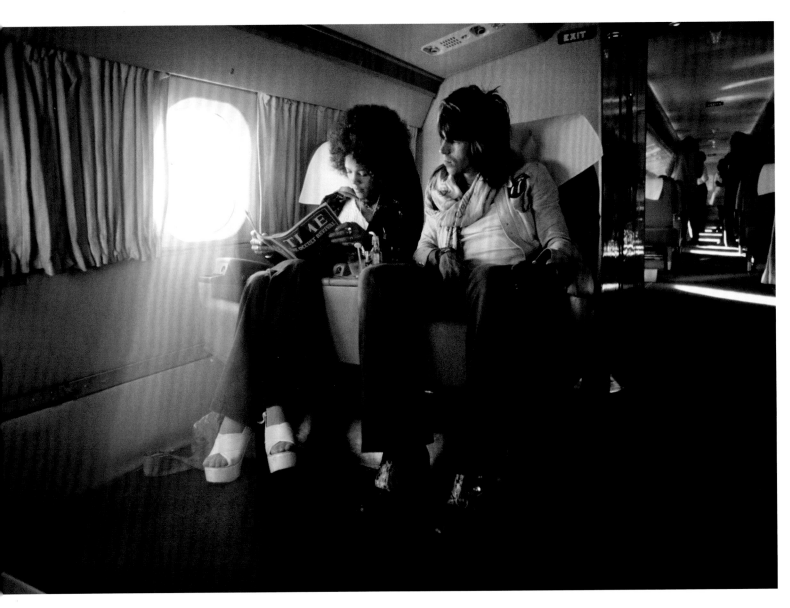

Jolie Jones and Keith Richards on the plane back to Los Angeles.

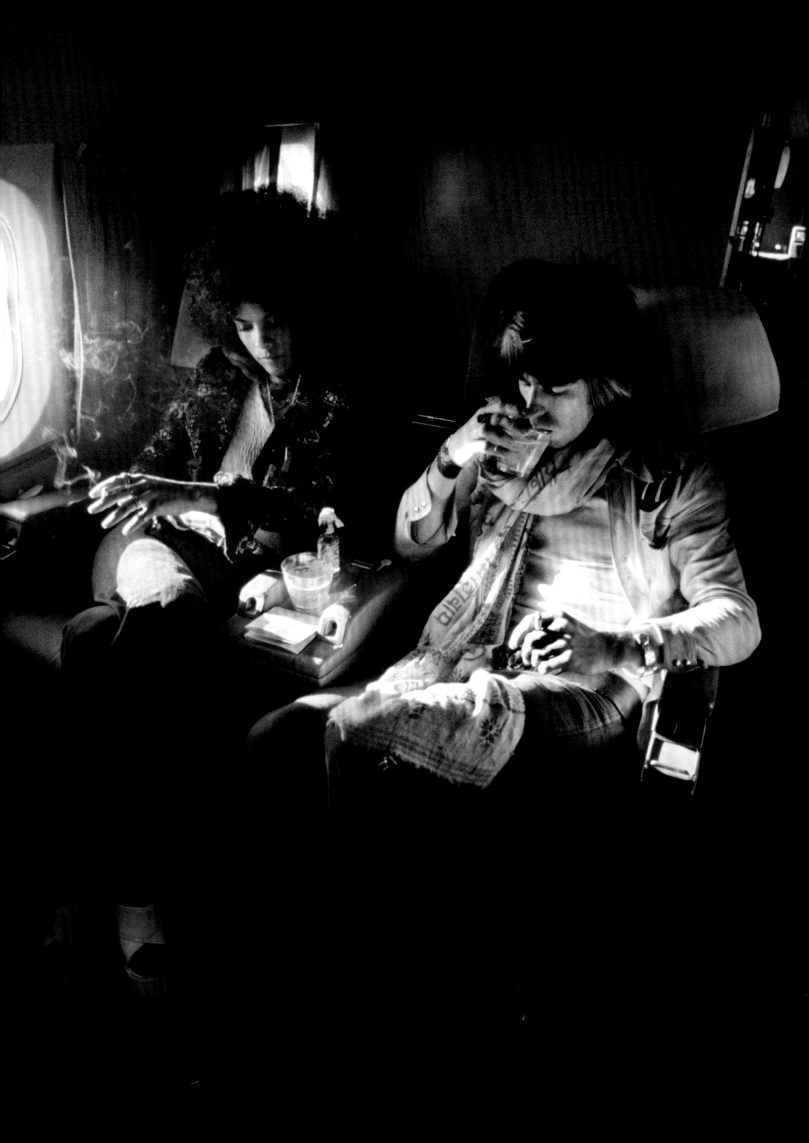

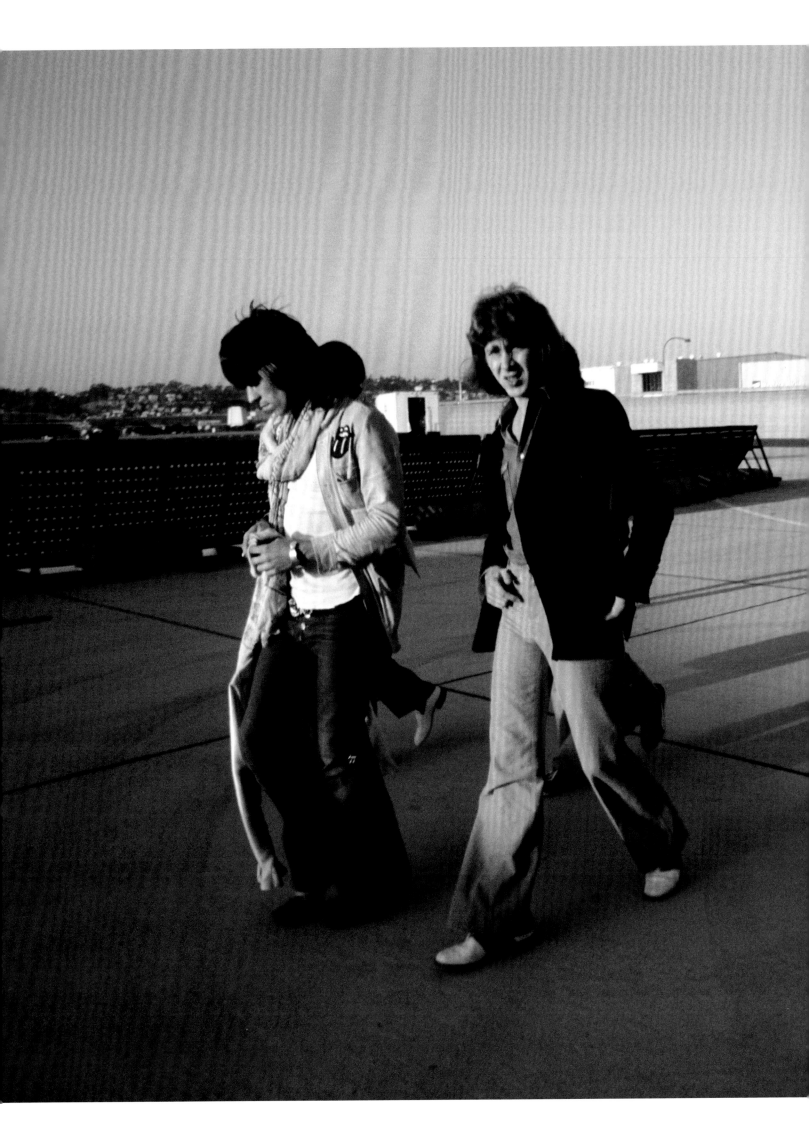

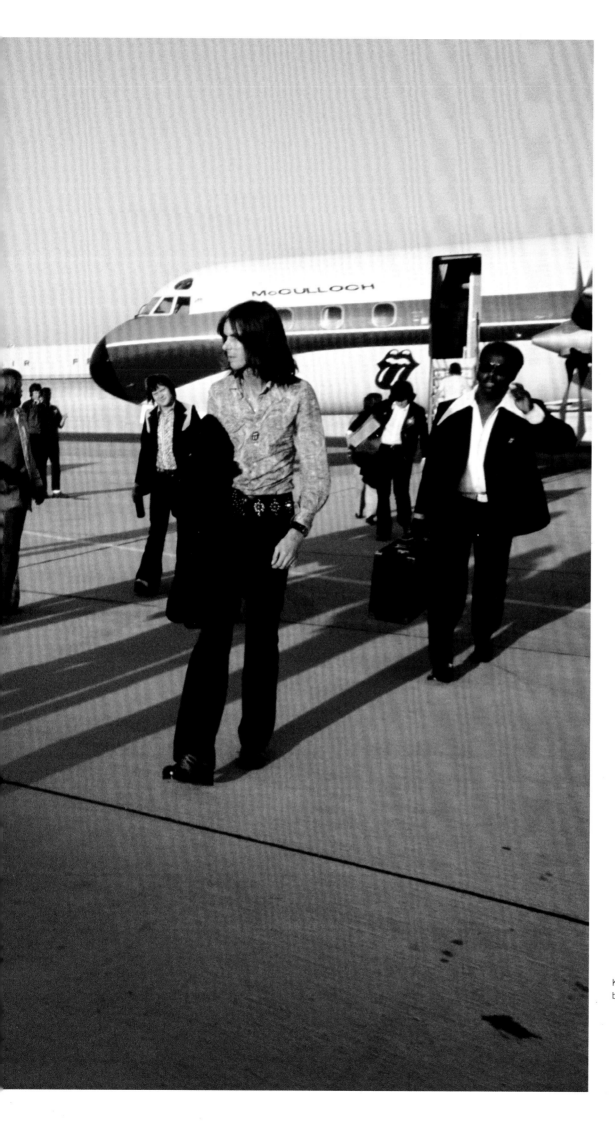

Keith Richards and Mick Taylor, trailed by Stones sideman Nicky Hopkins.

# THE INVISIBLE MAN

As humans, we pine for technology and speed to give us the advantage over the common man. Faster is better and all that . . . Sometimes the idea is better than the outcome.

I sometimes wish life moved slower so we could totally grasp the moment like a photograph. I've been asked, "If you could be a superhero, who would you choose to be?" Well, the Invisible Man, of course, so I could be a fly on the wall like the late, great Jim Marshall.

Jim didn't need banks of lighting, hair, makeup, and the other fluff. It was all in the simplicity of the tool he held in his hand, a Leica camera. He was the glue to the magic. Only the Invisible Man could achieve this.

The Rolling Stones. Gods of rock and roll. The riffs cut you like a box cutter as your heart exploded with their sexual rebellion. Potent like battery acid. Who were these musicians? I mean really, *Who are they?*

I found out two ways: through the lens of Jim's camera and from hours of listening to vinyl. I've never seen a photographer capture honesty the way Jim did. The Stones were shrouded in mystery and so be it. Thank God for Jim hitting the road with them in 1972, because it felt like they had their skin peeled away, exposing a layer so raw it still bleeds. That's called truth . . .

Syrup is thick on the tongue (like those vagabond lyrics on "Torn and Frayed") and hits you across the back of your head like a freight train. (Consider that drug-infused riff in "Tumbling Dice.") That mad-scientist documentarian hiding in the shadow? Well, that's Jim of course.

Jim Marshall's lifelong fascination with the camera ended up taking our collective breath away because we got to see what he really saw—not what the media showed, not what the record company needed, and not even what the band intended you to see—*raw power.*

Decadence wrapped up in great musicianship and edgy, honest songwriting. How do you capture that? I think it's twofold: the Rolling Stones having trust in the photographer and the photographer's killer instinct.

As a photographer whose number-one love is documenting life as it happens around me, I've learned two things: Let it unfold naturally, and always have your camera on hand or nearby. In Jim's case, that camera was his Leica. It speaks worlds that Jim Marshall was offered $25,000 in 1973 for that same camera.

His work will live on in our souls and imaginations forever. I wish I had been there for Hendrix at Woodstock, Johnny Cash in San Quentin, Neil Young, Bob Dylan, the Who, Led Zeppelin, the Beatles, and the list goes on. But I feel like I was, because Jim was.

So we live through Jim's photos and joyfully will for decades to come. Here's to Jim Marshall, Leica cameras, and a double shot of Jack Daniel's with Keith and Mick.

*Nikki Sixx*
2021

# PERFORMANCES

Beneath a banner of the band's new tongue-and-lips trademark, the Stones typically opened with "Brown Sugar," followed by a rousing "Bitch," a two-piece horn section lighting a fire under the loud, rocking band, or "Rocks Off," from *Exile*. The introduction to "Gimme Shelter" featured a cascading tangle of guitars from Keith Richards and Mick Taylor, over which pianist Nicky Hopkins dropped some nicely dissonant chords. Keith Richards's vocal number, "Happy," and "Tumblin' Dice" gave way to the set's first blues, "Love in Vain," with Taylor and Richards both playing lengthy solos.

By the time the band was done with "Sweet Virginia," Jagger blasted a harmonica solo, and the horn players joined back in. Lead guitarist Taylor took a star turn on a towering "You Can't Always Get What You Want," followed by another new rocker, "All Down the Line." The Chuck Berry guitar licks that announce "Bye Bye Johnny" signaled that they were headed toward a rock-and-roll finish. "Rip This Joint" was the most raucous track from the new album. The cacophonous "Street Fighting Man" brought it all to a close. —JS

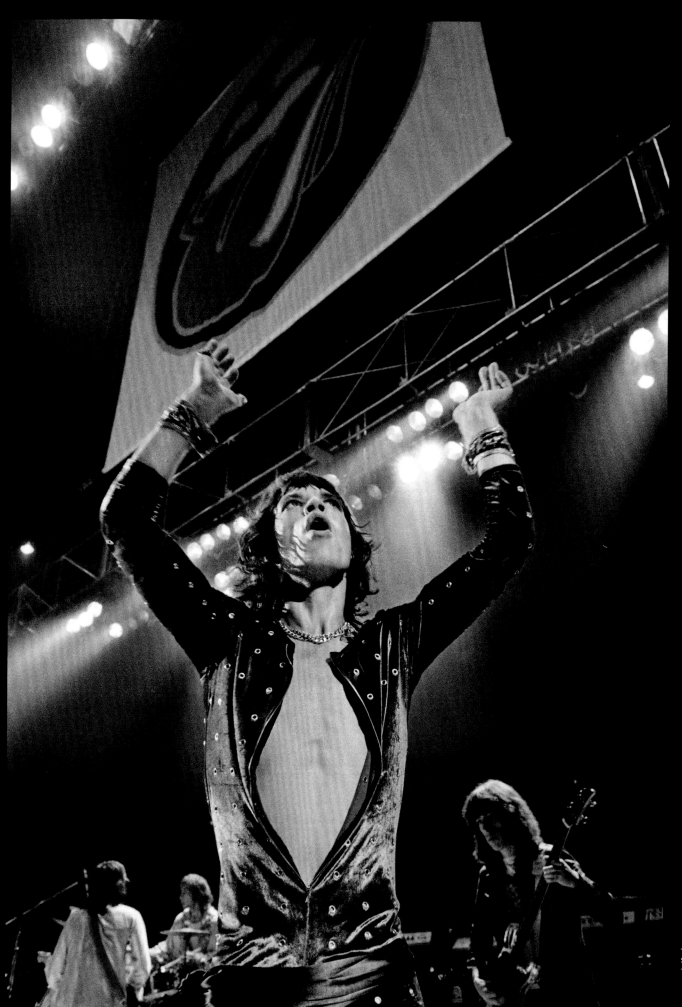

Jagger on-
stage, "Honky
Tonk Women."

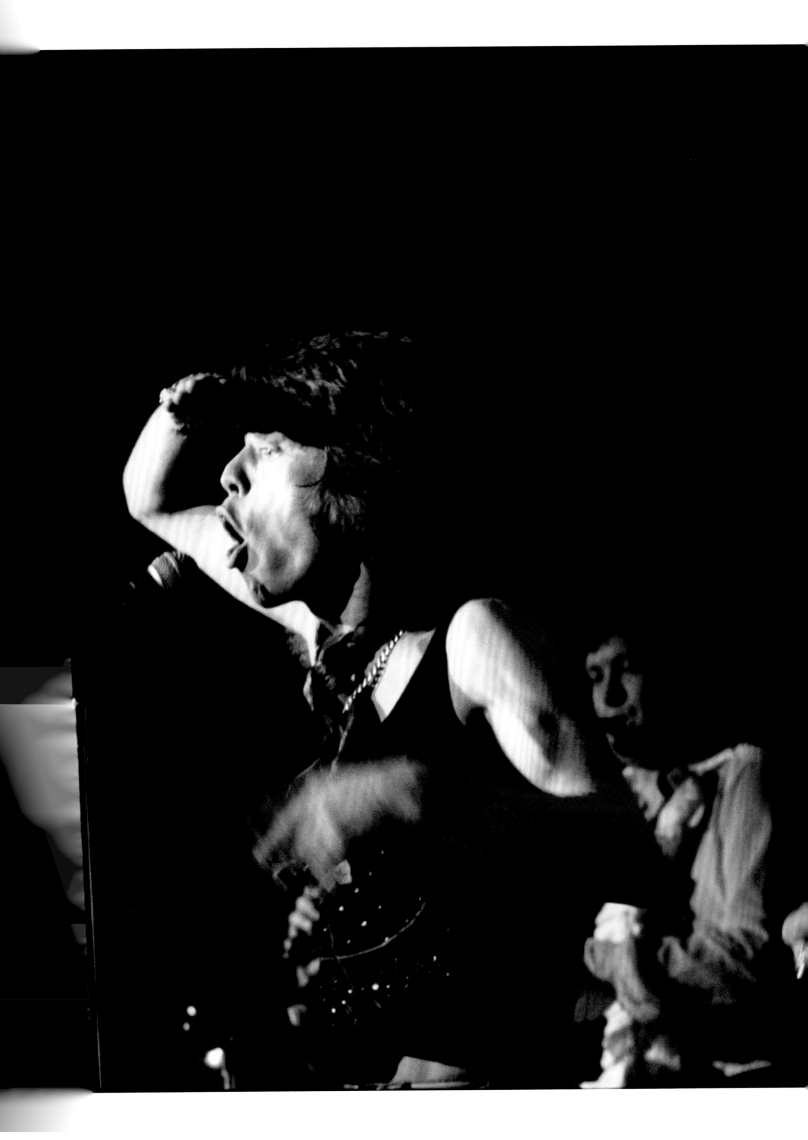

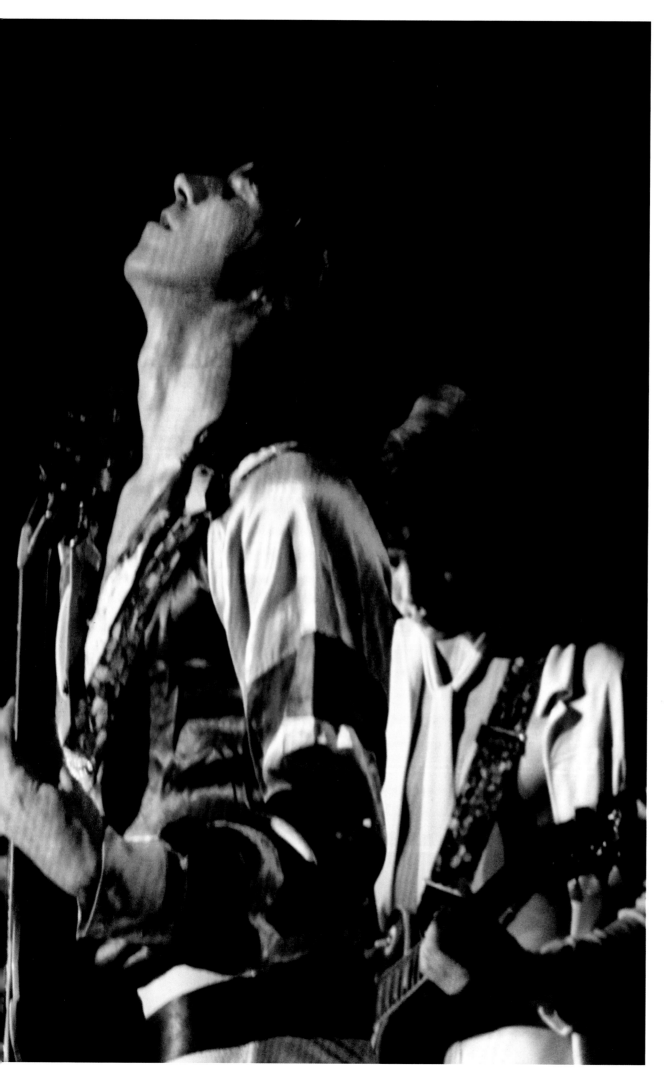

Jagger, saxophonist
Bobby Keys, Richards,
and Taylor.

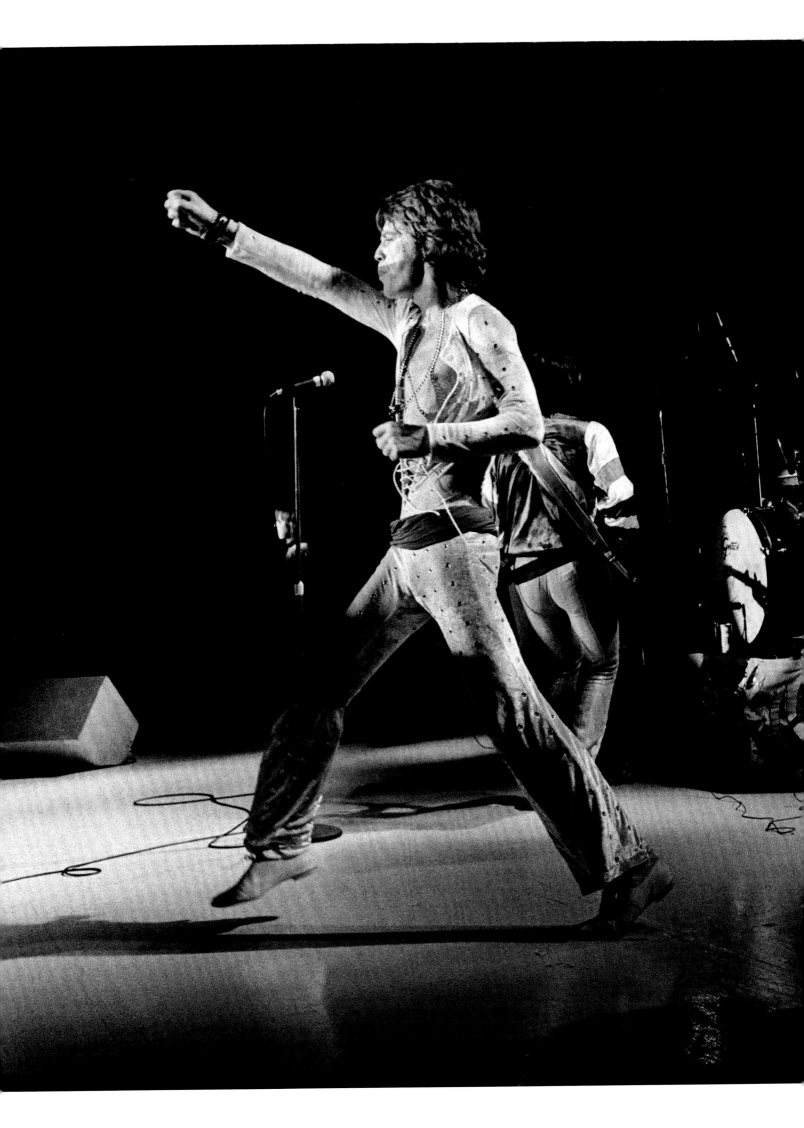

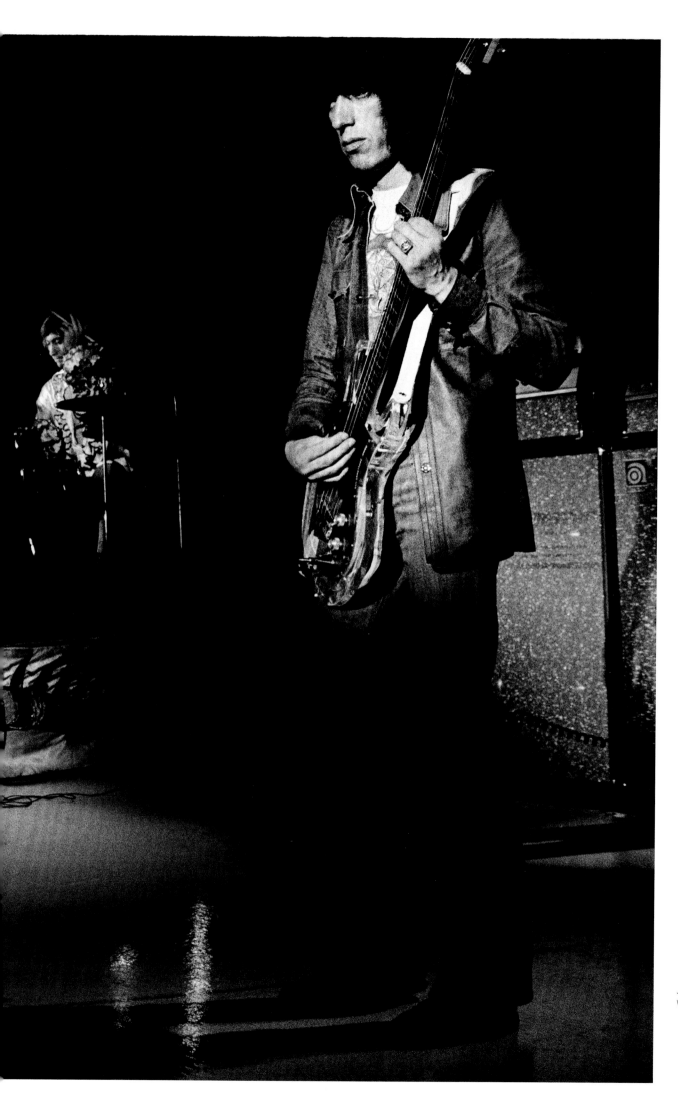

Jagger, Richards,
Watts, and Wyman.

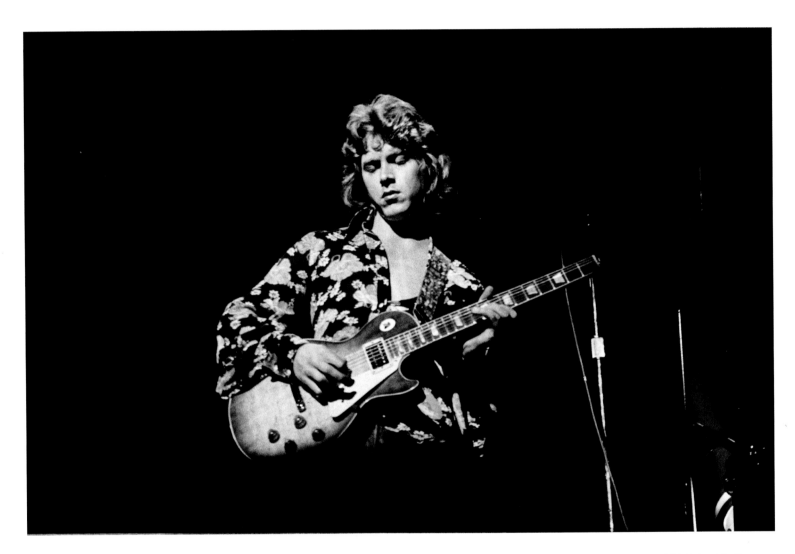

Mick Taylor at the Forum,
Los Angeles, California.

> Jagger and Richards.

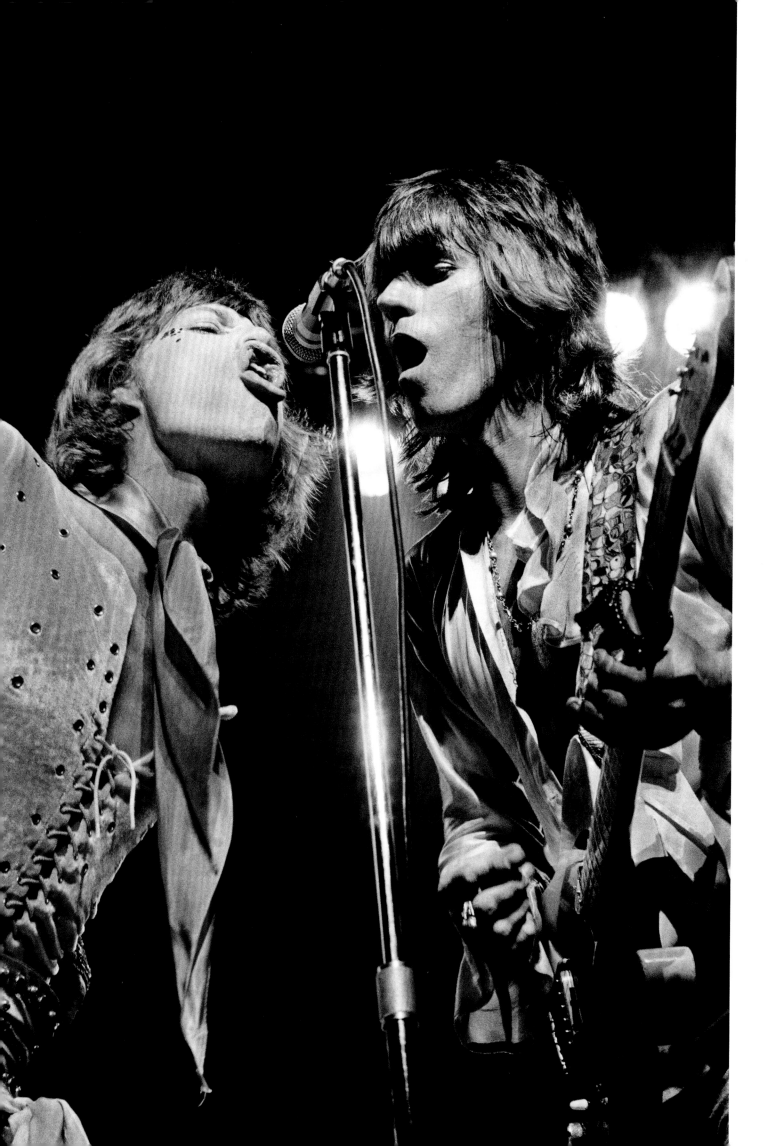

Watts and Richards,
acoustic segment
of "Sweet Virginia."

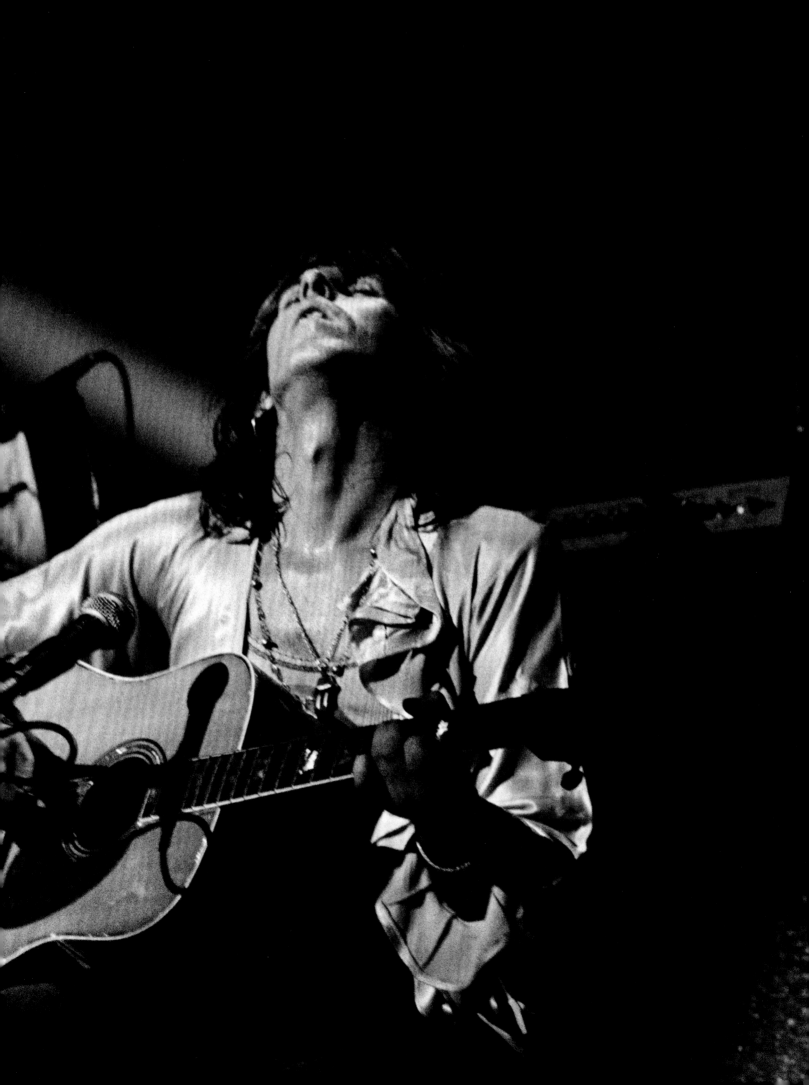

Jagger performing "Midnight Rambler" at
the Winterland, San Francisco, California.

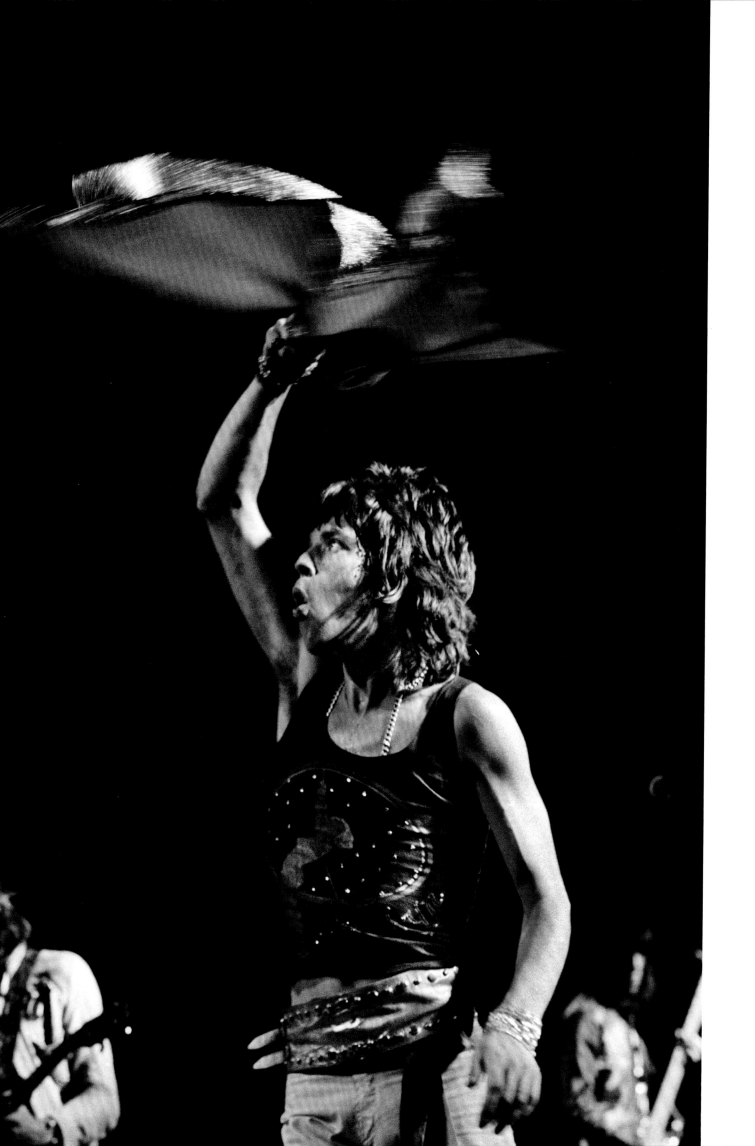

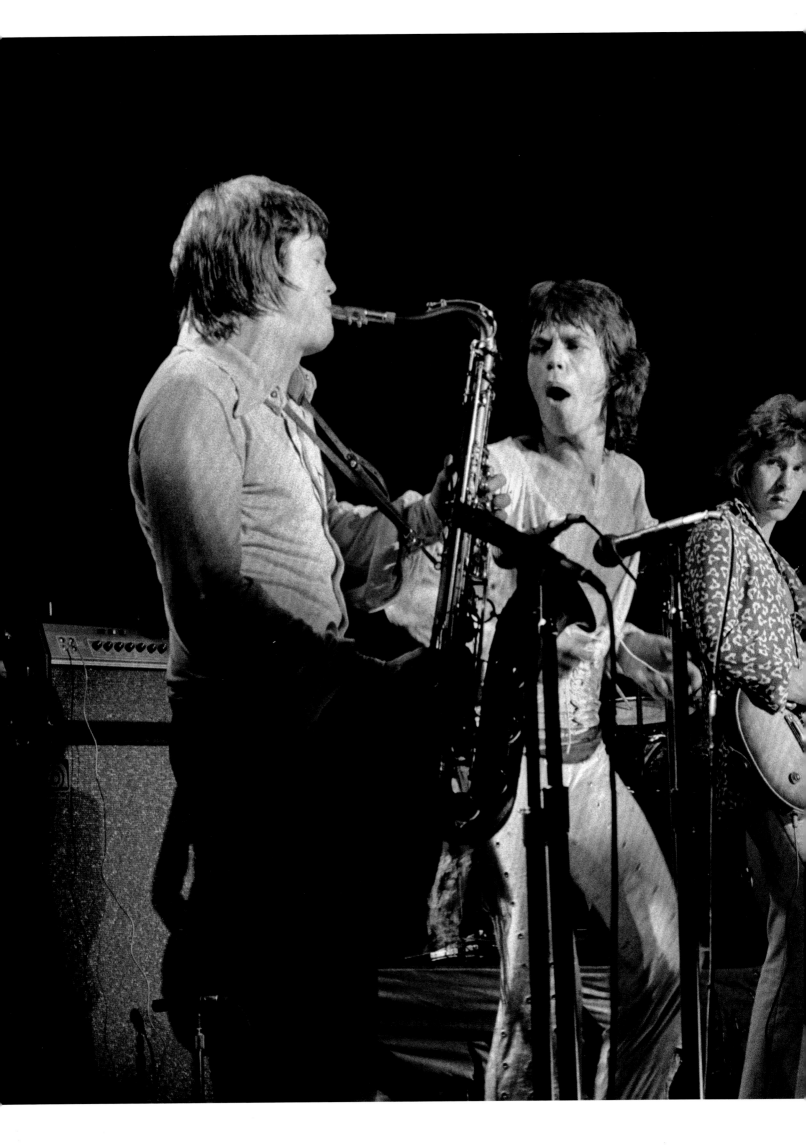

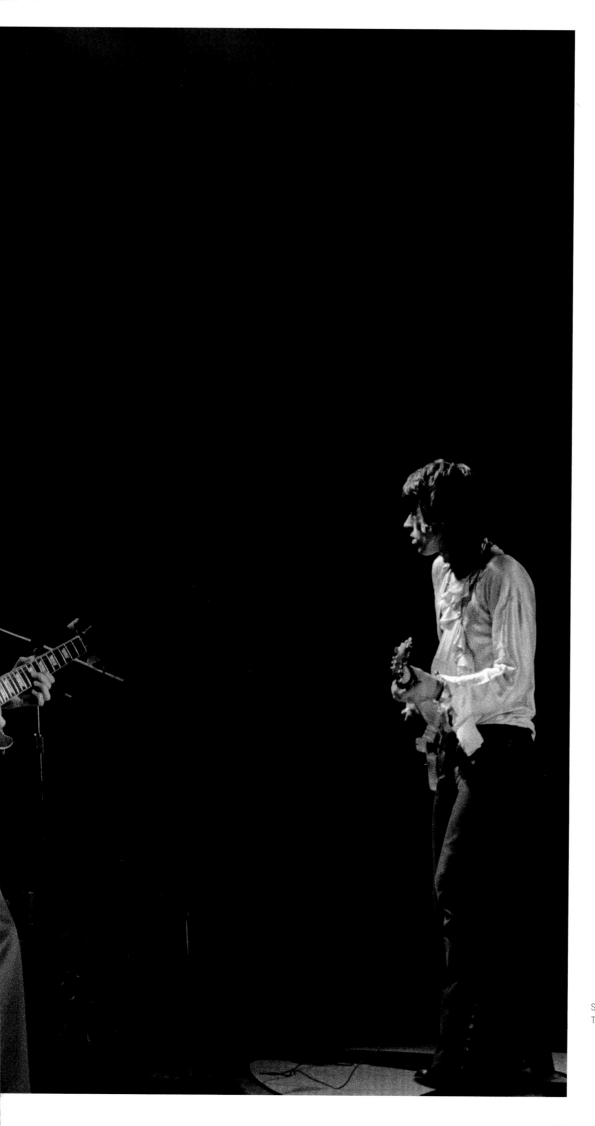

Saxophonist Bobby Keys, with Jagger, Taylor, and Richards on "Brown Sugar."

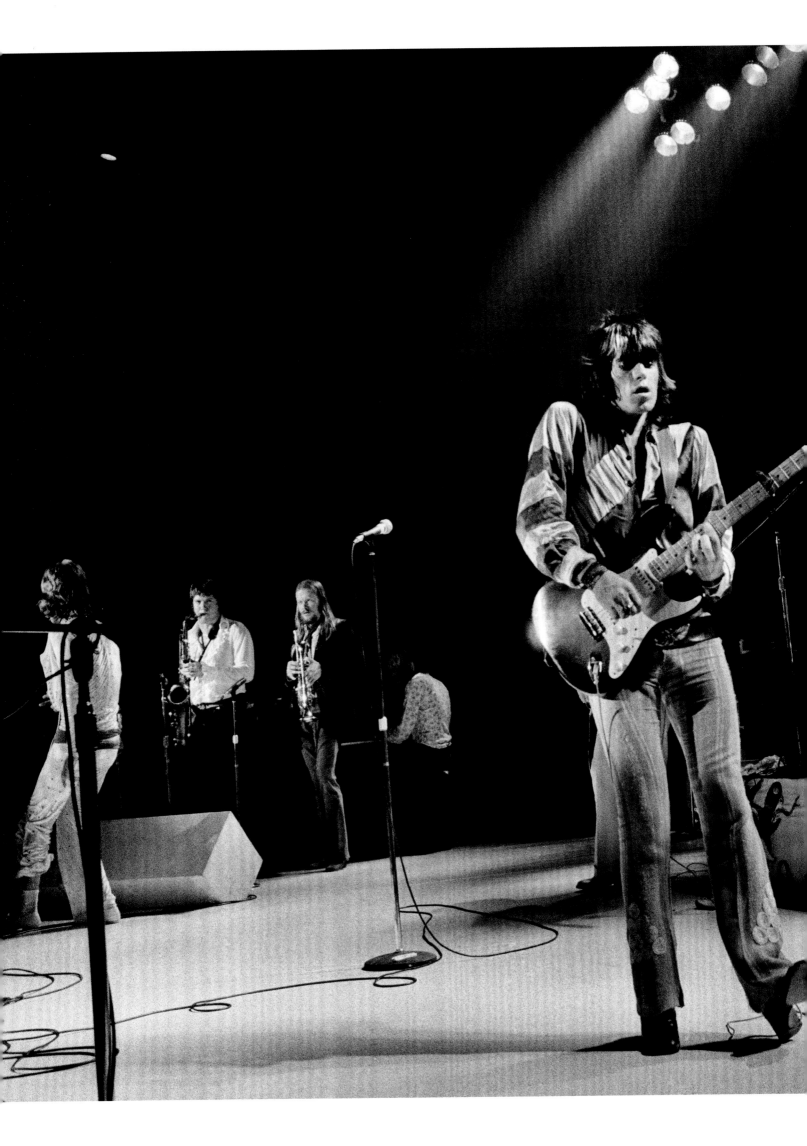

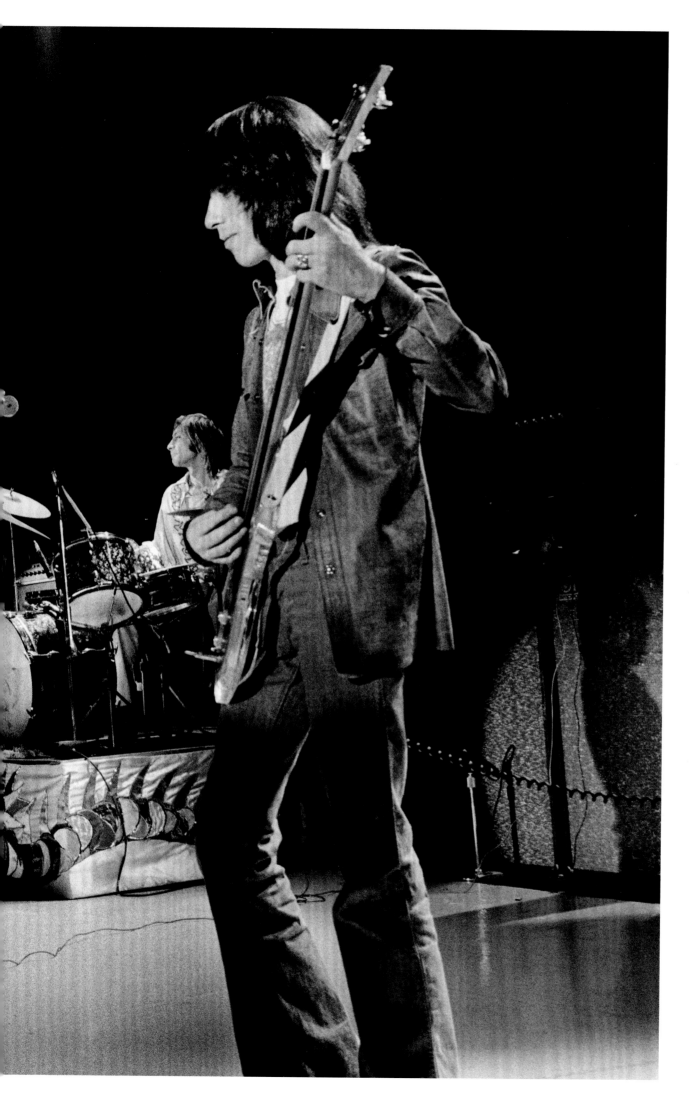

From left: Jagger,
Bobby Keys on
saxophone, Jim
Price on trumpet,
and Nicky Hopkins
on piano; Richards,
Watts, and Wyman
hold the foreground.

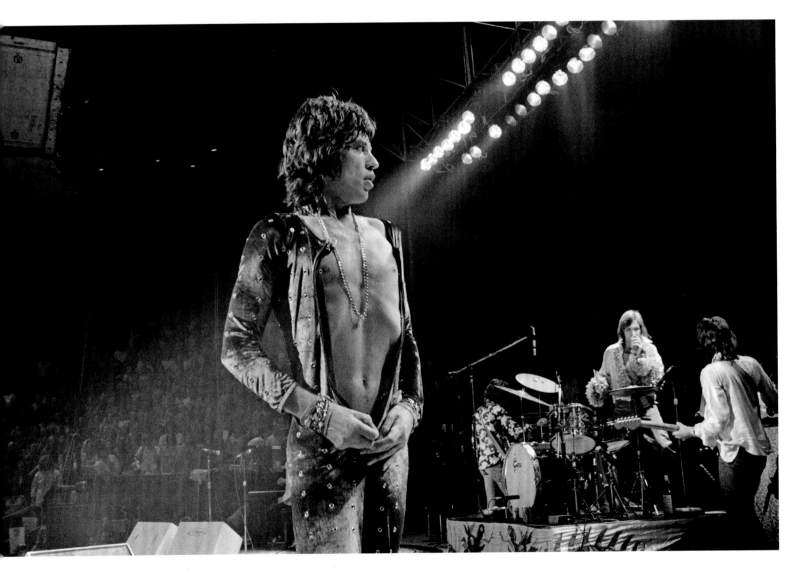

Jagger, Watts, and Richards onstage.

> Bill Wyman.

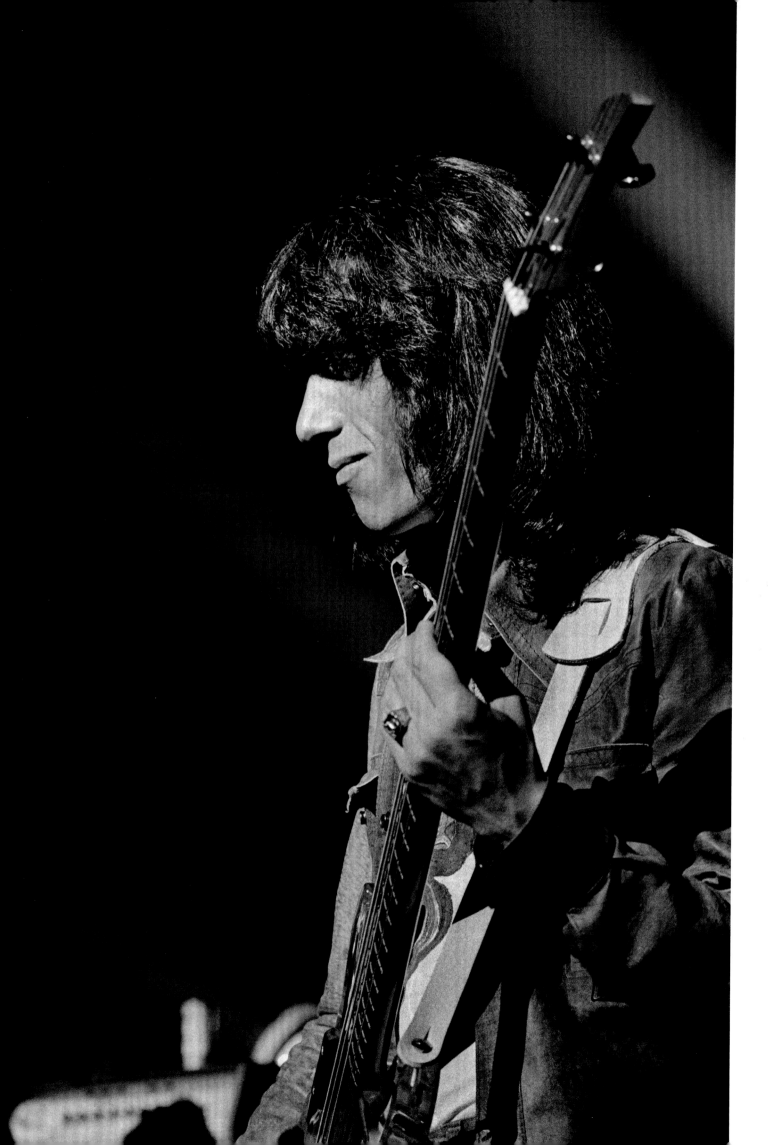

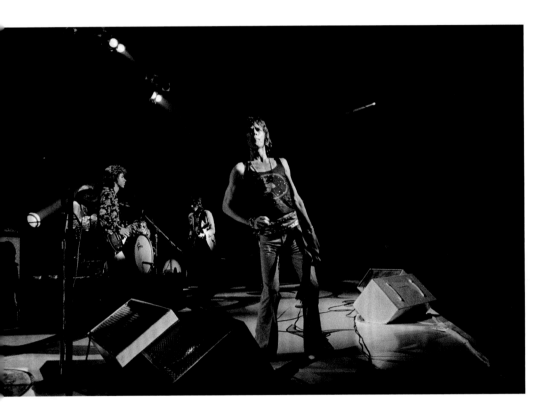
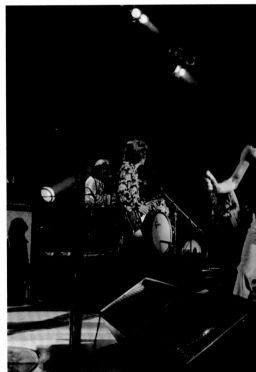

Jagger, Taylor, Watts, and Richards at the
Winterland, San Francisco, California.

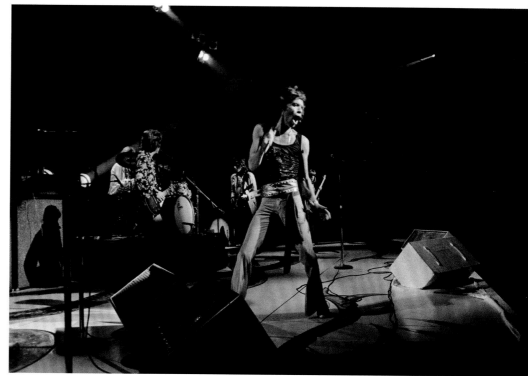

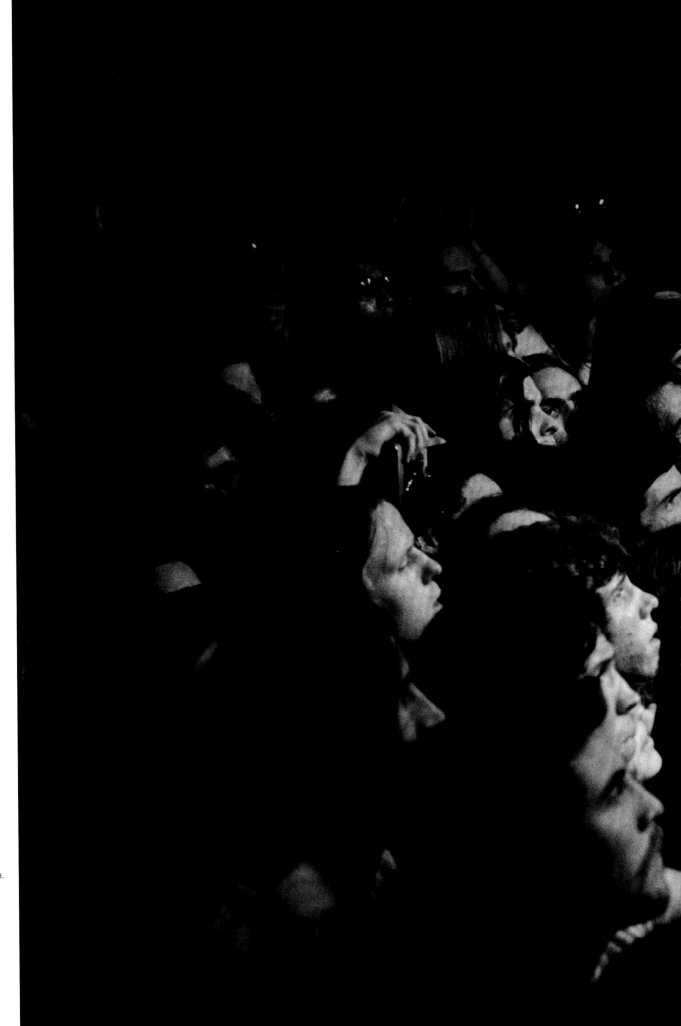

Fans at the Winterland,
San Francisco, California.
Jagger reportedly kept
press out of the first
twenty rows of any
concert, so he had
direct contact with the
energy of the crowd.

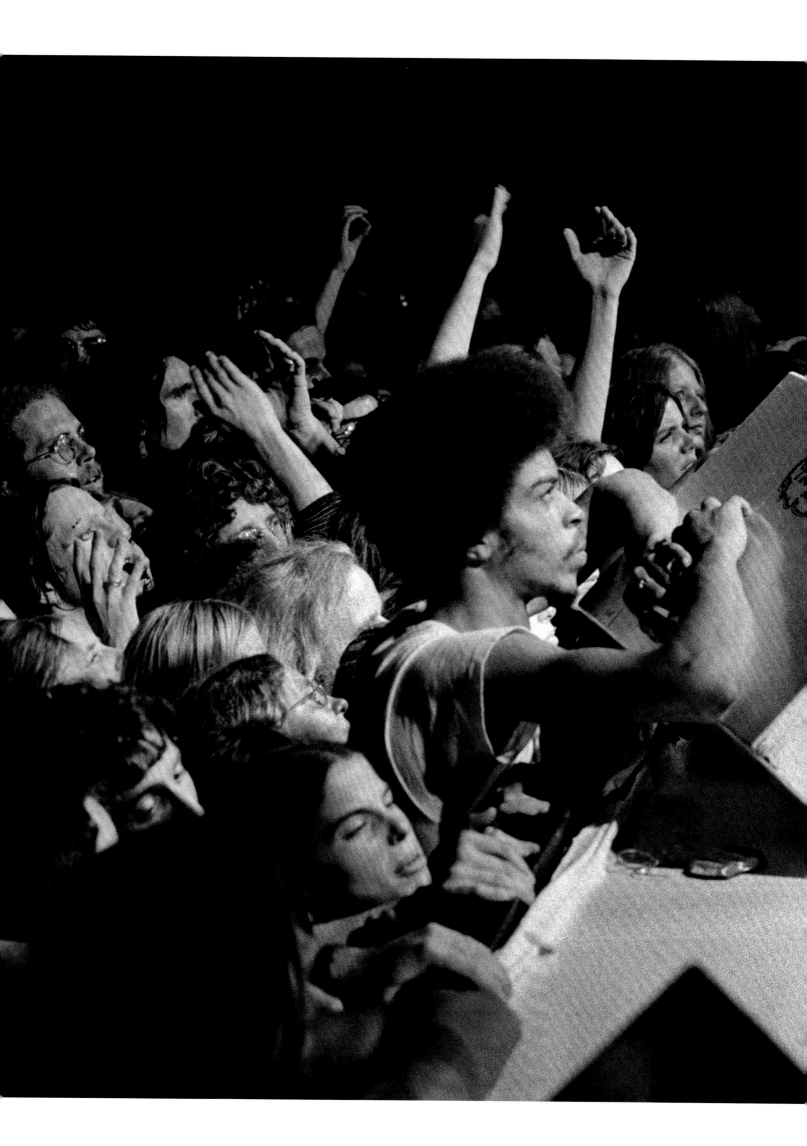

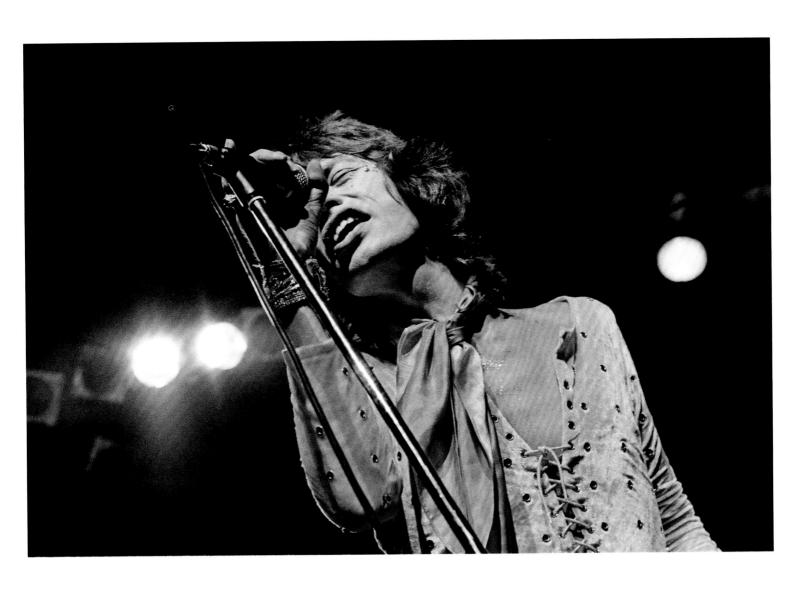

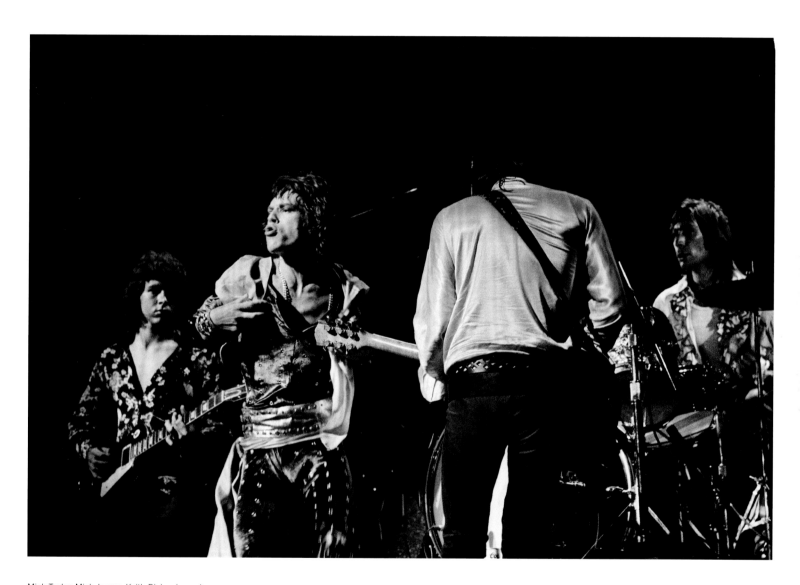

Mick Taylor, Mick Jagger, Keith Richards, and
Charlie Watts performing onstage.

< Mick Jagger singing onstage at the Forum,
Los Angeles, California.

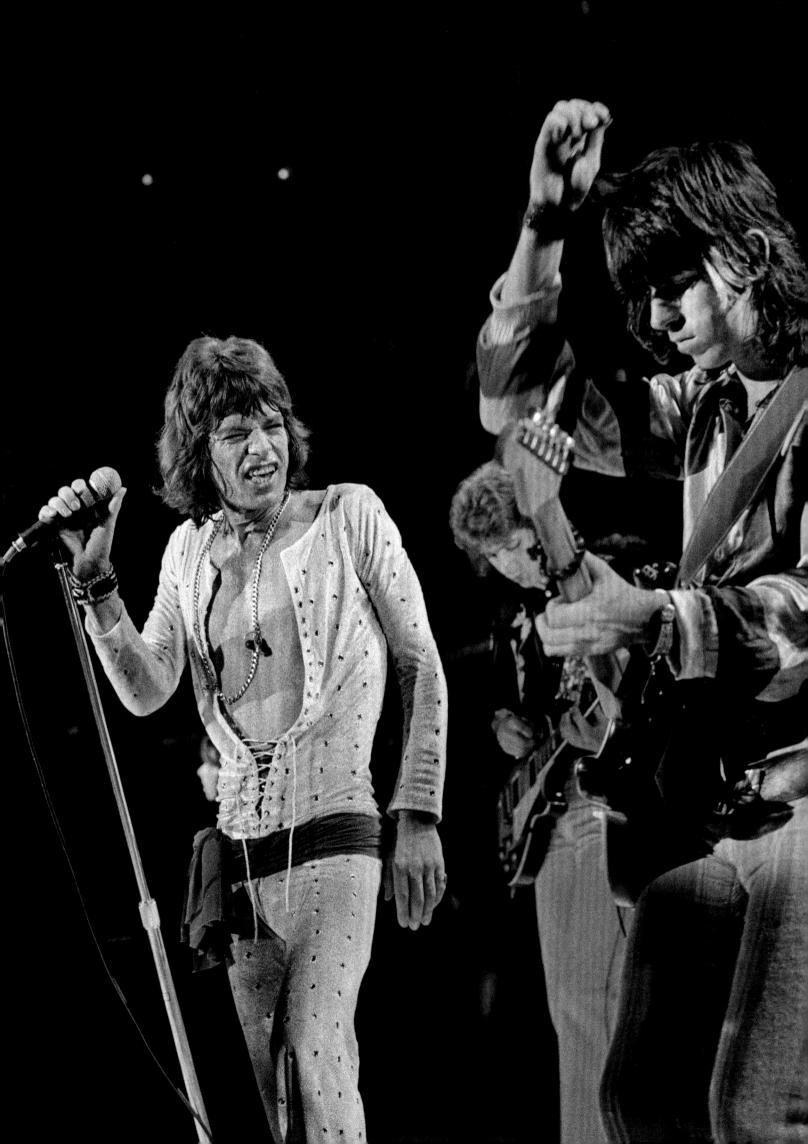

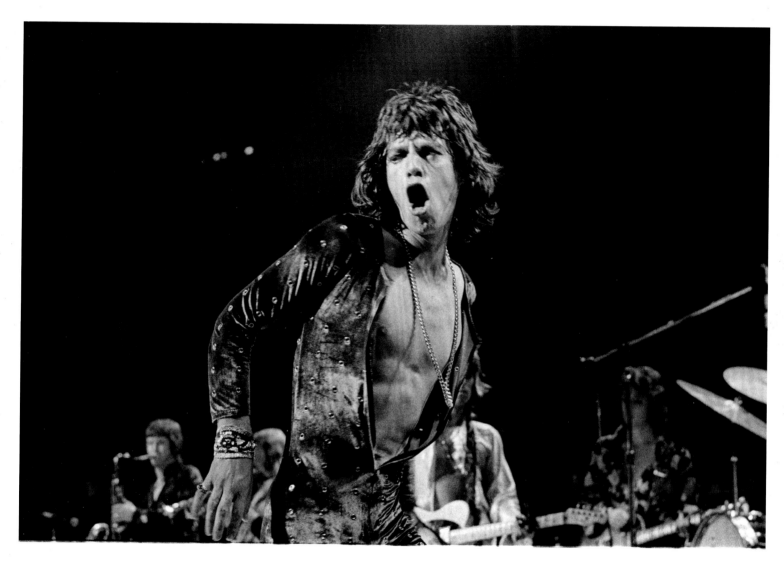

Mick Jagger onstage at Winterland,
San Francisco, California.

< Mick Jagger and Keith Richards with
Mick Taylor behind Jagger.

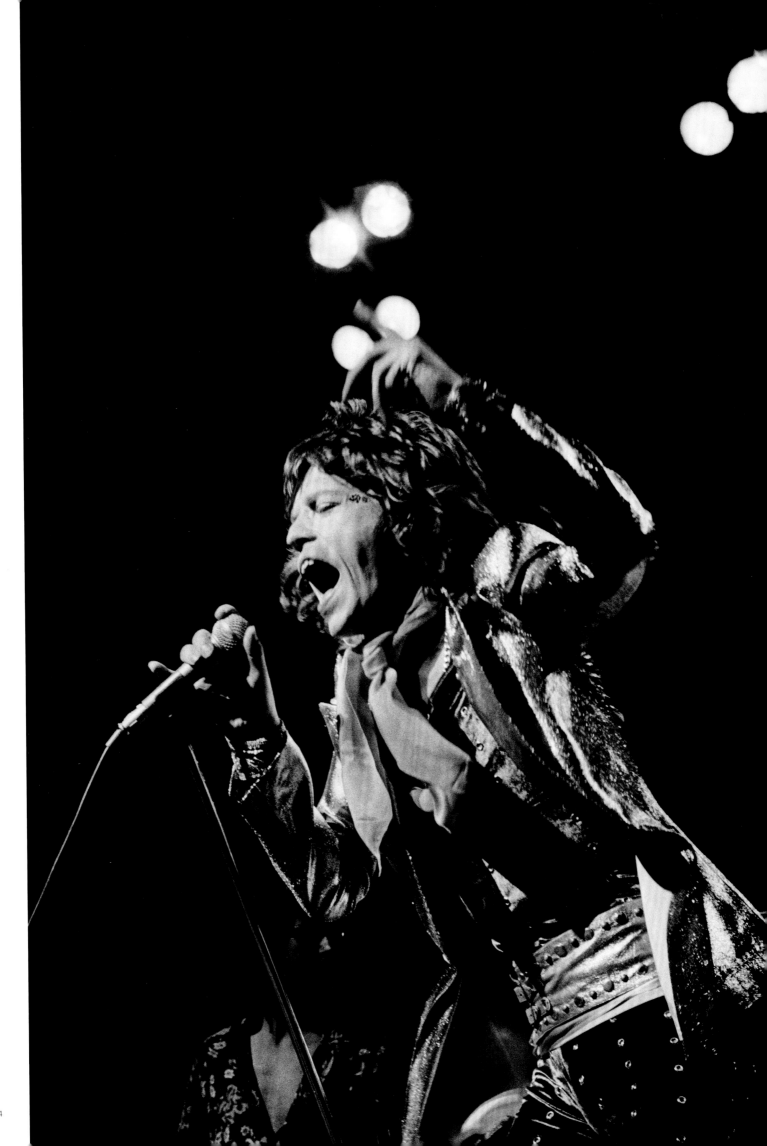

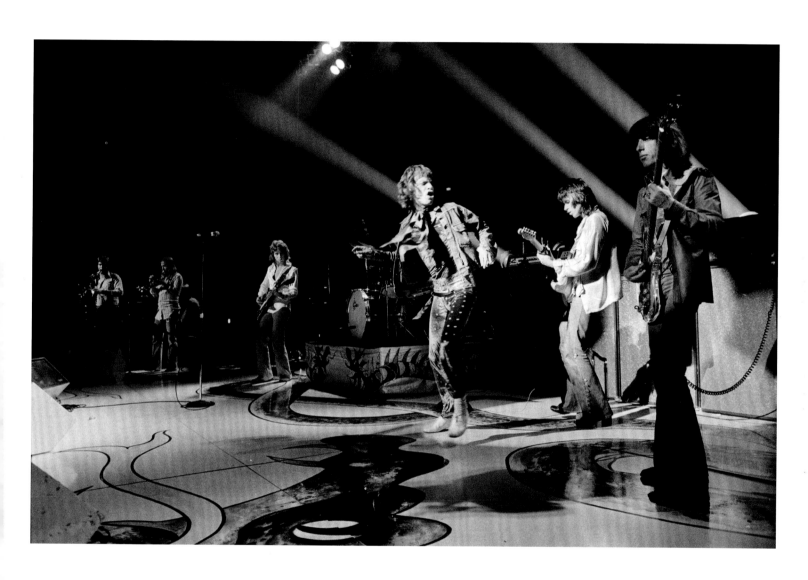

Mick Jagger onstage at Winterland,
San Francisco, California.

Jagger with Bobby Keys
in the background.

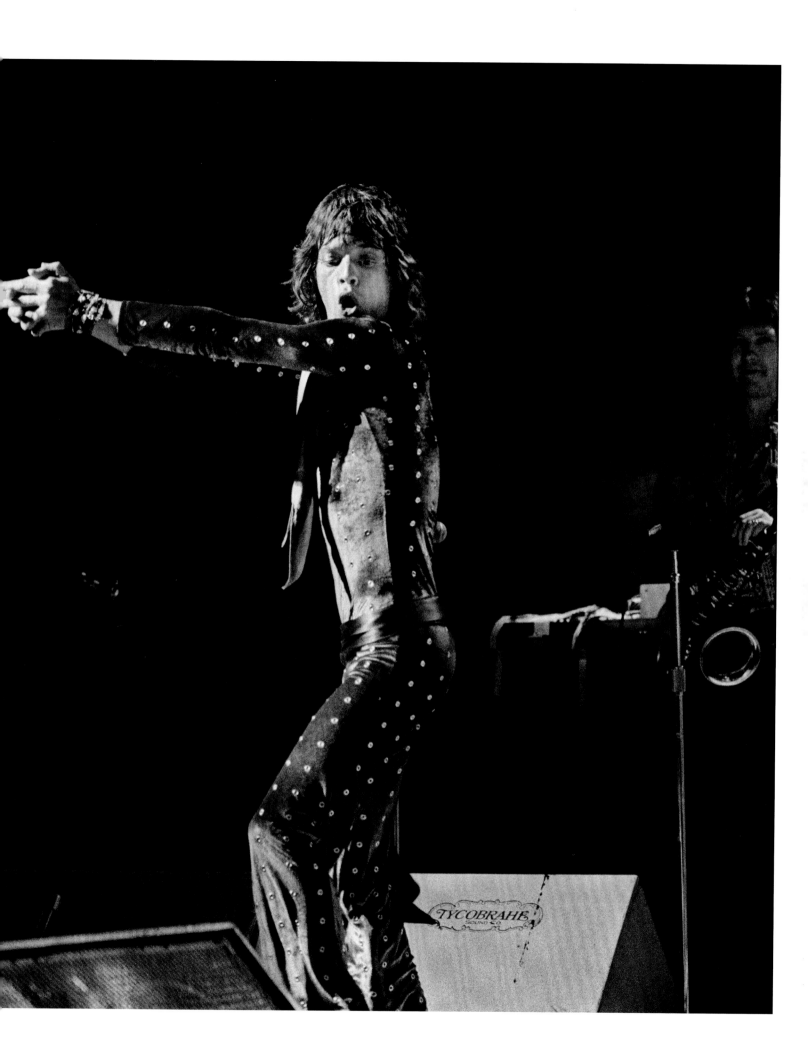

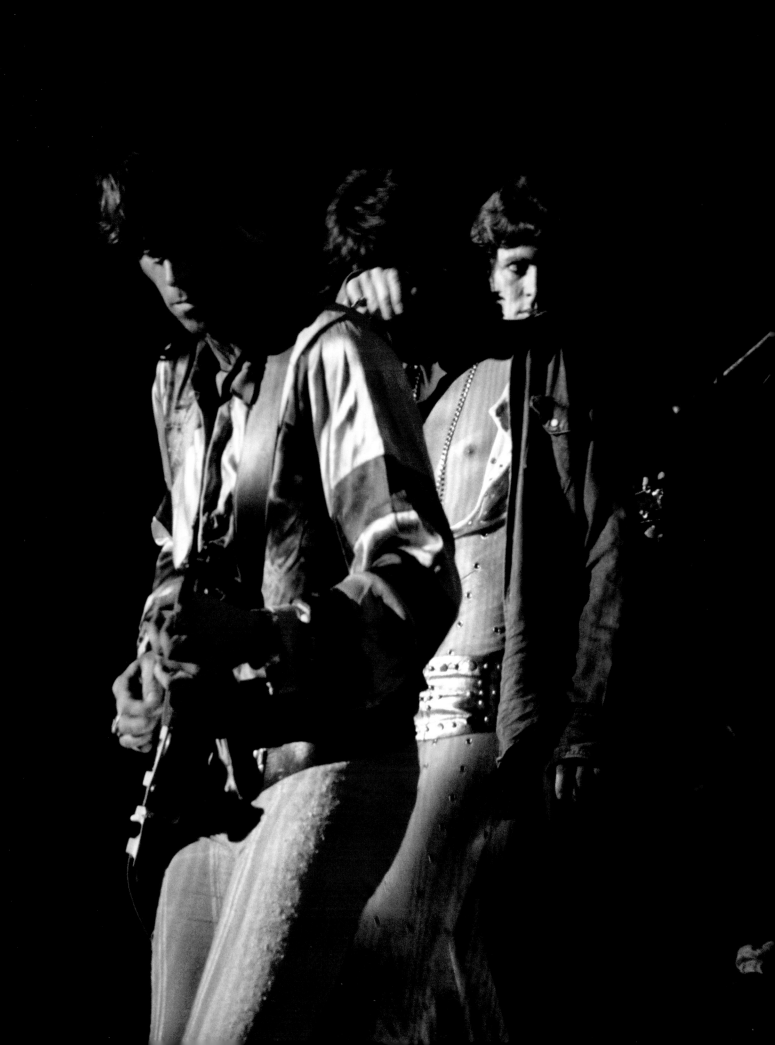

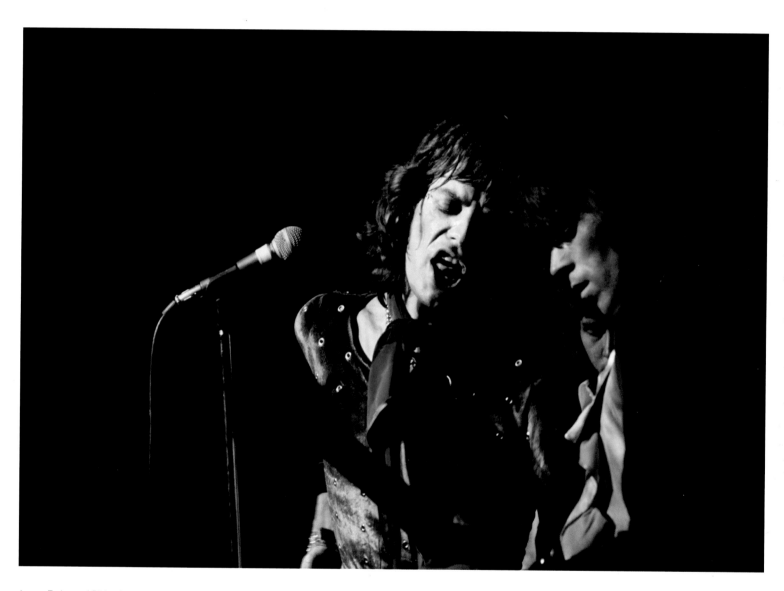

Jagger, Taylor, and Richards.

< Richards, Jagger, Taylor.

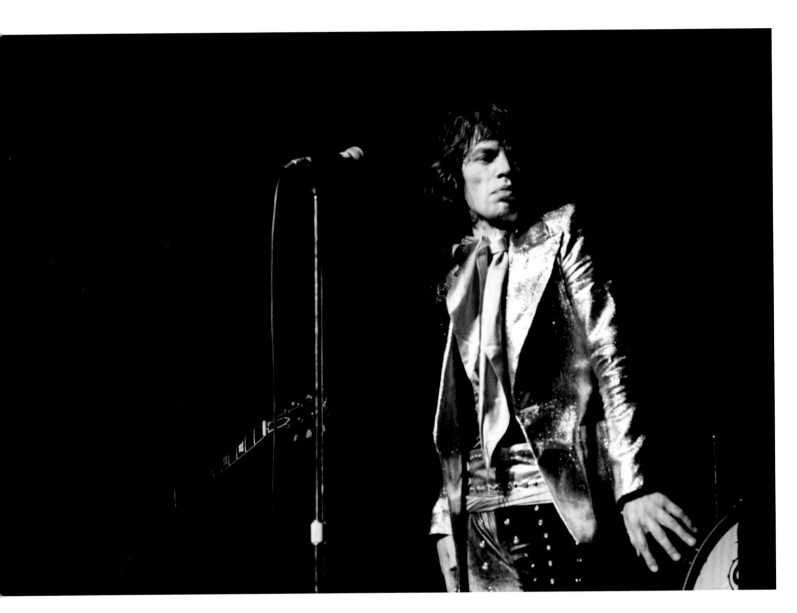

Taylor and Jagger at the Forum,
Los Angeles, California.

> Fans at the Hollywood Palladium,
Los Angeles, California.

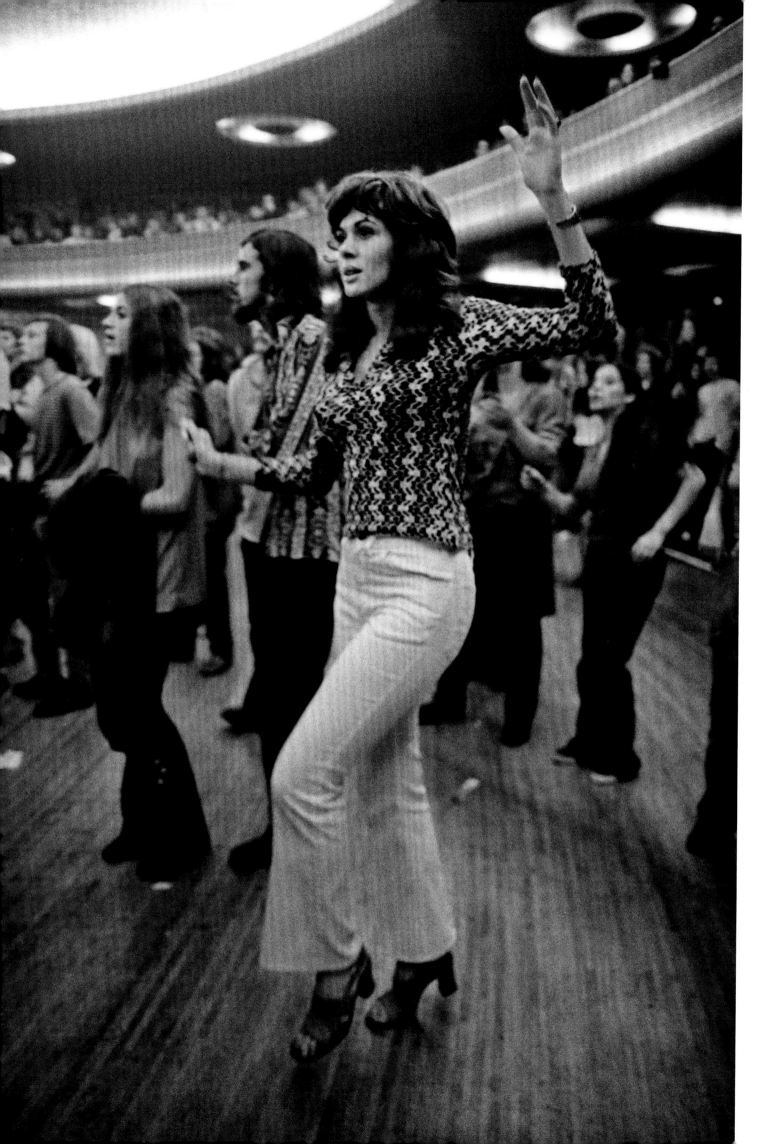

Jagger and Richards at the Forum,
Los Angeles, California.

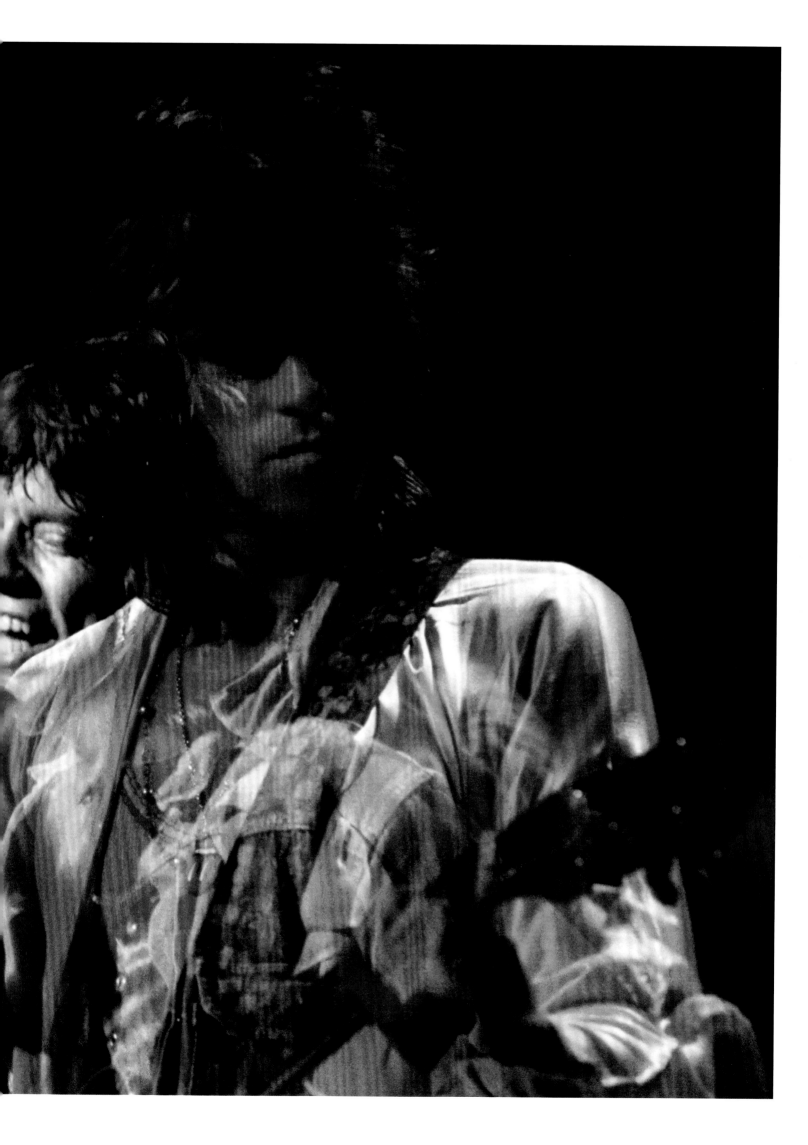

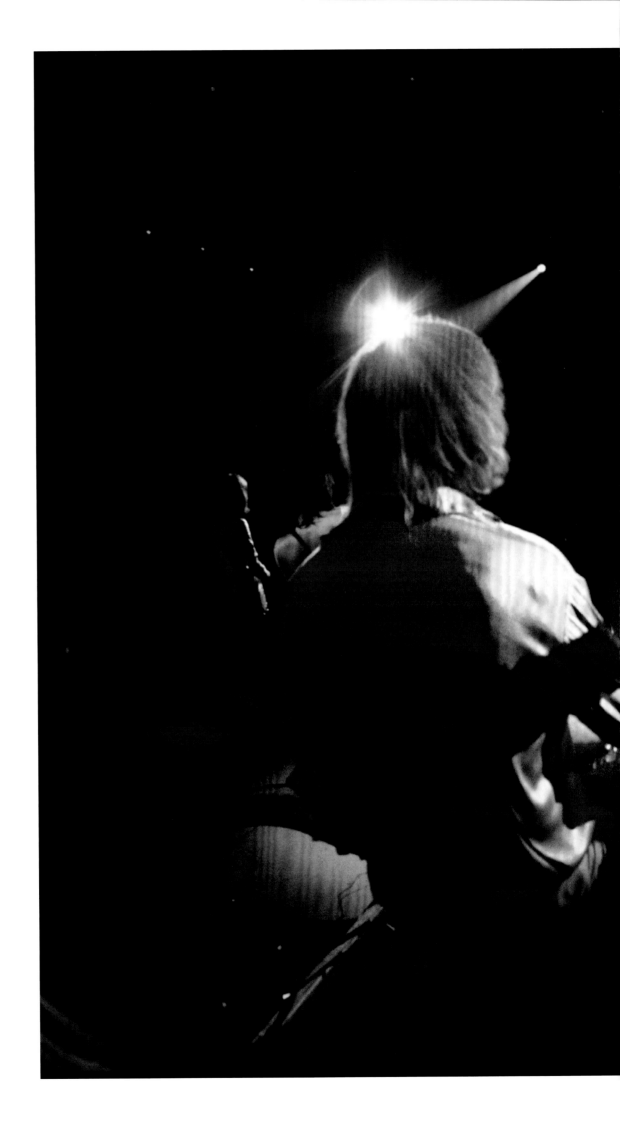

Charlie Watts at the Forum,
Los Angeles, California.

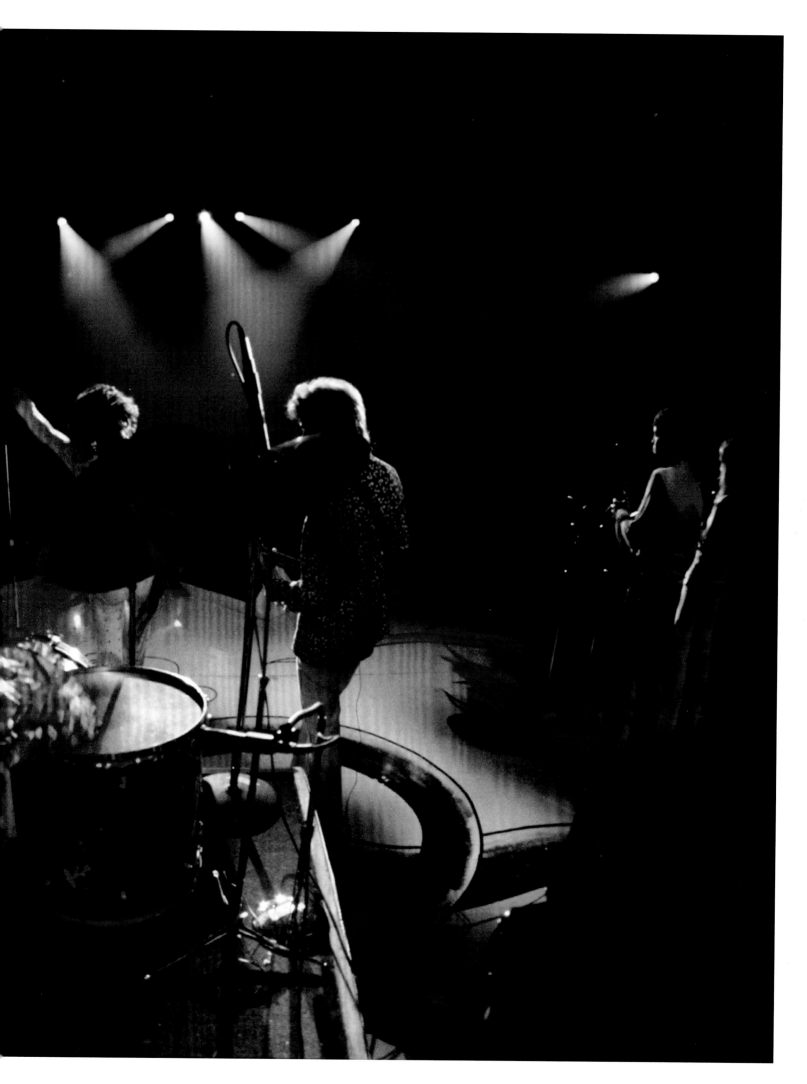

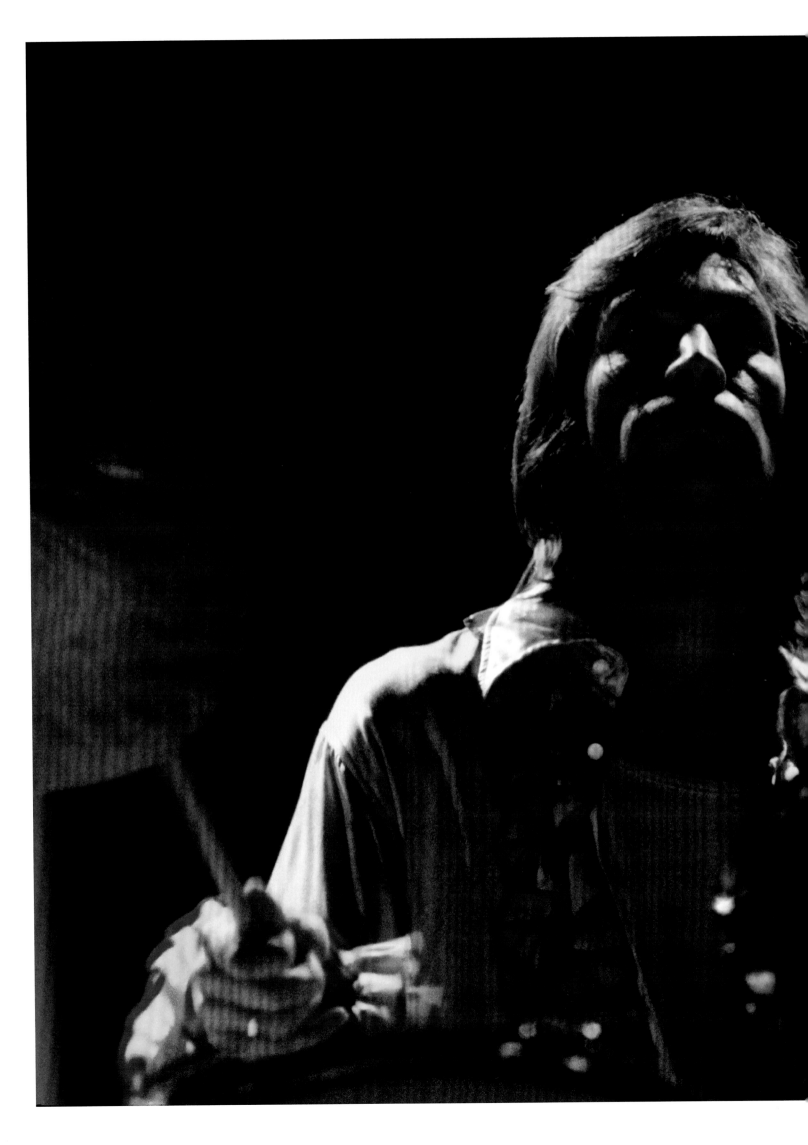

Charlie Watts at the Forum,
Los Angeles, California.

Mick Jagger.

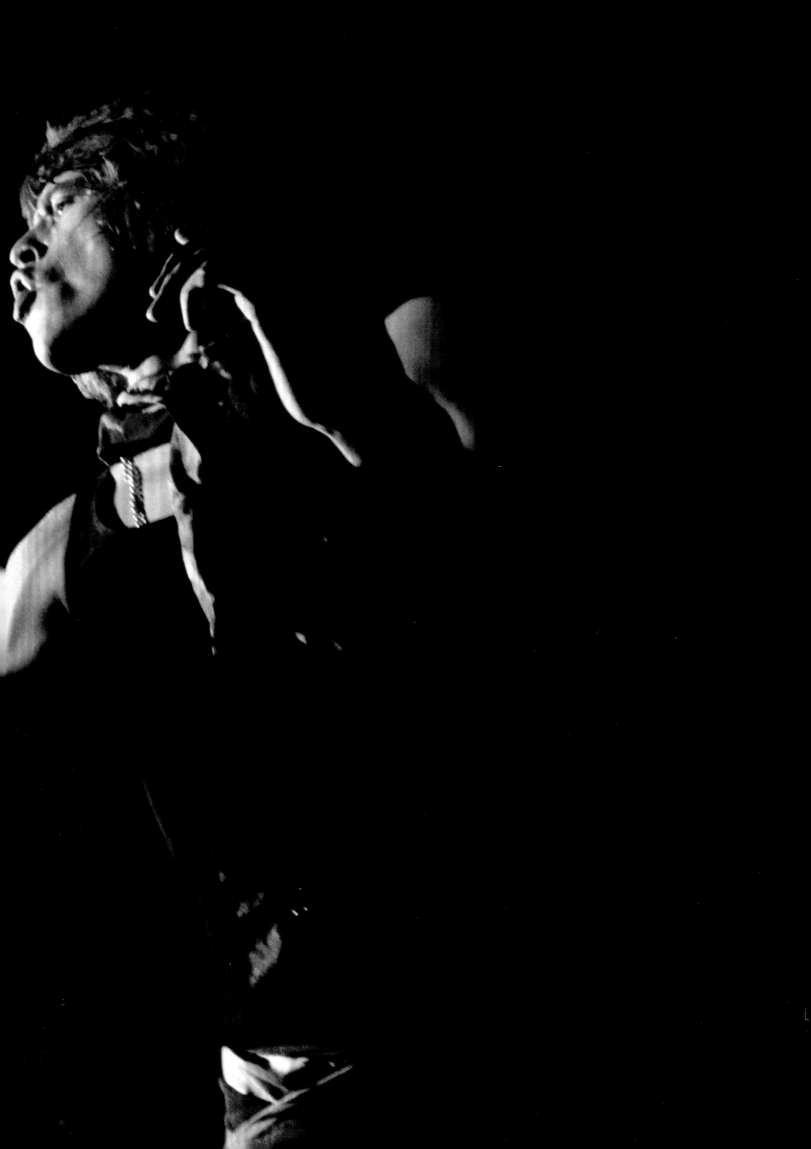

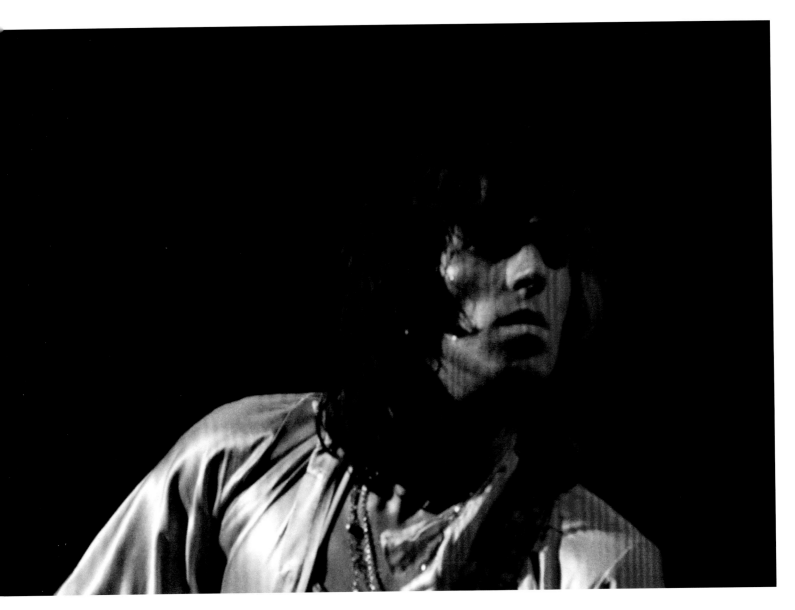

Keith Richards.

> Jagger and Richards.

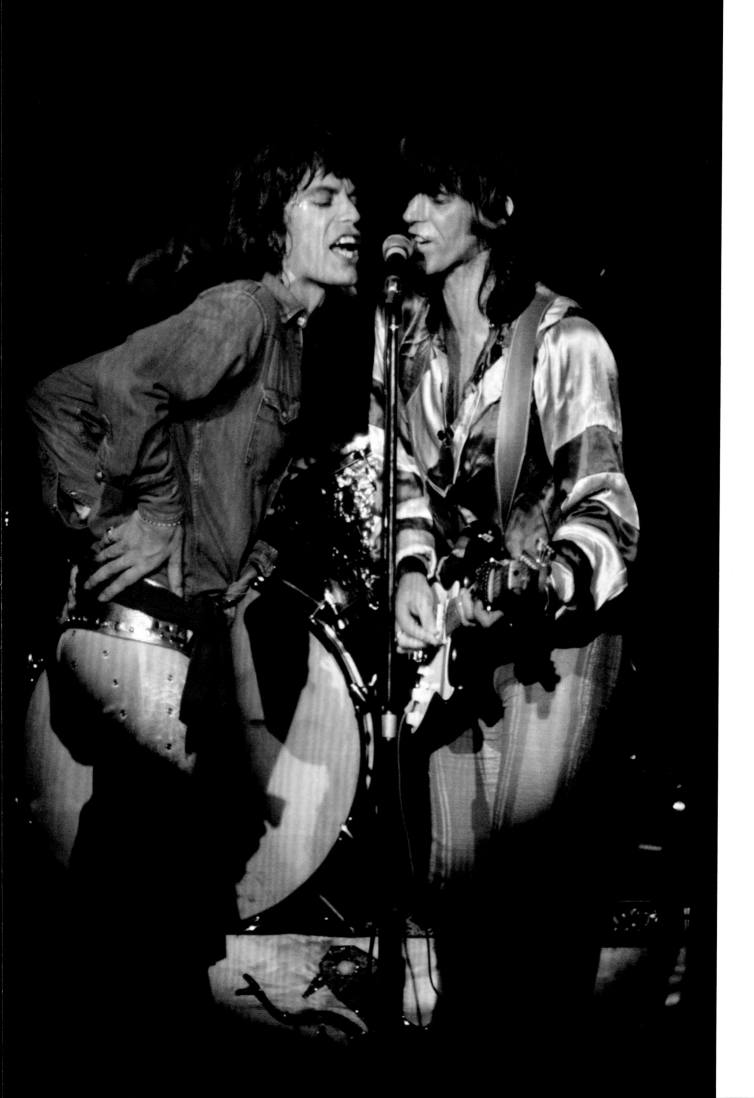

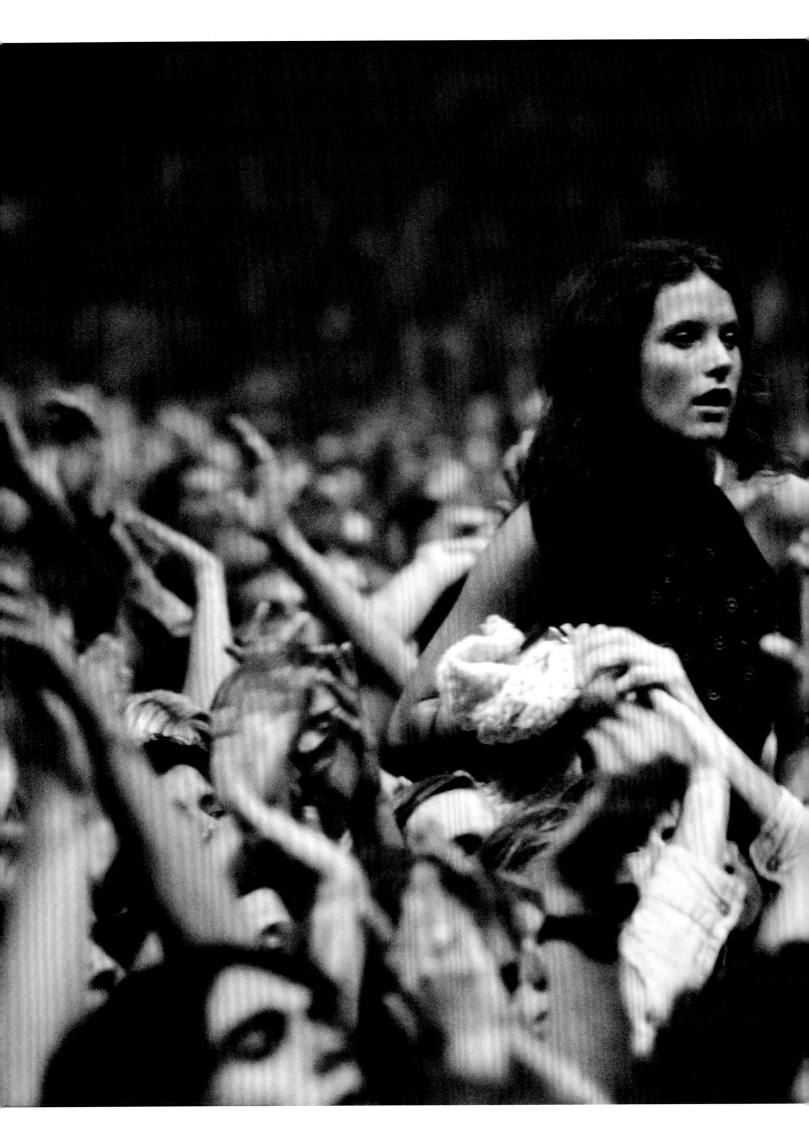

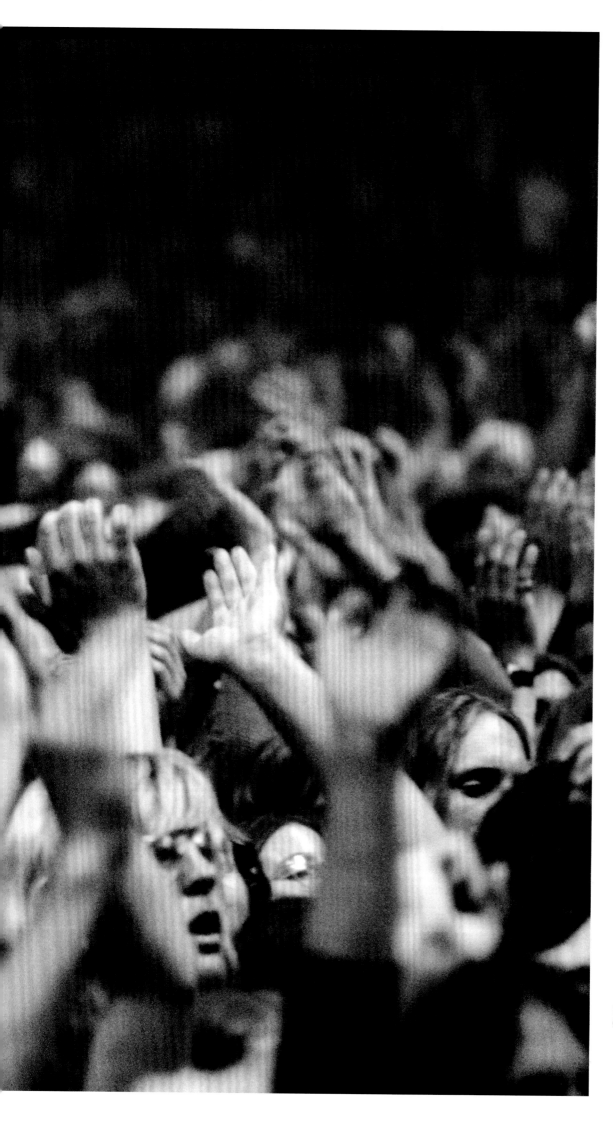

Fans at the Forum, Los Angeles,
California.

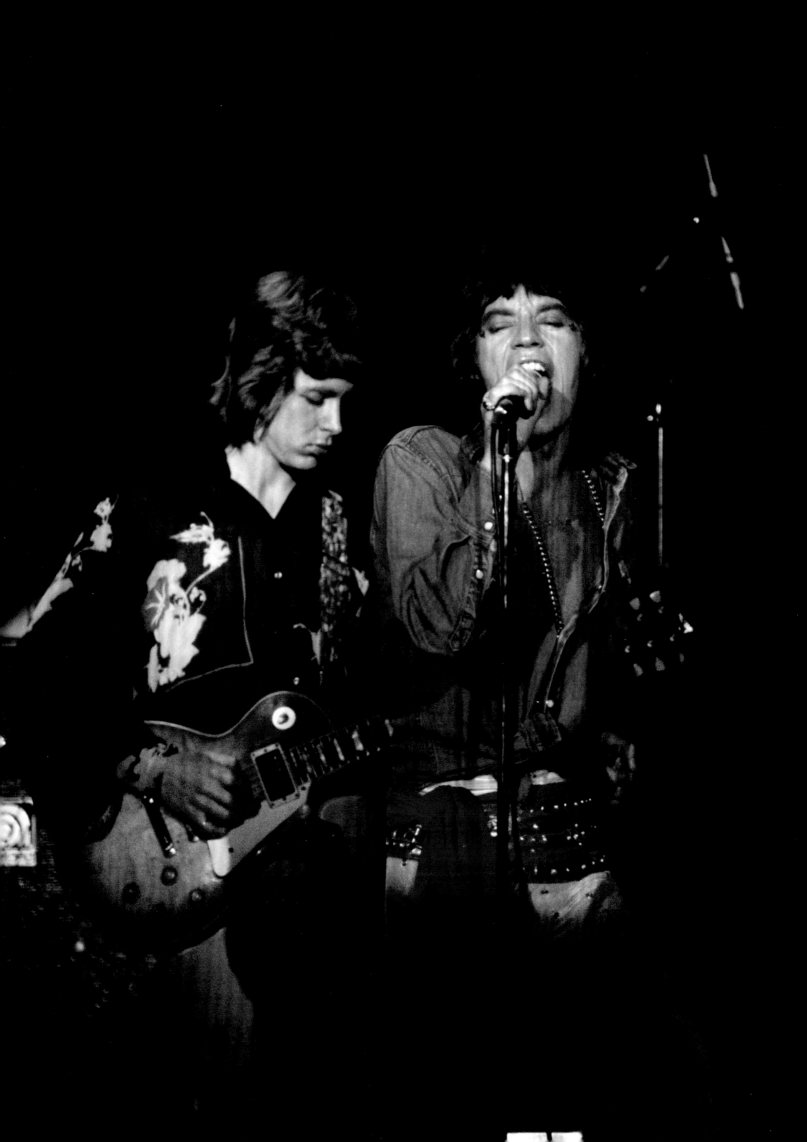

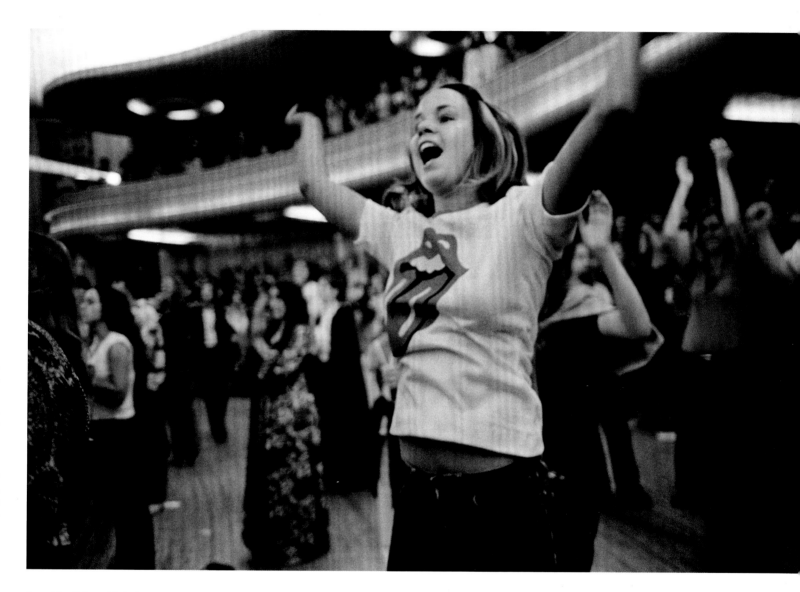

Fans at the Hollywood Palladium,
Los Angeles, California.

< Taylor and Jagger.

Jagger and Wyman.

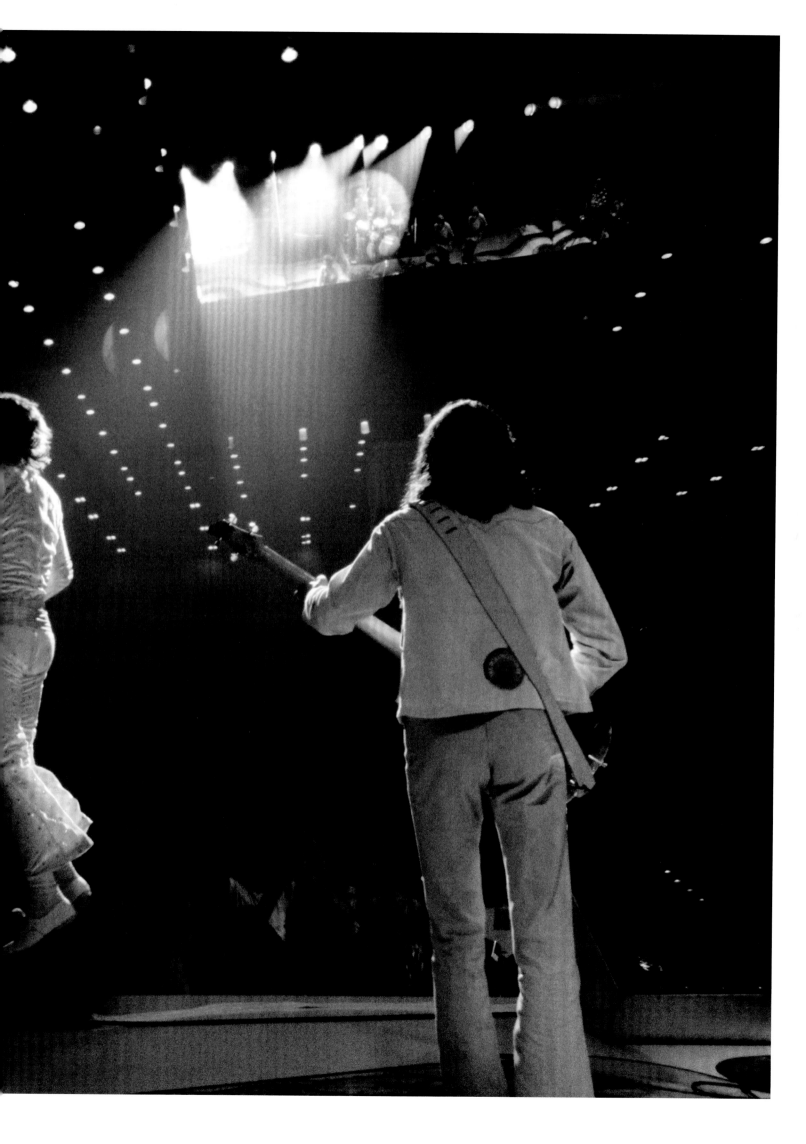

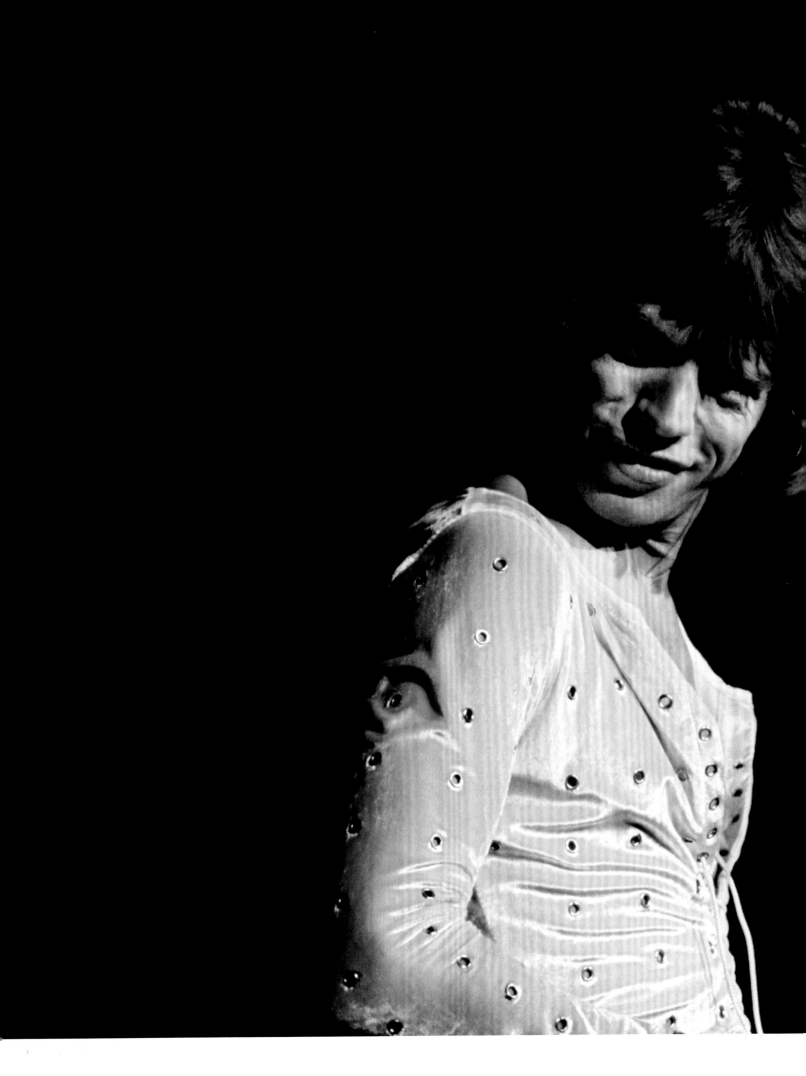

Jagger at
the Forum,
Los Angeles,
California.

Jagger, Richards, Watts, and Wyman at the
Forum, Los Angeles, California.

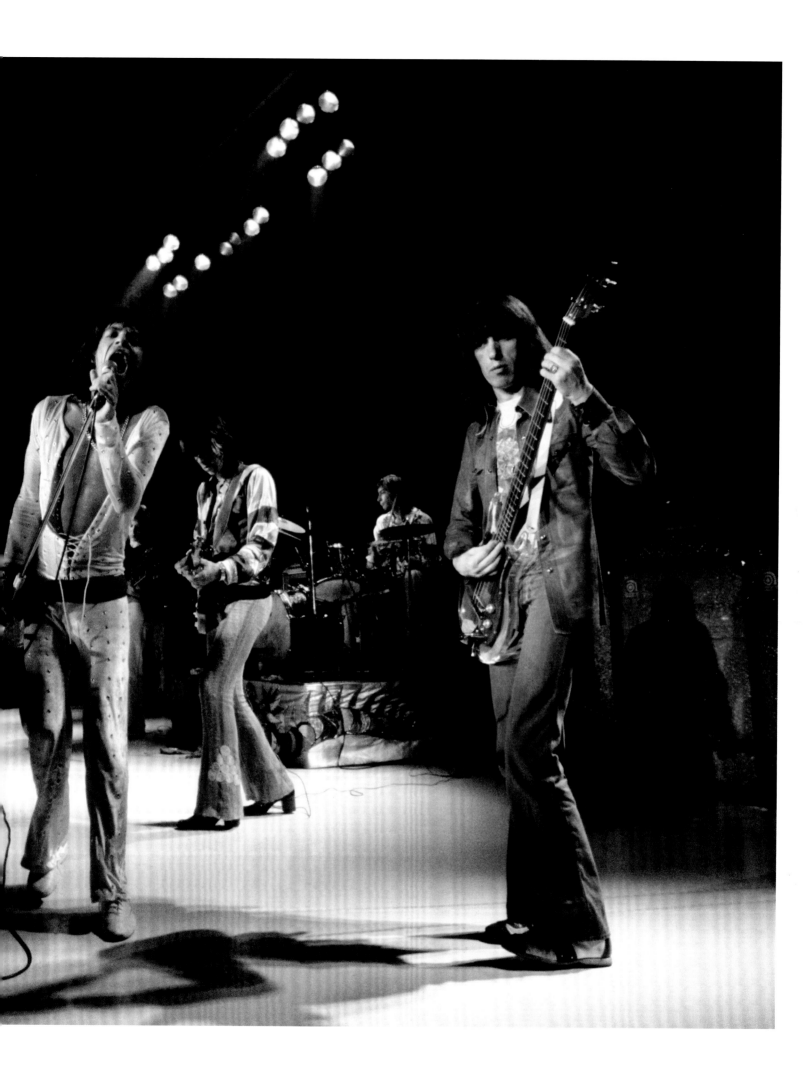

At the Forum, Los Angeles, California. This photograph was used on the cover of *Life* magazine, newsstand date July 14, 1972. It has often been captioned as taken at Madison Square Garden; those performances occurred about two weeks after the *Life* issue was released.

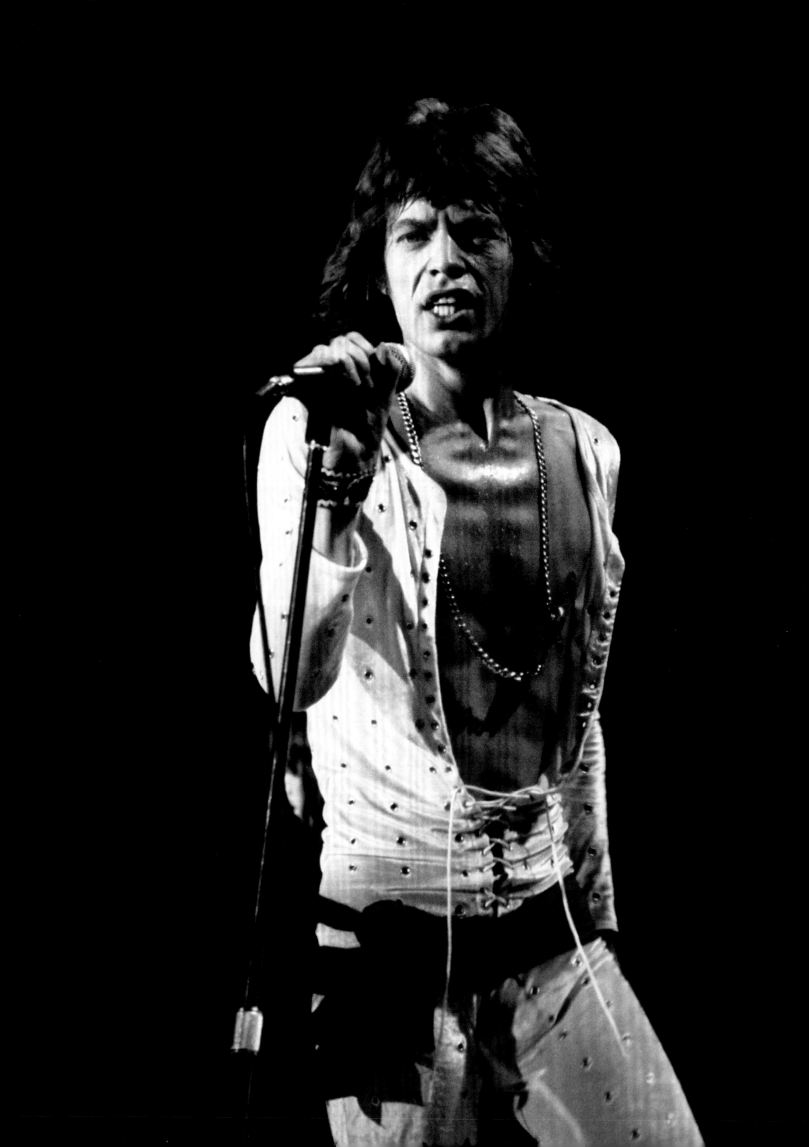

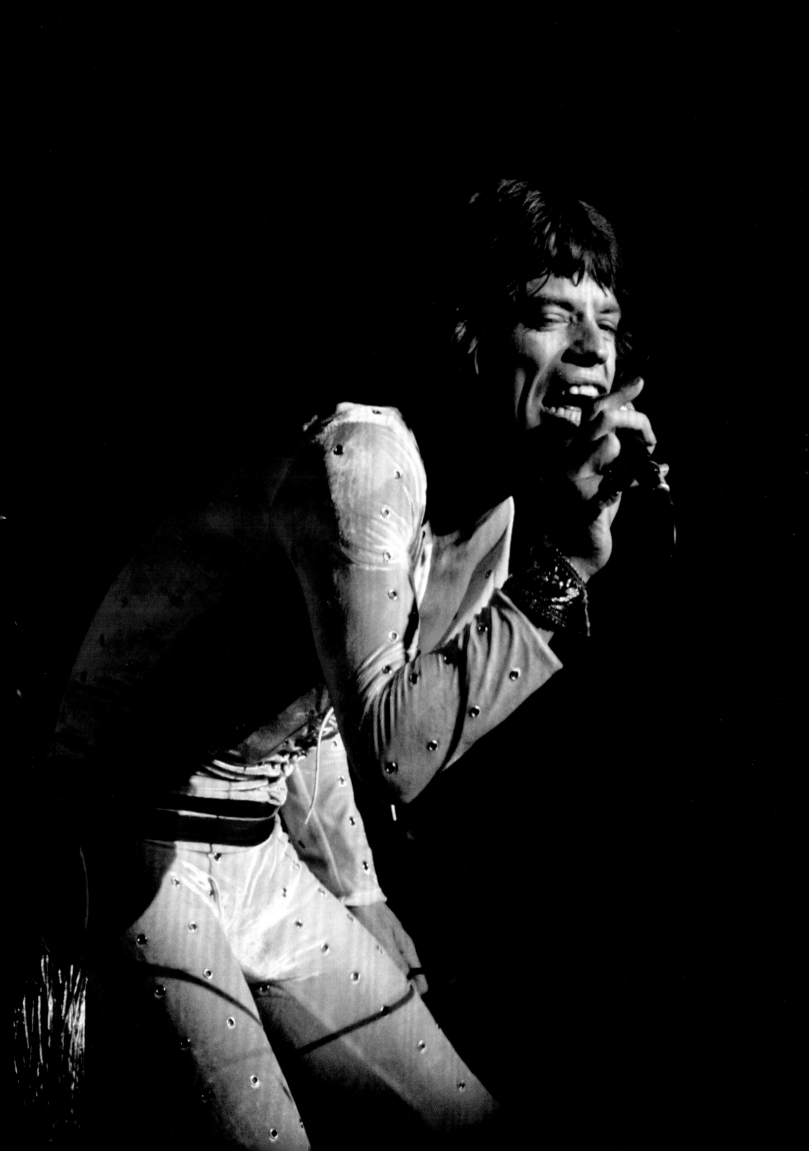

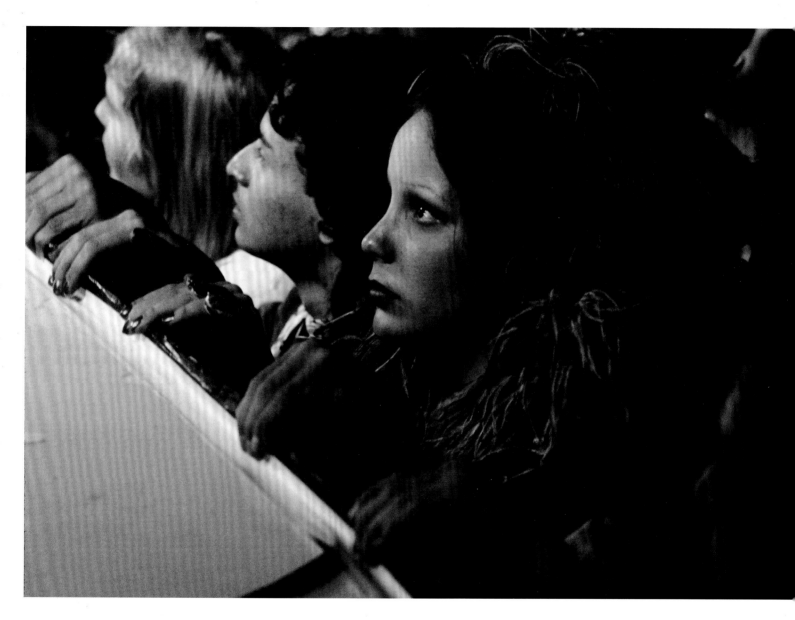

Fans at the Forum, Los Angeles, California.

< Jagger at the Forum, Los Angeles, California.

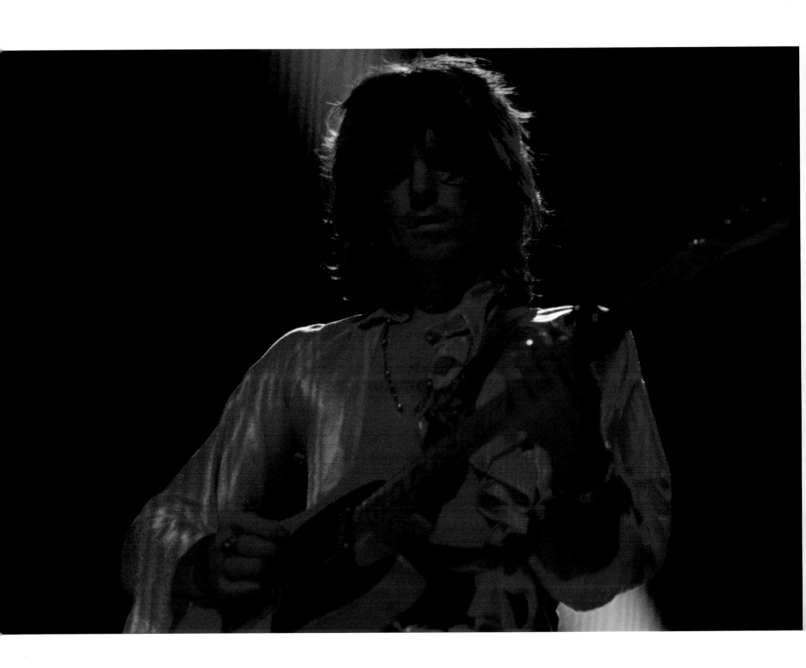

Mick Jagger.

< Keith Richards.

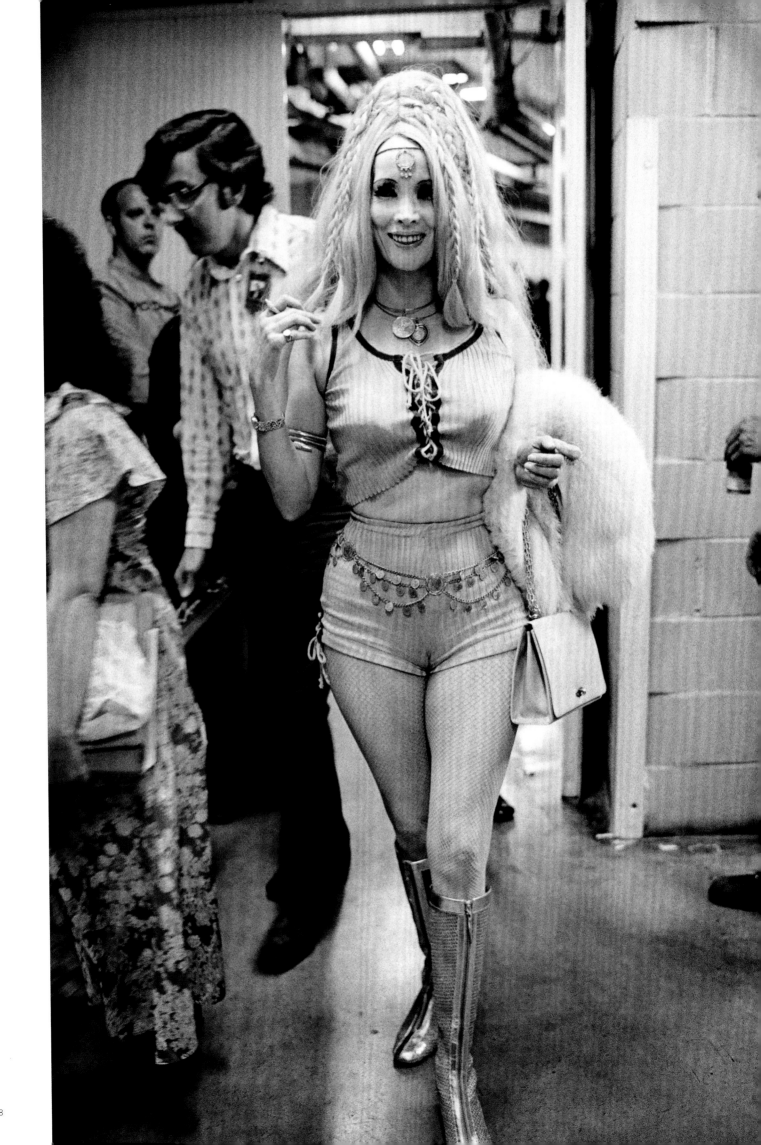

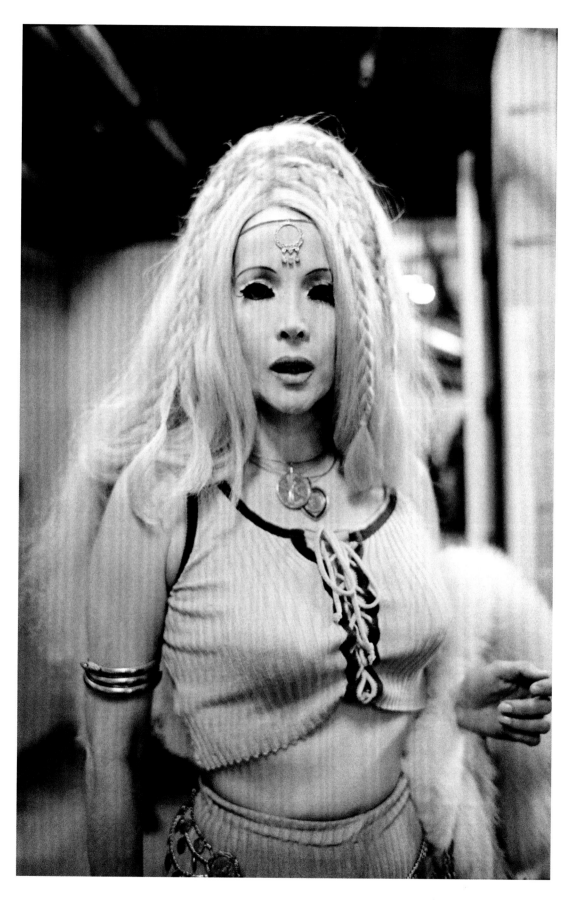

Carol Doda backstage. Carol Doda was a topless
dancer at the Condor Club in San Francisco's
North Beach. She started the topless revolution in
1964 as a 26-year-old go-go dancer.

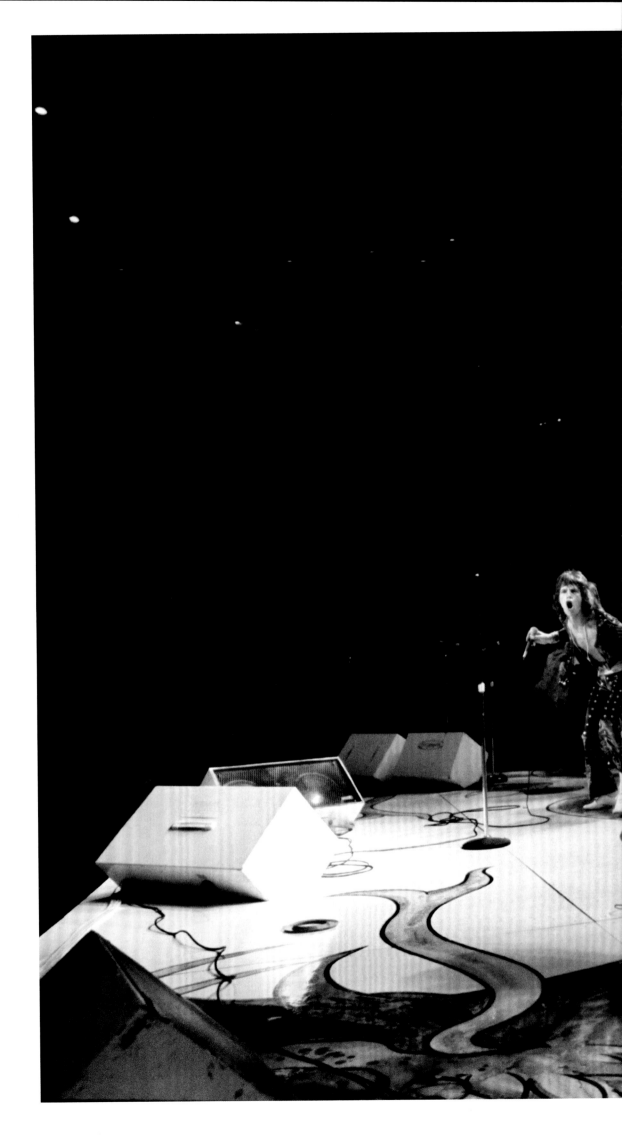

This spread and following
three spreads: At the Forum,
Los Angeles, California.

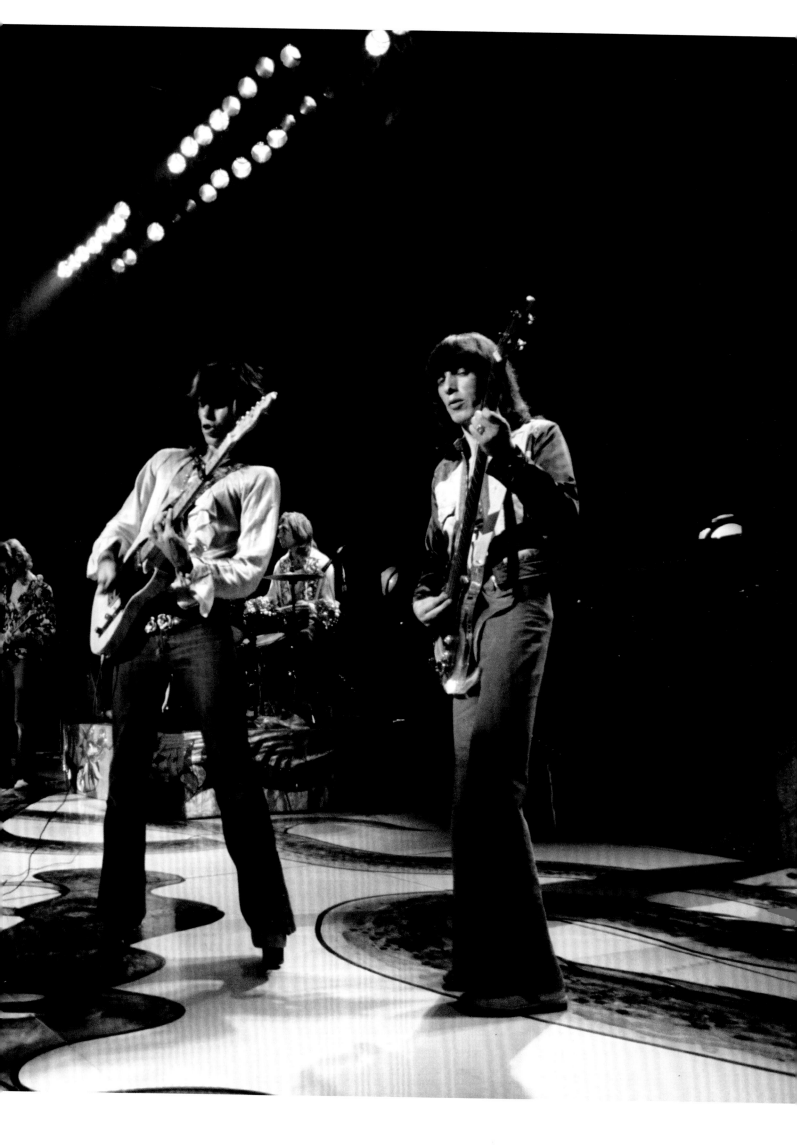

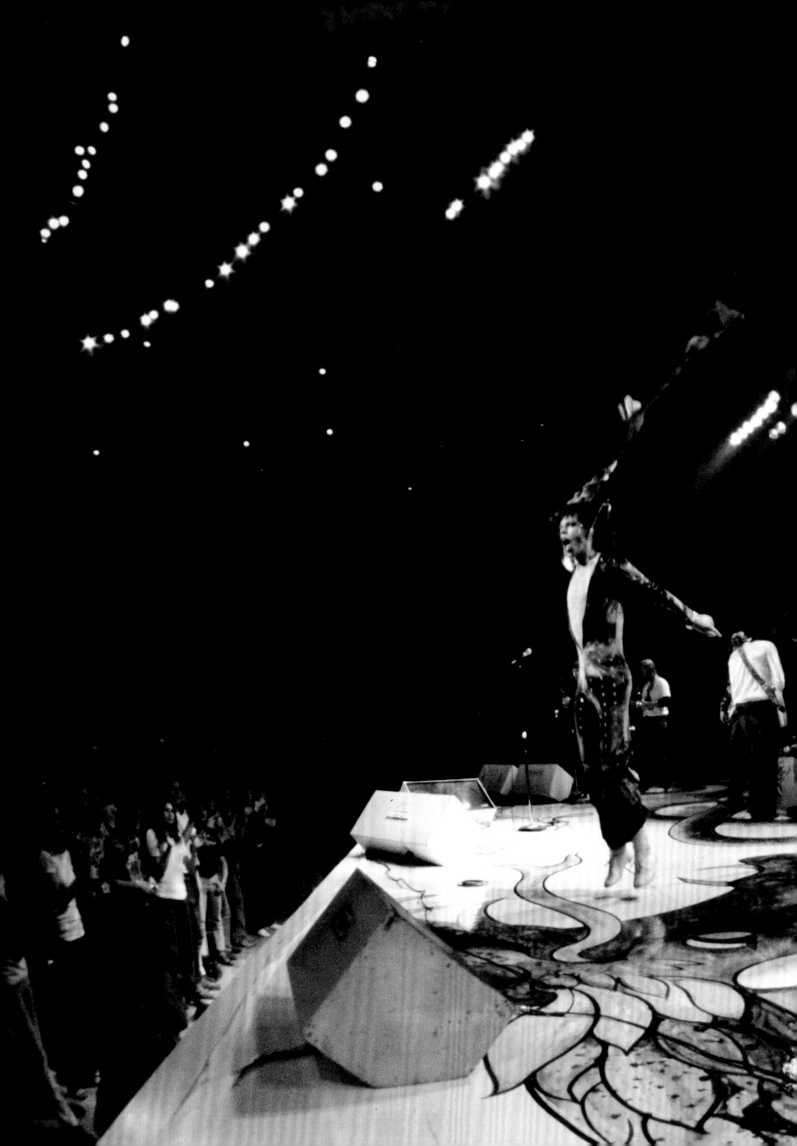

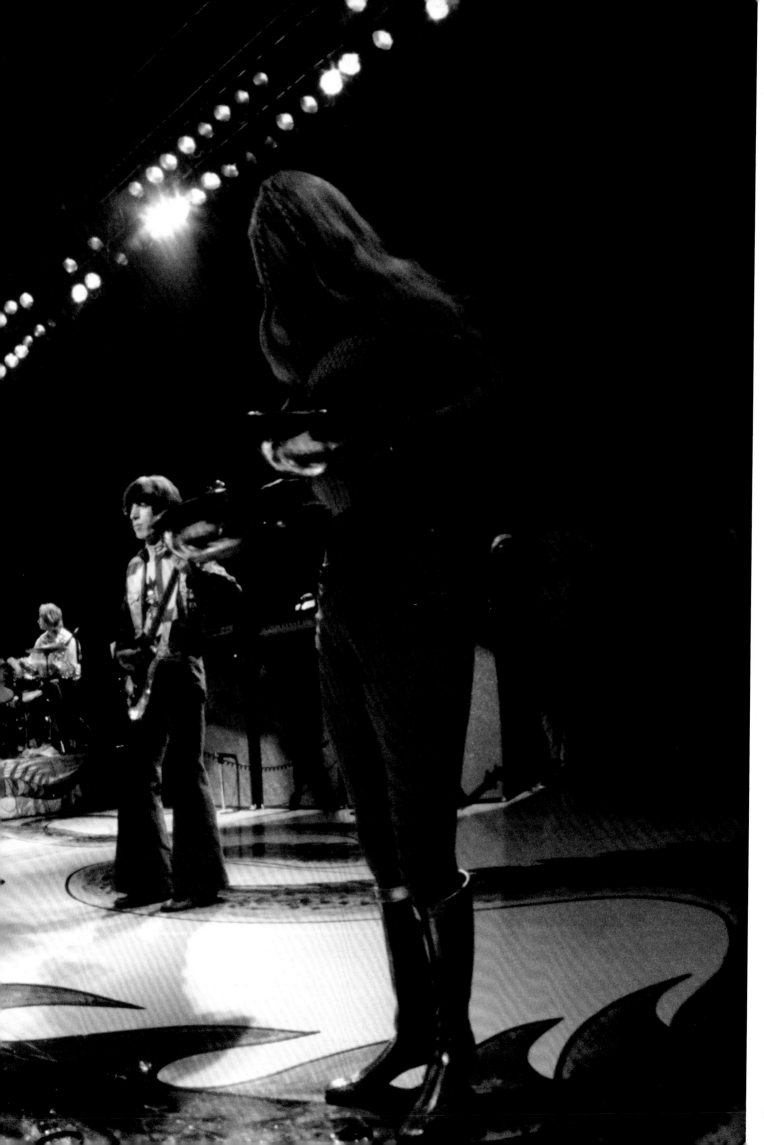

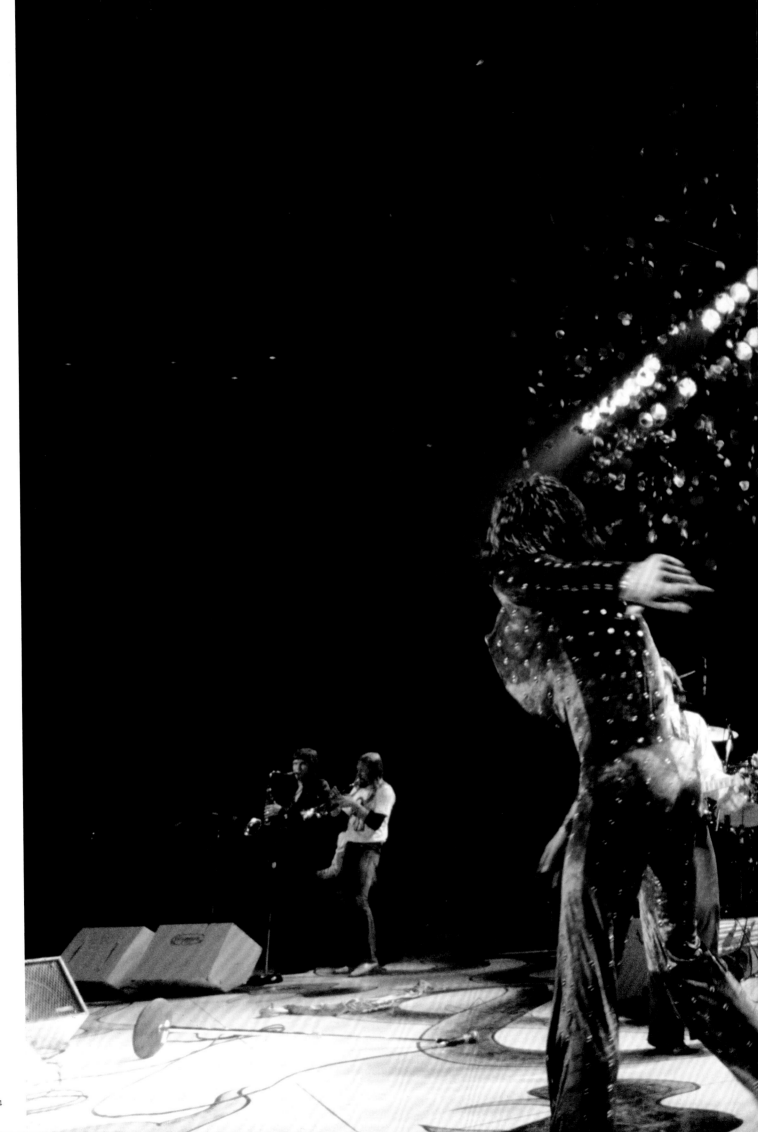

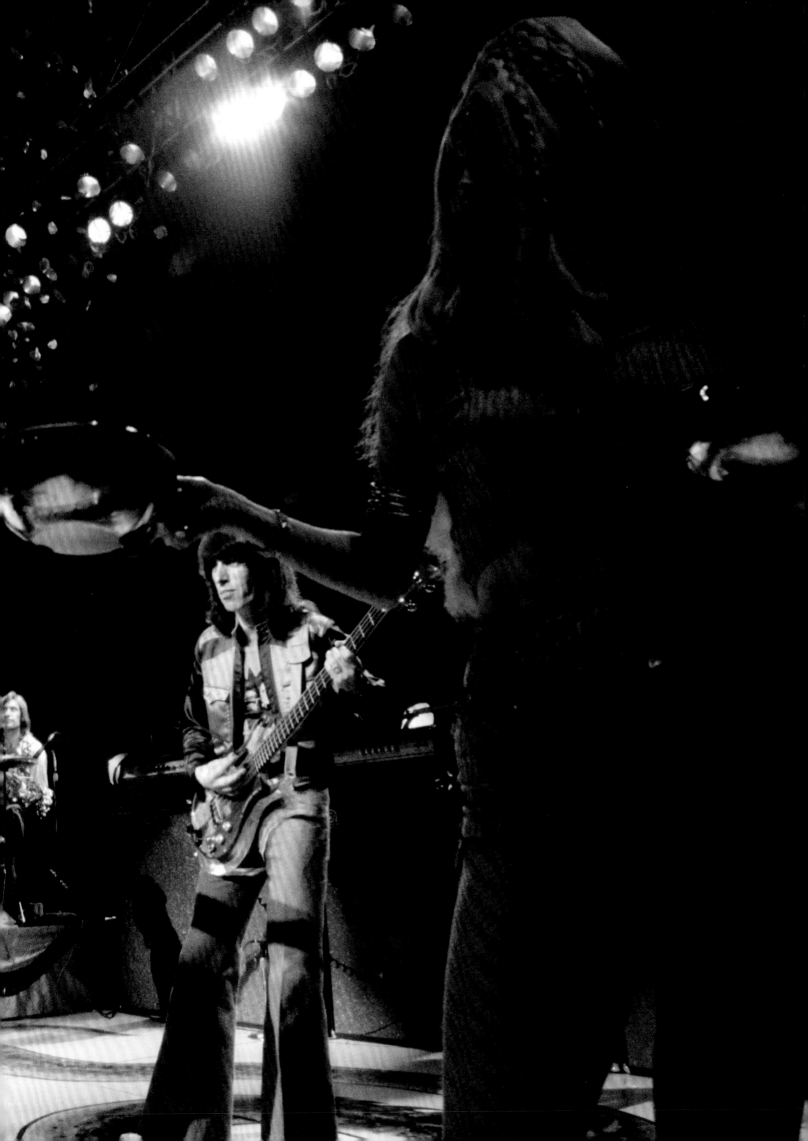

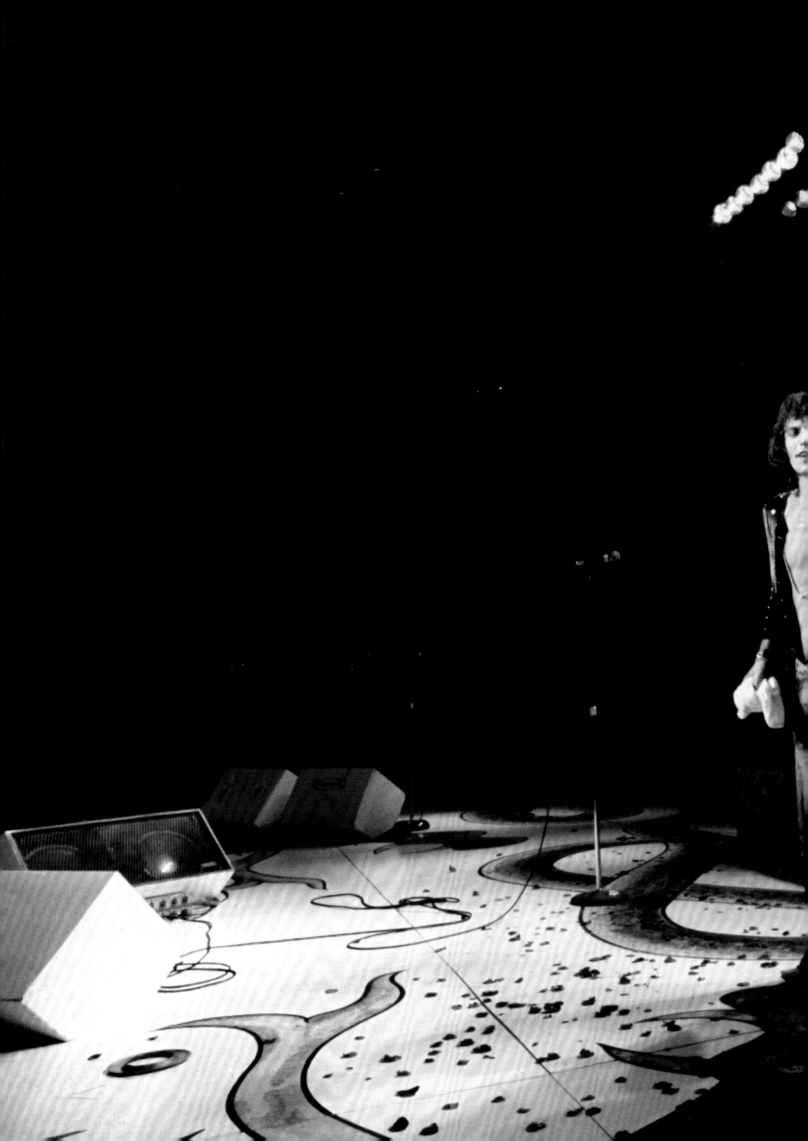

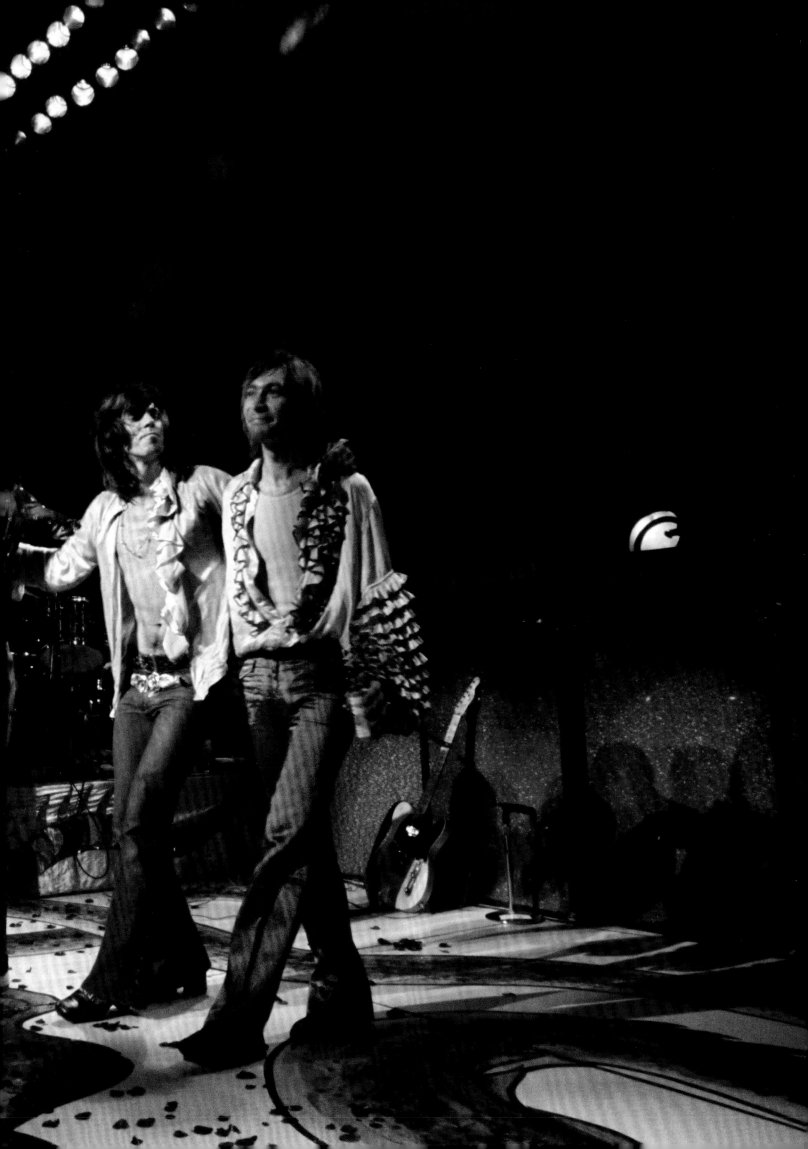

# HISTORY IS IN THE PROOF

The proof sheet is a glimpse inside the mind of a photographer, much like a journal or sheet music is a glimpse into the mind of a writer or a musician. Jim wanted others to see what he saw, love what he loved, and feel what he felt. He did this through his camera lens.

Most of the time we just get to see the hero shot the photographer chose to print, without knowing what else he saw or the process he went through to get to that one shot. Jim not only had a unique eye for the moment but was also a true technician. He mastered his camera; it was an extension of him. He didn't have to think twice about film speed, f-stop, or shutter speed in any situation he was in, whether that was on the street, onstage at a live concert, or backstage. Jim could capture that moment without ever second-guessing himself. These proof sheets from the Rolling Stones 1972 tour illustrate what a master at his craft Jim Marshall was.

Jim was the only photographer at Sunset Sound Studio when Mick and Keith were putting down vocals for *Exile on Main Street*. Just look at the proof sheets. They tell a story, and you will see what Jim saw. He was part of the band. When I look through these proof sheets I always feel like a participant; I never feel like a voyeur looking in. We are transported to a different time. I love these proof sheets because most people have only seen the hero shots from them.

These proof sheets tell the story of two musicians seemingly together but yet miles apart. Each frame reveals their individualism yet shows them working together to make the unique sound and music of the Rolling Stones.

We forget what it is like taking a photograph on a manual camera, with a fixed lens and 35mm film of 36 frames on one roll of film. Or going into a darkroom and developing film, hoping you didn't overexpose or underexpose your film. Then making a proof sheet and deciding which image is the best one to print. It was a long process, not immediate like today when everyone has a camera in their phone. Freelance photographers of the 1960s and 1970s were working photographers, and if their photographs did not come out, they did not get paid or even sometimes eat. Jim spent over half of his life taking photographs and perfecting his craft. These proof sheets prove that. There are no mistakes on Jim's proof sheets. Each frame is perfectly composed, capturing the moment uninterrupted with no need for cropping.

Jim captured all aspects of the touring life, the ups the downs and everything in between.

Look at these proof sheets and feel what Jim felt, see what Jim saw, and be in awe that Jim was there to preserve this history for future generations to see. Feel the excitement of being onstage with thousands of screaming fans, feel the boredom of waiting to perform and the exhaustion of being backstage after a live concert, and feel what it was like to be in the recording studio for the *Exile on Main Street* vocals at Sunset Sound.

Take a look and celebrate rock-and-roll history, when the Rolling Stones were Rock Gods and also mere mortals, as shown through Jim Marshall's proof sheets.

—AD

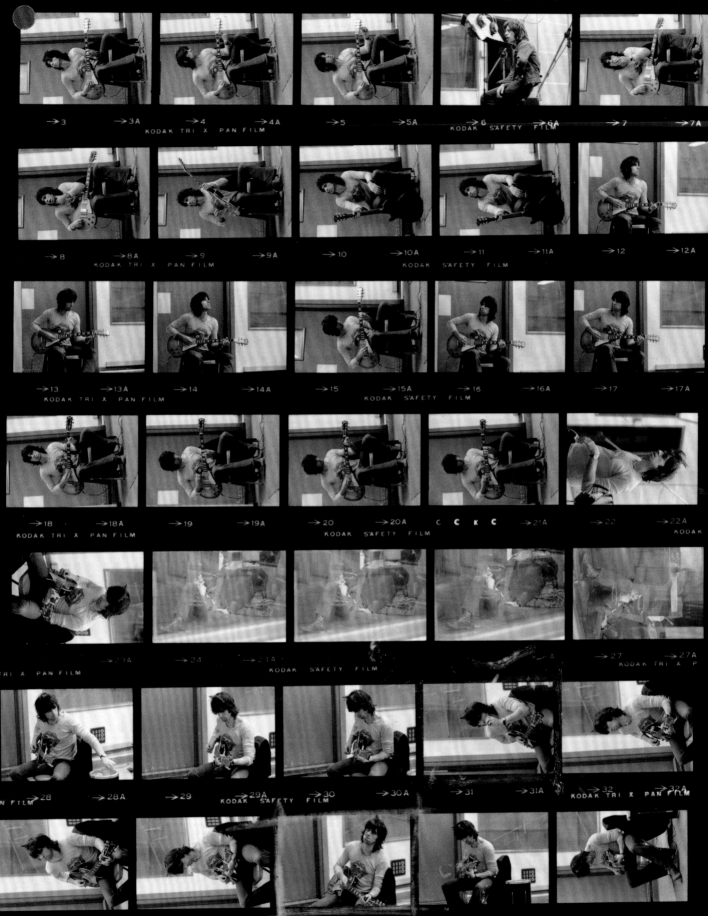

Keith Richards sits by himself with a cigarette hanging from his mouth and his eyes closed, listening to the notes from his guitar, completely unaware that Jim is there.

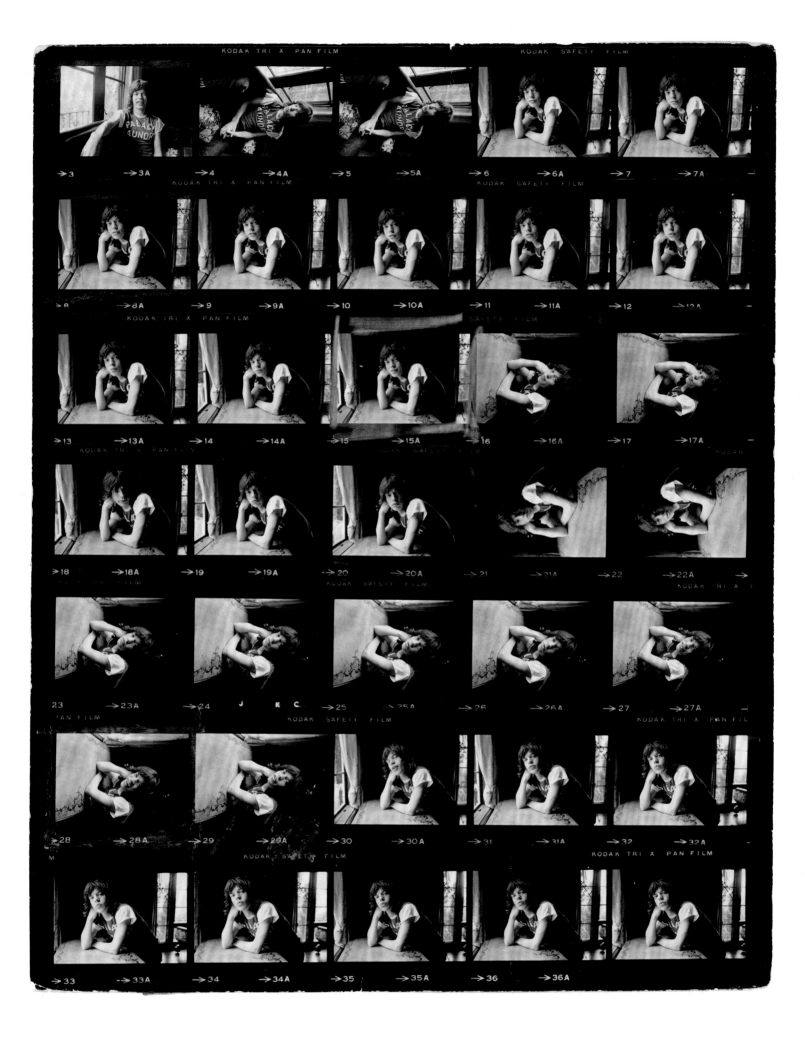

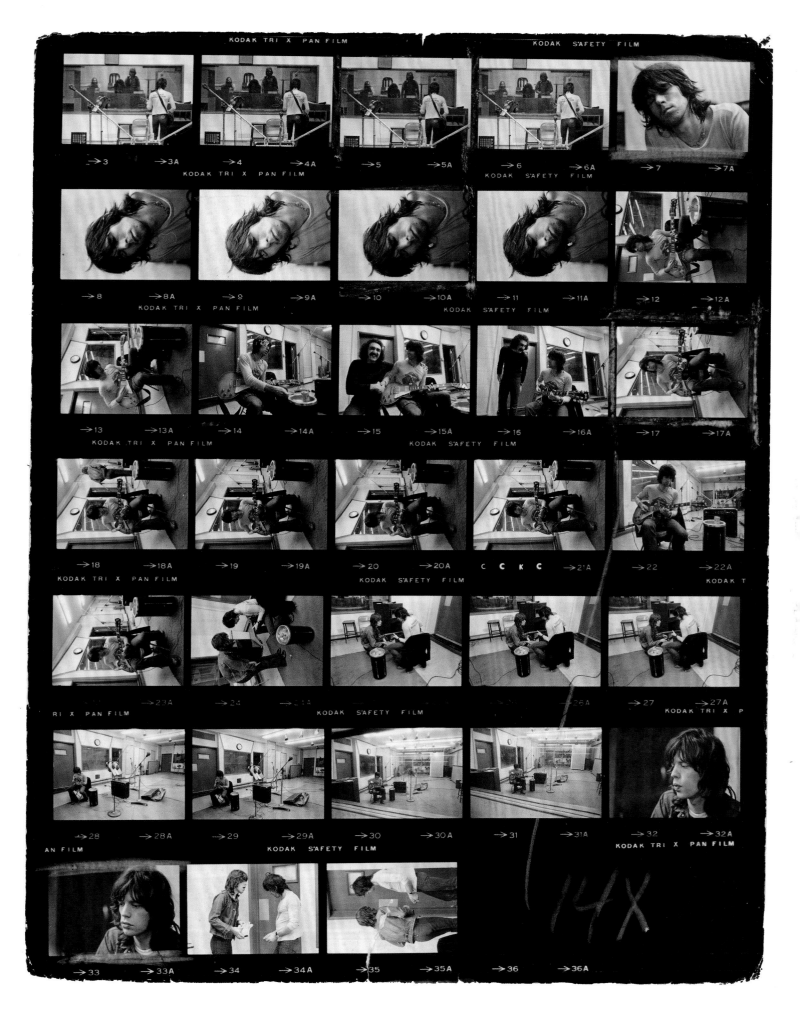

< Jim photographed what was happening around the Stones and the tour itself, waking up a sleepy Mick Jagger and coaxing him to get out of bed for some promo shots.

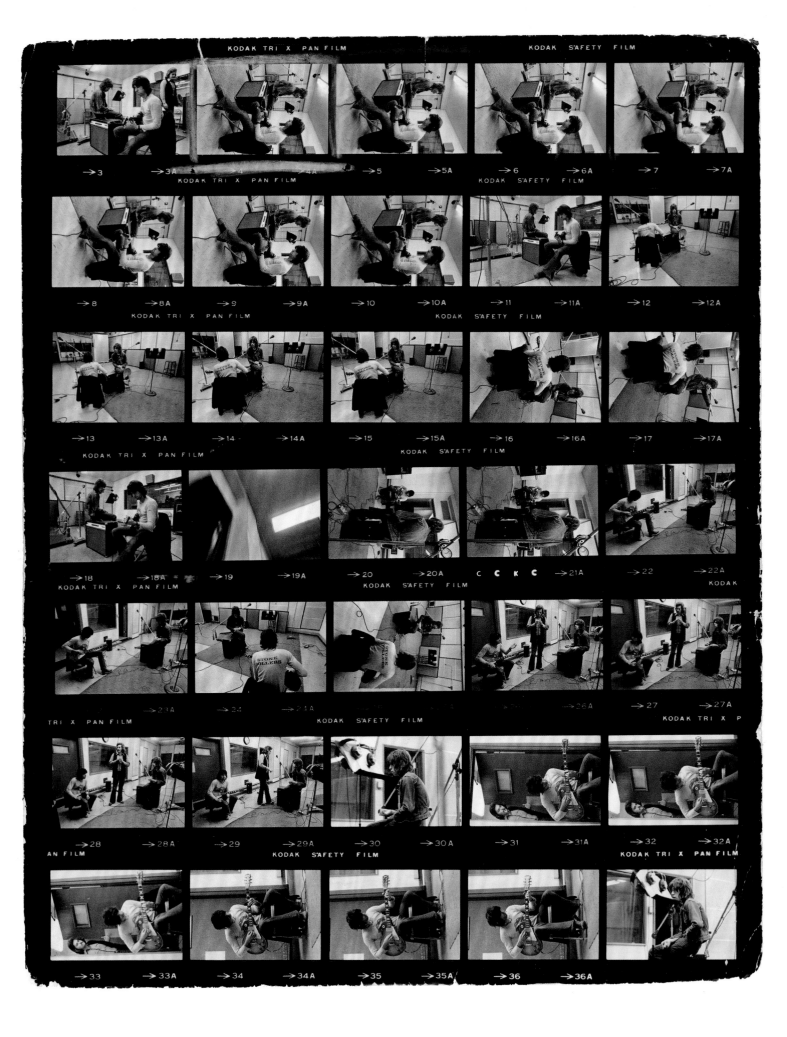

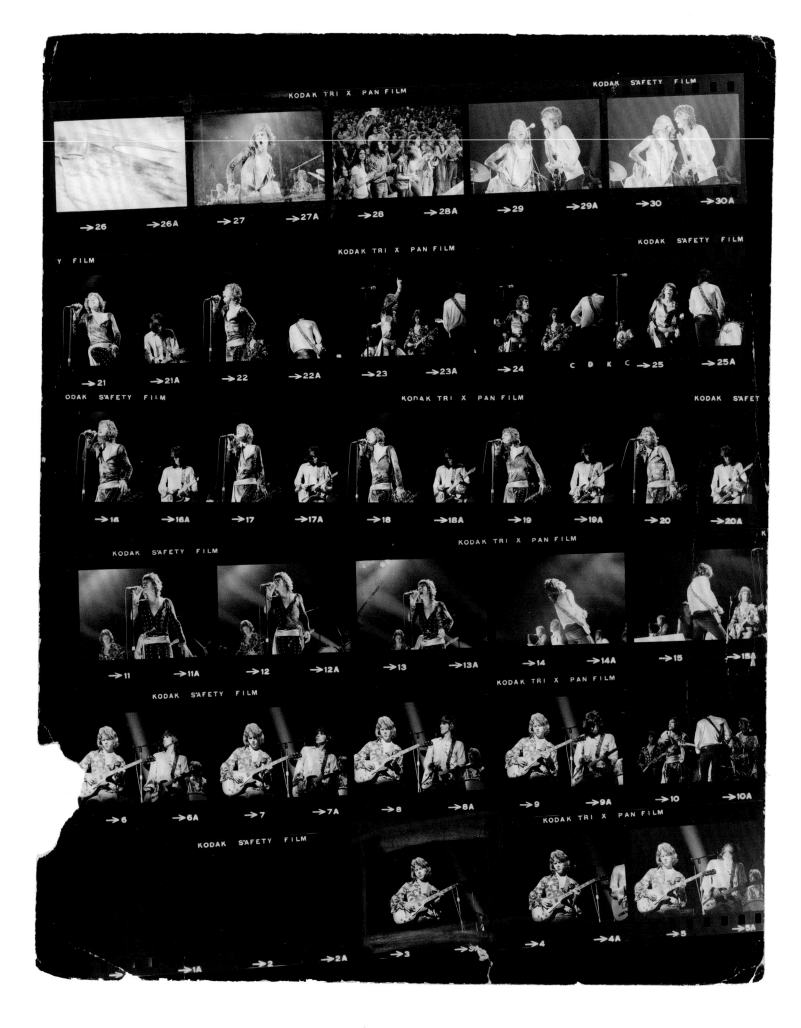

< Mick sits on a speaker while listening to Keith
play his guitar.

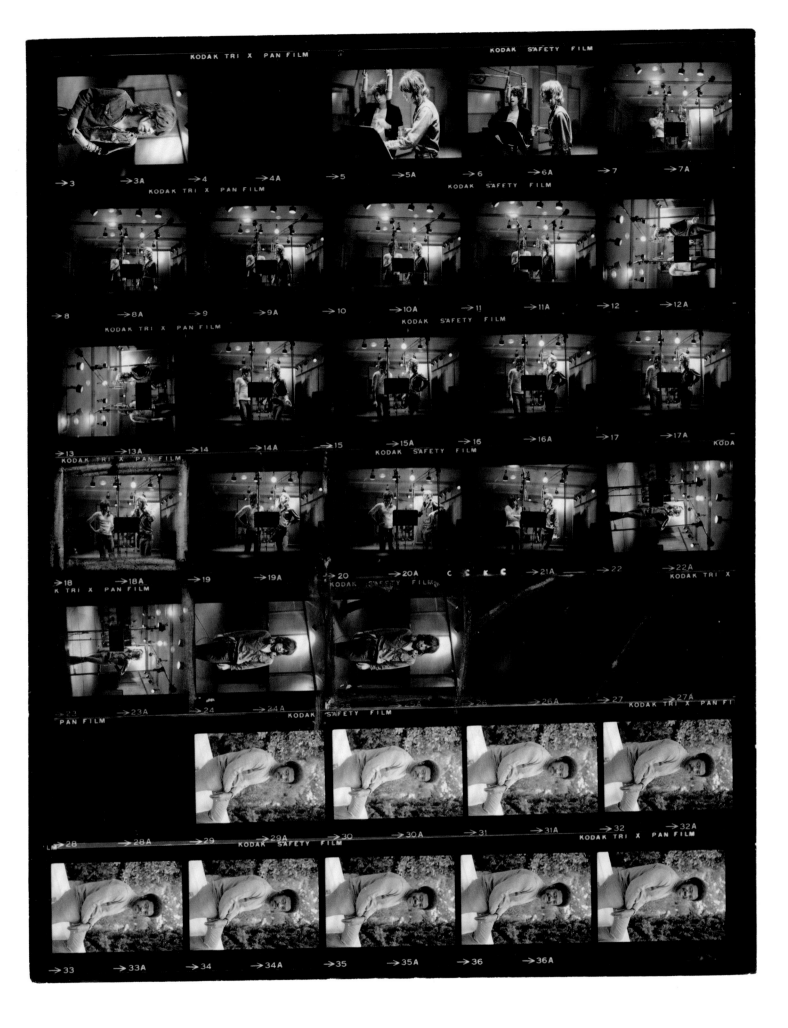

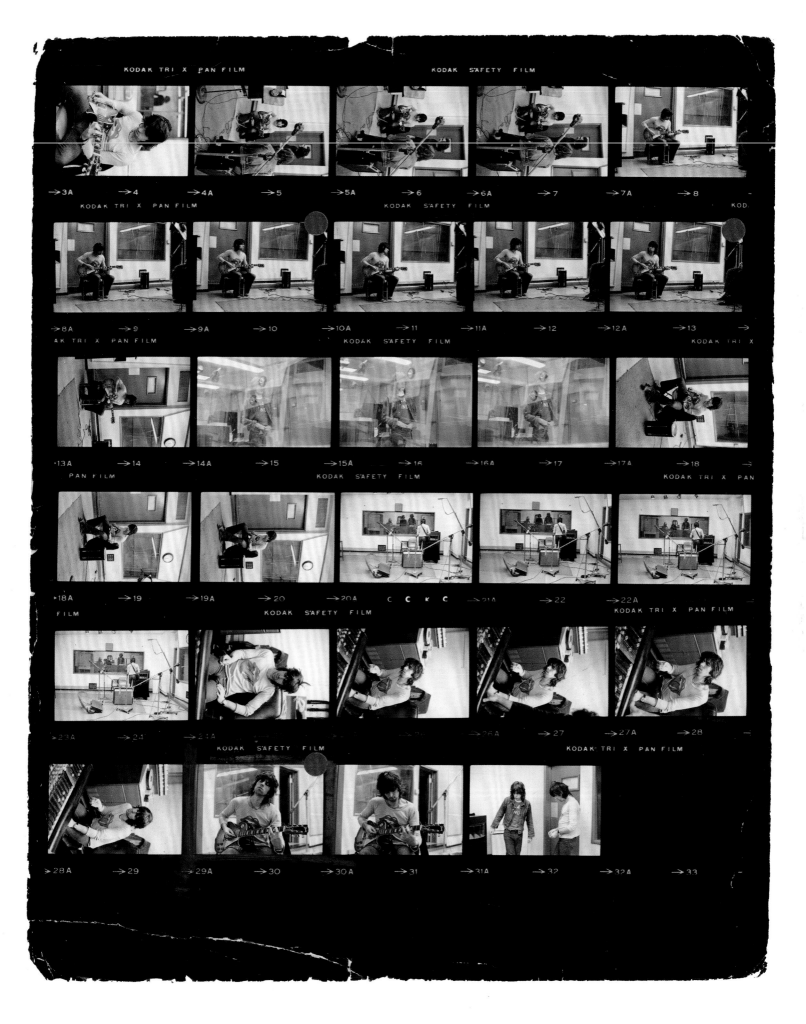

< Keith and Mick stand together with a music stand in front of them and microphones hanging above them. Mick clutches his headphones, singing into the microphone, but Keith looks down just listening to Mick sing. Just six frames away, Jim captures Mick by himself quietly looking down at the floor in his own space and his own thoughts.

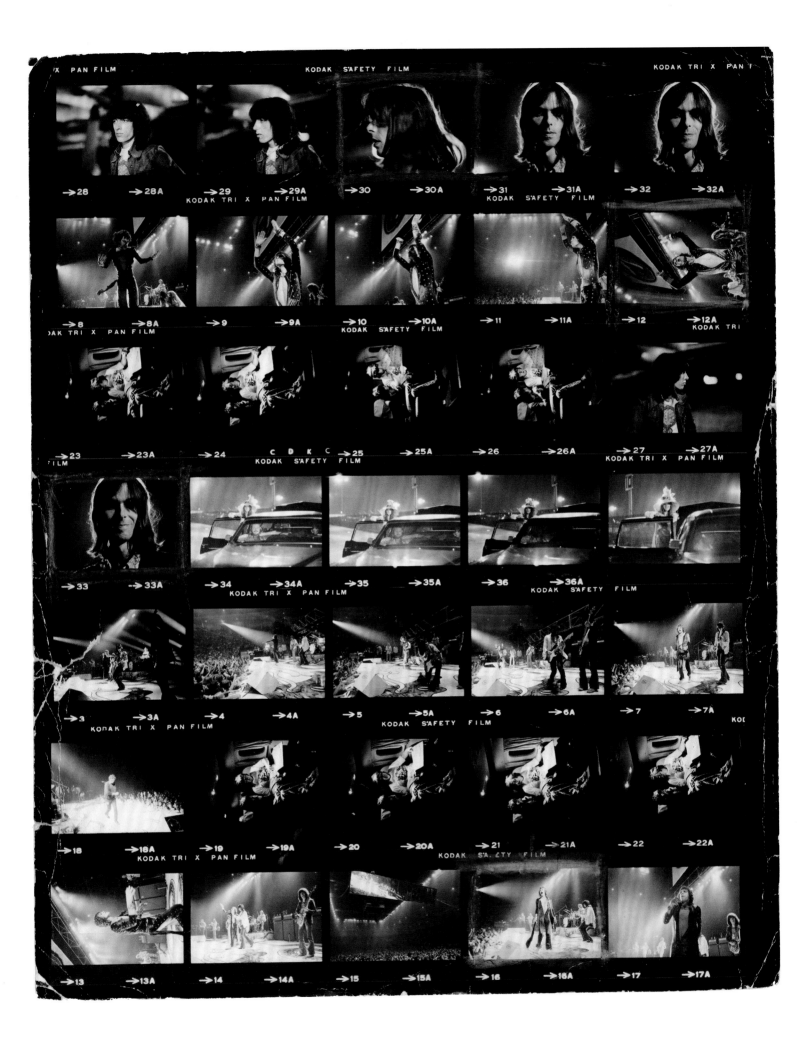

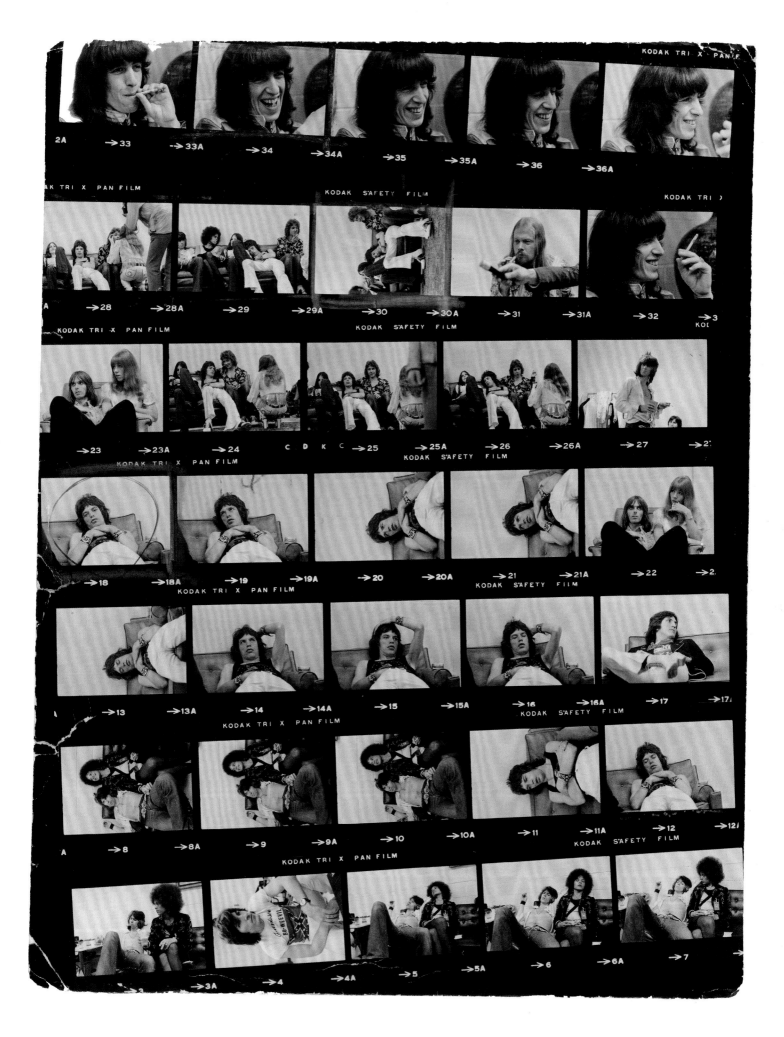

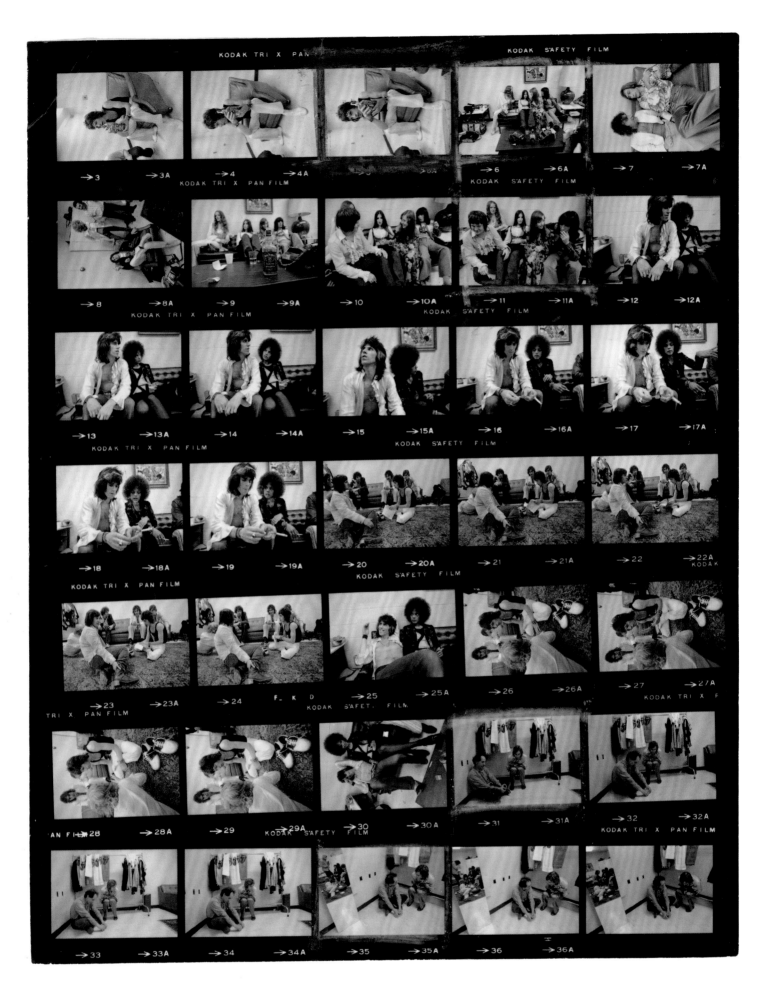

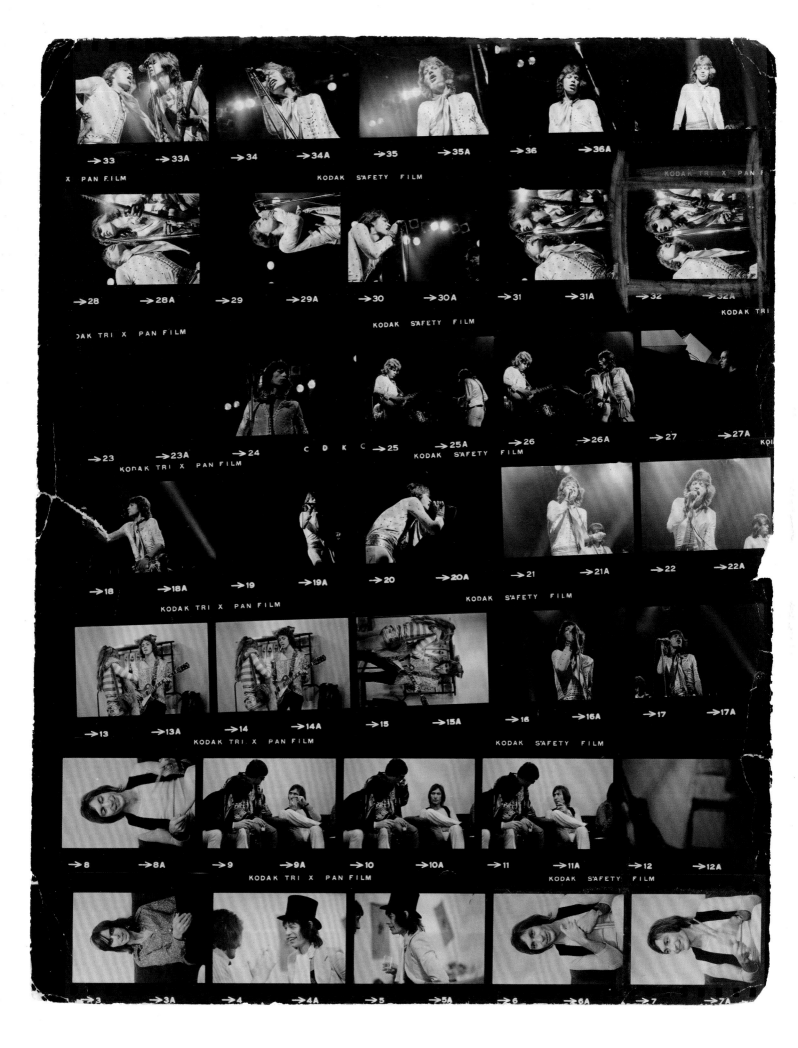

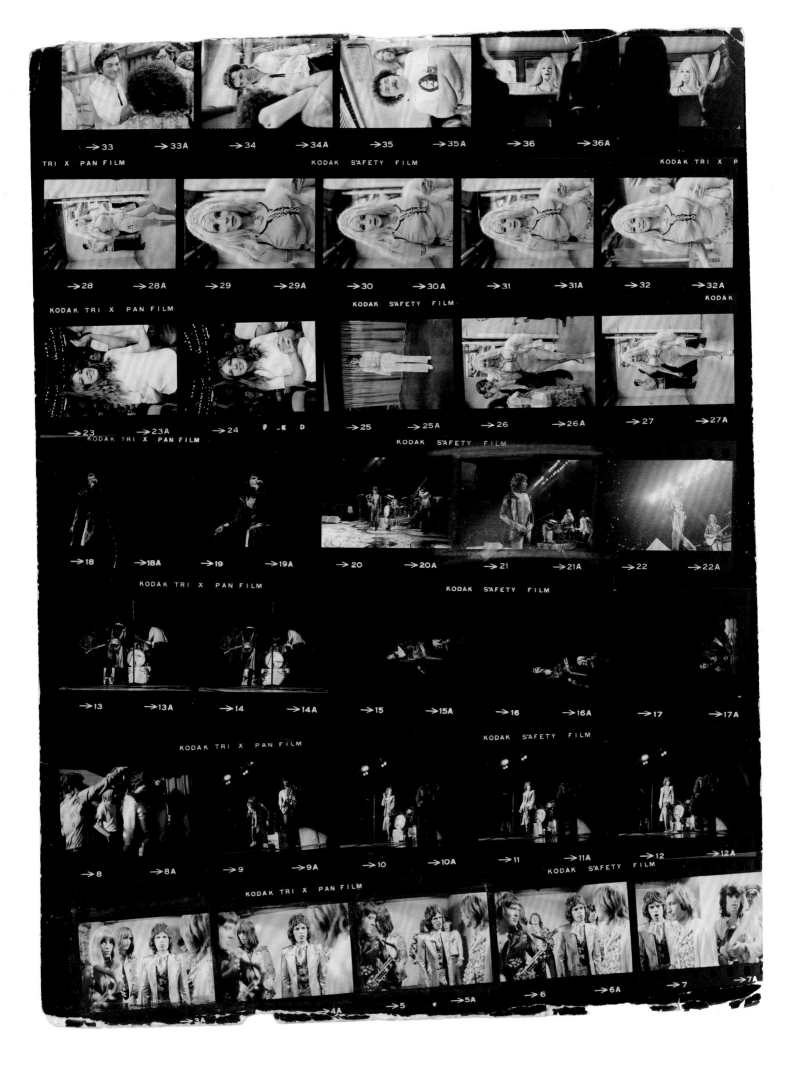

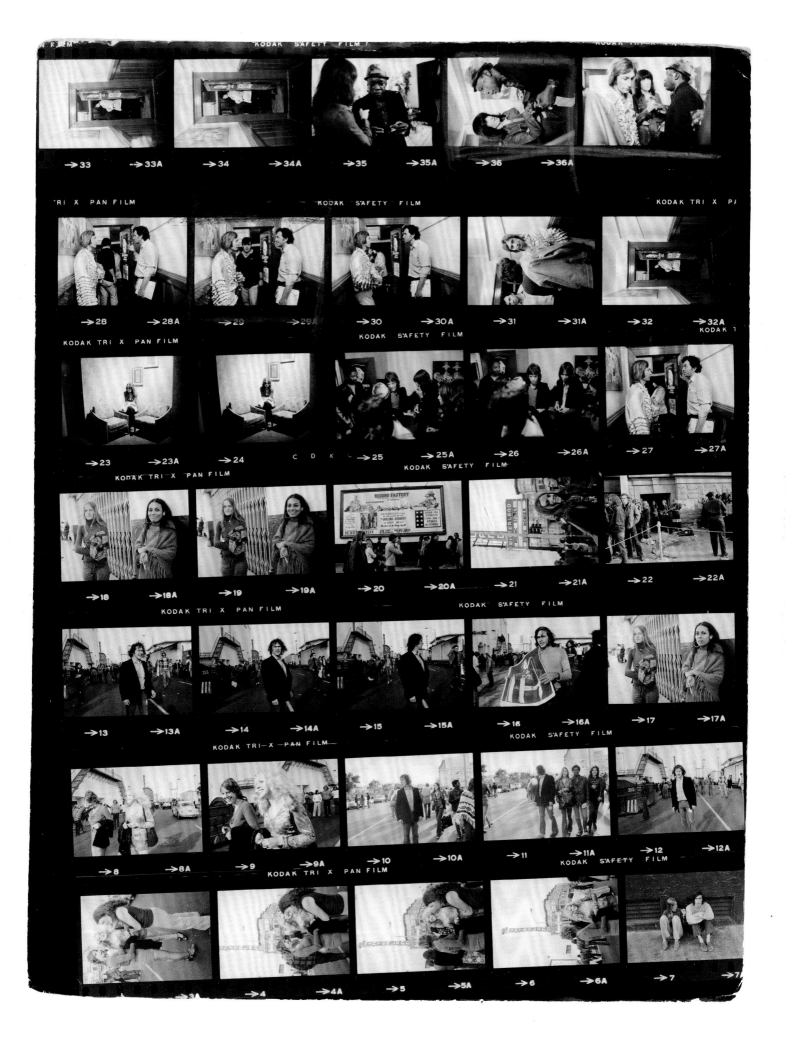

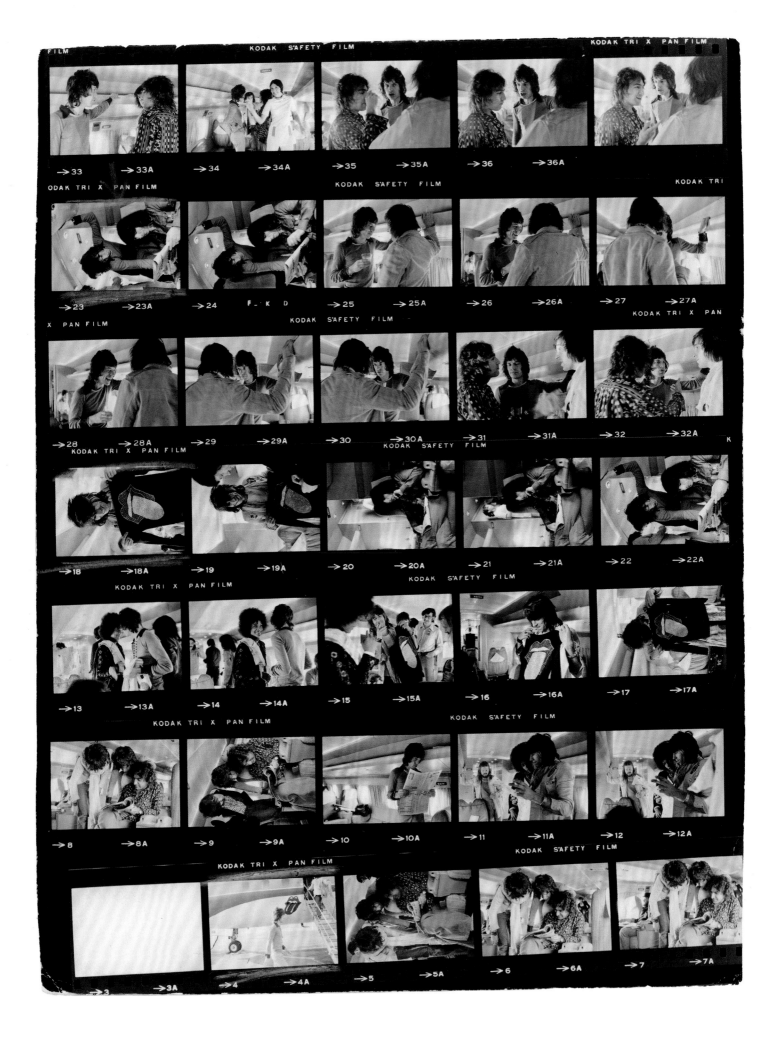

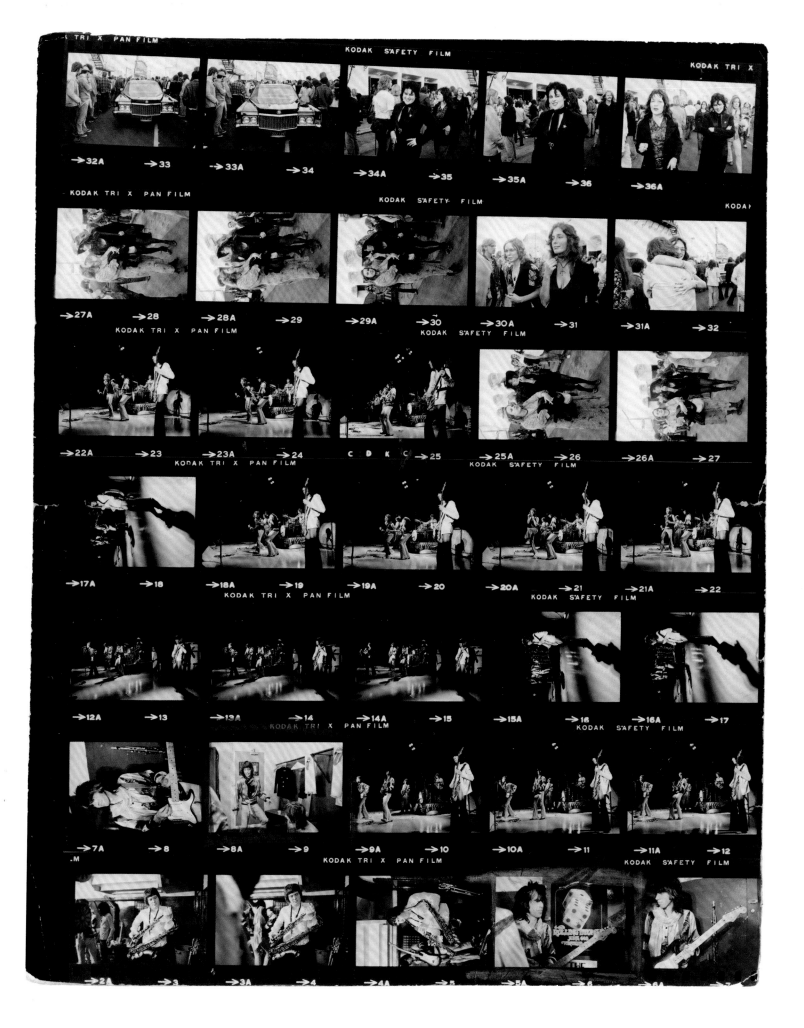

# EDITOR'S NOTE MICHELLE DUNN MARSH

In the process of developing this publication, I discovered that details such as
dates and locations were not always standard fare in the magazines of the 1960s
and '70s—even *Life* and *Rolling Stone* did not regularly identify dates and locations
in captioning their photographs. Hence, for many years I believed that Jim's image
of Mick Jagger used on the cover of *Life* (p. 183) was from one of the Madison
Square Garden concerts in 1972—it was only when I ordered said issue as part
of my research that I discovered otherwise, the magazine being on the newsstand
weeks before the Garden concerts actually took place. We now believe this image
was made at the Los Angeles Forum.

Though Jim kept great records of his contact sheets by artist and year, allowing
us to quickly pull all those related to the Stones in 1972, the chronology of sheet
numbers did not match the passage of time—he had nearly fifty rolls of black-and-
white film from the six to seven days he spent with the Stones in June of 1972,
and the sequential numbers apply only to the order in which the film was developed.

As a result, we do not always know with certainty which photographs were
made at a particular location. Joel Selvin, with the assistance of Robert Greenfield,
carefully pored over the images and provided caption information, including
locations only where he felt fairly confident of accuracy. Please feel free to be
in touch through Chronicle's website if you can provide additional information
regarding location for any of the images.

This is the first book produced since Jim Marshall left us for rock-and-roll
heaven on March 24, 2010. His voice has been in my head and his eye has
penetrated my vision as I worked with his assistant and the beneficiary of his
estate, Amelia Davis, to review over one thousand frames that would result in the
edit of just over one hundred photographs for *The Rolling Stones 1972*. Reconciling
this body of work with the short period of time in which it was made is just one

more testament to the mastery of Jim Marshall. Prior to this volume, only about twenty of Jim's photographs of the Stones had been nationally published—ten of those were in the 1972 *Life* magazine article. Jim was an incredible editor of his own work—if you haven't seen *Proof* (Chronicle Books, 2004), take a look, as that book is one of the finest examples of his judicious eye. We have made every effort to maintain his strict, high bar of quality for the images included here.

In his lifetime, Jim often spoke of the importance of access and of trust in creating his photographs. I am deeply aware of the trust he invested in me and the access now extended to me by his estate. It remains a great joy to edit and sequence his work, and I wish he were still here to argue with me about it.

If you are interested in learning more about the force that is the Rolling Stones, I suggest the following, which served as resources in the creation of this book:

*Cocksucker Blues*, documentary by Robert Frank, 1972.
Bootleg portions available on YouTube.

George-Warren, Holly, ed. *Rolling Stone: The Complete Covers 1967–1997*.
New York: Abrams, 1998.

*Gimme Shelter*, documentary by Albert and David Maysles,
originally released 1970.

Greenfield, Robert. *S.T.P.: A Journey Through America with the Rolling Stones*.
Cambridge, MA: Da Capo Press, 2002.

Loewenstein, Dora, and Philip Dodd, eds. *According to the Rolling Stones*.
San Francisco: Chronicle Books, 2003.

Richards, Keith. *Life*. New York: Little, Brown, 2010.

*Stones in Exile*, documentary by Stephen Kijak, U.S. release May 2010.

Wyman, Bill. *Rolling with the Stones*. New York: Dorling Kindersley, 2002.

# ACKNOWLEDGMENTS

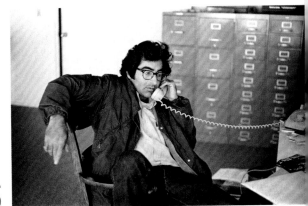

Jim Marshall in his apartment and office in San Francisco, circa 1972.

Big thank you to Anton Corbijn for his contribution and always saying "yes" to anything I ask him to do in support of Jim's work and legacy. Thank you to Nikki Sixx for his complete and totally original insight into Jim's photography: You are a rock star! I could not have gotten to Nikki without the help and support of Paris Chong, the Leica Gallery LA Goddess. Thanks to Jerry Pompili for helping to identify Carol Doda and Astrid Lundström.

Peace and love to the whole Chronicle Books team who worked on this book; it is always a joy. Bonita Passarelli, you are my rock star. Peace out.

—AD

Eternal love to the one and only Keith Richards, who made time to share his thoughts about Jim for this book. Special thanks to Steve Bing, Zach Schwartz, Dawn Holliday, Jane Rose, and JJ Emanuel for facilitating contact with Keith and bringing it to fruition.

Longtime Marshall collaborator and friend Joel Selvin provided the introduction and captions, and we are grateful for his sense of humor, deep knowledge of music, and loyalty to Jim. Robert Greenfield, Jasen Emmons, and John Pritzker also served as resources in the development of the book.

Jay Blakesberg and Ben Kautt provided key assistance at many steps throughout the process; Dave Brolan, Helene Crawshaw, Michelle Margetts, Mark McKenna, Tony Page, Michael Whalen, and the rest of Team Marshall continue to support efforts around Jim's work with love and enthusiasm. Many thanks also to my husband Brian Marsh, to Jeff Dunas for my initial introduction to Jim, and to Graham Nash for his ongoing inspiration in music and photography.

Special thanks for ongoing support to Theron Kabrich at San Francisco Art Exchange, Guy White at Snap Galleries, and Steven Kasher of Steven Kasher Gallery. We would also like to acknowledge Freddy Fletcher and Caroline Burruss of Austin City Limits Live, and Matt Appleby, Jennifer Powell, and Brett Bornemann of Jack Daniel's for their partnership and interest in Jim's legacy.

Lastly, peace, love, and whiskey to Jim—always. You changed our lives, and I will do all I can to support Amelia in taking good care of your children.

—MDM

# ROLLING S

3053 - 54 - 55 - 5

3241 - 42 - 43 -

3501 - 3508

3929 - 30 - 31 - 0

73 12 93

7431 - 43 studio

901 - 45 - UF

7909 - dickert

+ color on Ja